HOW TO PAINT
Watercolor Landscapes

HOW TO PAINT

Watercolor Landscapes

From Photograph to Sketch to Your Very Own Masterpiece in Six Easy Steps

Photographs by Joe Cornish
Written by Hazel Harrison

Reader's Digest

The Reader's Digest Association, Inc.
Pleasantville, New York/Montreal/London/Sydney

A READER'S DIGEST BOOK

This edition published by The Reader's Digest Association,
Inc., by arrangement with Quarto Inc.

Conceived, designed, and produced by
Quarto Publishing plc
The Old Brewery
6 Blundell Street
London N7 9BH

FOR QUARTO
Project Editors: **Donna Gregory and Paula McMahon**
Art Editor: **Jill Mumford**
Designer: **Penny Dawes**
Picture Researcher: **Claudia Tate**
Photographer: **Joe Cornish**
Copywriter: **Hazel Harrison**
Assistant Art Director: **Penny Cobb**
Art Director: **Moira Clinch**
Publisher: **Paul Carslake**

FOR READER'S DIGEST
U.S. Project Editor: **Marilyn Knowlton**
Copy Editor: **Barbara Booth**
Canadian Project Editor: **Pamela Johnson**
Project Designer: **Amanda Wilson**
Associate Art Director: **George McKeon**
Executive Editor, Trade Publishing: **Dolores York**
President & Publisher, Trade Publishing: **Harold Clarke**

Library of Congress Cataloging-in-Publication Data:
Harrison, Hazel.
 How to paint watercolor landscapes : from photograph
 to sketch to your very own masterpiece / by Hazel
 Harrison and Joe Cornish.
 p. cm.
 Includes index.
 ISBN 0-7621-0660-3
 1. Landscape painting—Technique. 2. Watercolor
 painting—Techniques. I. Cornish, Joe. II. Title.

ND2240.H37 2006
751.42'2436—dc22 2005055185

Address any comments about
How to Paint Watercolor Landscapes to:
 The Reader's Digest Association, Inc.
 Adult Trade Publishing
 Reader's Digest Road
 Pleasantville, NY 10570-7000

For more Reader's Digest products and information,
visit our website:
 www.rd.com (in the United States)
 www.readersdigest.ca (in Canada)
 www.readersdigest.com.au (in Australia)
 www.readersdigest.co.uk (in the United Kingdom)

Manufactured by Modern Age Repro House Ltd, Hong Kong
Printed by SNP Leefung Holding Ltd, China

1 3 5 7 9 10 8 6 4 2

Contents

Before you begin

Projects

Before You Begin

The core of the book is the series of 60 stunning photographs covering a wide range of landscape subjects. Each photograph occupies a whole page, with a step-by-step demonstration of a watercolor treatment on the accompanying page. You can either copy the watercolor or interpret the subject in your own way.

How to Use This Book

But before rushing for your paints and brushes, have a look at the earlier chapters, which provide valuable advice on working from photographs, choosing materials, and mastering watercolor techniques. If you are new to watercolor, try out the techniques before attempting a full-scale picture, as this will help you to familiarize yourself with the medium and enable you to work with confidence and enjoyment.

Editing your photographs Pages 8–9 give advice on how to interpret your own photographs, which may not be as technically accomplished as the ones in this book. Here the artist has turned a dull photo into a vibrant painting by simplifying the foreground, increasing the height of the rocks, and bringing in a dramatic sky.

Materials and Equipment These, shown on pages 10–13, detail the basic resources you will need to start watercolor painting, explaining the differences between different kinds of papers, brushes, and paints.

Basic techniques The techniques in this section, found on pages 16–22, are those you will be using for most of your landscape paintings, either on their own or in combination. To practice them, you can either copy the step-by-step sequences or use your own subject matter.

Advanced techniques Shown on pages 23–27, these differ from the basic techniques in that they are not essential, and you may use only one or two of them. But in spite of the term "advanced," none of them are difficult, and they are great fun to try out. Sometimes you may find that a touch of spattering, sponge painting, or wax resist brings a painting to life.

All the demonstrations in this book have been specially commissioned from a team of professional watercolor painters, each of whom has an individual style and way of working. If you find you respond strongly to one artist's interpretation of a subject, you might try a "mix and match" approach, choosing a photograph that appeals to you and painting it first in the style of the associated artist and then in another. Trying out different methods is an important step toward finding your own way of expressing yourself. The two images shown, from pages 31 and 81, will give you an idea of the different styles possible in the watercolor medium. The first has been worked on a large scale, entirely wet-in-wet, while the second was built up in a series of separate brushstrokes, with the shapes of the marks varied to describe both forms and textures.

page 31, *Sunset over Sand* by **Robert Tilling**

page 81, *Sun-kissed Hills* by **David Webb**

Subjects and Methods

The photographs and their associated paintings are loosely grouped into the categories shown on page 5 so that you can quickly find a subject that interests you. For example, if you enjoy painting textures, you might complete several in the Rocks and Cliffs group, and if you like to paint water, you have a wide choice from both Sea and Shorelines and Rivers and Lakes.

Each painting project has a complete list of the materials you will need, and is shown as a step-by-step sequence.

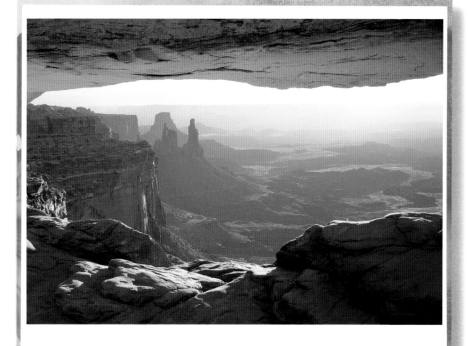

THE PHOTOGRAPHS

In many cases, the artists have cropped the photographs to focus in on a central area. For the sake of clarity, the photographs have also been cropped to match the paintings, but you may find it interesting to see their original formats, which are shown on pages 152–157, together with information on where they were taken.

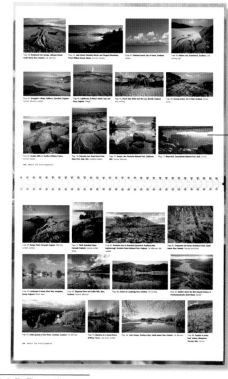

Original-format photograph

Paints Colors are listed in order of use. Note that names can change slightly according to the manufacturer.

Materials The paper, brushes, and other equipment used by the artist are listed. Sable brushes are not essential, as there are excellent alternatives.

Techniques These are the methods used by the artist in each painting. They are cross-referenced to the Techniques pages so that you can refresh your memory if needed.

Step-by-step sequences Follow the steps to see how the artist builds up a painting from start to completion.

Mesa Arch at Sunrise

This photograph beautifully captures the way the sunrise makes the underside of the arch glow a brilliant deep orange. The artist has chosen to subtly alter the composition by focusing on the striking landscape beyond the arch, balancing the colors to suit the medium of watercolor.

PAINTS
Winsor blue
Venetian red
Dioxazine violet
New gamboge

MATERIALS
Watercolor board
Round brushes, #7 and #3
2-in. (5-cm) flat brush
Dip pen
Masking fluid

TECHNIQUES USED
Overlaid washes, page 16
Masking fluid, page 21
Scrumbling, page 25
Salt spatter, page 25

1 Sketch the scene in pencil and then mask out all the highlights—the sides of the rock faces lit by the sun and the light areas in the middle distance.

2 With a pale wash mixed from Winsor blue, Venetian red, and a touch of dioxazine violet, lay in the distant hills and mountains in separate layers, allowing each to dry before adding the next. Use the #7 round brush to paint in the details of each horizon, and blend in with the 2-in. (5-cm) flat brush.

3 Use the pen dipped in watercolor to draw in the fine fissures on the pinnacles (inset), and then use a #3 round brush to scumble in shadows of the rocks and strata in the middle distance, making the colors stronger toward the foreground. When dry, remove the masking fluid from the centre only.

4 With the 2-in. (5-cm) flat brush, wash clear water over the top of the painting and then lay a thin wash of Venetian red over the bottom half, blending the two in the middle. This will soften and unify the middle distance.

5 Scumble and dry-brush a darker mix of the Winsor blue and red mixture over the left-hand cliff to suggest darker shadows, overhangs, crevices, and vegetation (inset), then wash over the whole cliff with a layer of the darker mix. When dry, remove the masking fluid and wash Venetian red alone over the whole cliff area.

6 Using the #7 round brush, scumble texture onto the foreground rocks, then use both the smaller brush and the pen to paint in the cracks, the darker shadows of the foreground rocks, and the roof of the cave with a dark mix of blue and red. Use the 2-in. (5-cm) flat brush to paint over the lower foreground rocks with a dark mix of Winsor blue and Venetian red, adding a little water to lighten the rocks on the left. As the paper starts to dry, sprinkle in some salt to create texture. When dry, brush away the salt, remove the masking fluid, and add more washes of Venetian red and new gamboge. Several layers will be needed to create depth of color.

Details These allow you to "look over the artists' shoulders" as they use special techniques.

Final painting

The "Eye" of the Camera

Photographs are a wonderful reference for painting, and there are few artists nowadays who don't use a camera. However, it is important to remember that the camera doesn't always see as we do. Photographs can inaccurately capture the sense of space in a landscape, because everything is in equally sharp focus and distortions may occur, especially in the case of tall landscape features or buildings. If taking photographs specifically for a painting, it is always wise to make a quick sketch to record shapes and proportions.

Another difficulty is the misrepresentation of color. With photographs the colors and tones are not always true, because the camera can't easily deal with extremes of light and shade. This is a problem, and you will have to rely on your memory of the scene and your knowledge of the lighting conditions. Most people are familiar with photographs taken on a bright, sunny day that turn out with near-black shadows or bleached-out highlights obscuring vital details. If your camera has a facility for exposure-compensation, as many now do, including digital cameras, try a few shots at different exposures so that you have sufficient information to work from. The beauty of digital cameras is that you can see the result immediately.

PHOTOGRAPHS AND SKETCHES

The first shot, taken at the shortest focal length of 35 mm, has flattened out the mountains and made them appear more distant. In the second, taken at 75 mm, the longest length available on most cameras with built-in lenses, the spatial relationships are correct, but the mountains remain flattened, resulting in a landscape that lacks drama. The sketch, which took a few minutes, records the artist's impressions at the time.

CITYSCAPES

Taking photographs of tall buildings results in converging vertical lines, an effect that can be avoided only through the use of expensive professional equipment. The same thing would happen in a close-up photo of tall trees. The lines can be straightened quite easily, however, or you could use a modified version of the effect to emphasize height.

Taken at 35 mm

Taken at 75 mm

Sketch

Converging vertical lines

LIGHTENING THE COLORS

Club del Mar by Linda Kooluris Dobbs
This photograph is obviously not a true record of the scene; instead, the artist has drawn on experience and her immediate impressions to heighten the colors while retaining the composition. Notice especially the group of leaves above the broken branch, which are black in the photograph.

The photograph

The painting, with heightened colors

Editing Your Photographs

When sketching directly from the subject, you may decide to leave out some features and possibly change things around a bit to improve the composition. You should try to do the same with photographs. It is more difficult in this case, however, since a photograph presents only one viewpoint; if you are out in the landscape, you can move around to explore more possibilities. Always bear in mind that painting is about interpretation, not slavish copying. You don't have to follow the same format as the photo; instead, try framing it in different ways using L-shaped pieces of cardboard or paper. You might find that taking the middle section of a landscape-format photograph provides a more unusual vertical composition.

Remember also that there are ways to add to a photograph, such as by putting in more sky or foreground than is actually shown. Wide landscapes or seascapes often benefit from a low horizon, with the sky occupying more than half the picture space, while a large area of foreground has the effect of pushing a focal point back in space to create a stronger feeling of depth and of the image receding. Test this by sticking your photo down on paper and sketching in more sky or foreground with a quick-to-use medium such as pastel.

EXPLORING POSSIBILITIES

This photograph is rather cluttered, with the expanse of foreground reducing the importance of the building. In contrast, the smaller area offers a composition with strong possibilities.

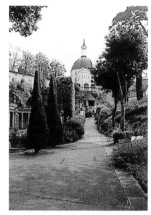

Uncropped photograph

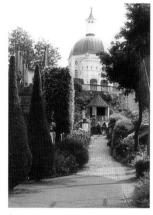

Cropped photograph

CHANGING THE EMPHASIS

The artist took this photograph mainly to capture the effect of the light on the waves, but when she looked at it again, she decided that it was unbalanced, so she extended the sky from her memory in order to achieve a more expansive image.

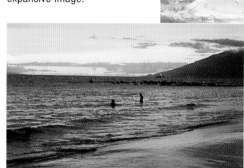

Painting with expansive sky

Photograph showing light on the waves

PULLING IT TOGETHER

Blue Skies by Sue Kemp
Here, the artist was interested as much in the light effects as in the rocks, and she has departed radically from the rather dull colors of the photograph. She has also given more emphasis to the rocks by increasing their height, and has improved the composition by intervening clouds that balance this dominant feature and also give a sense of movement.

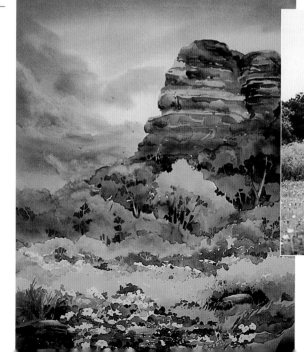

The photograph

The painting with improved color and composition

Watercolor Choices

Paints are priced according to the value of the pigment used in their manufacture, so some colors are necessarily more expensive than others. Fortunately, landscape painting doesn't require many of the expensive ones. Watercolors are available in two basic qualities: students' and artists' colors. Students' colors contain less pure pigment and thus don't achieve the same brilliance of color as the artists' paints.

Another choice to consider is regarding pans and tubes. If you intend to do the majority of your work indoors, tubes are ideal because they let you release a lot of color very quickly—an asset when laying broad washes or applying similar techniques. Many artists prefer pans, however, especially when working outdoors or on a small scale.

PALETTES

Even if you have a paintbox for your pans and tubes, you will almost certainly need extra palettes for mixing colors, and the more you have, the better, because colors will stay cleaner if you use a separate well for each mixture. There are many different palettes available, in both plastic and ceramic, the latter being the most ideal to use.

PANS

Pans can be bought in both whole and half sizes. The latter is the most readily available. Both are designed to fit into paintboxes and can be removed and replaced when used up. Clean the paints after a working session by brushing over them with water. This will prevent the colors from becoming mixed up and muddied.

TUBES

Regular tubes of watercolor are quite small. Some manufacturers make larger sizes, but these are not necessary—it takes a long time to get through even a regular tube. Good-quality paints can be kept indefinitely as long as you screw the caps back on after use. If you prefer tubes to pans, you may not need a paintbox; you could use one of the palettes shown above.

Limiting Your Color Choices

Manufacturers produce such a large range of colors that it can be difficult to make an initial choice, especially since some of the color names seem to have little relationship to the landscape. However, once you try your hand at painting, you will begin to think instead in terms of pigment colors, describing a sky as cerulean rather than blue, or a flower as crimson rather than just red. You will learn to choose and mix colors instinctively. It is best to get to know the colors of a basic range well, both alone and as mixtures.

The 14 colors listed in the starter palette at right are probably more than you will need initially, but bear in mind that you will always need two versions of each of the primary colors—red, yellow, and blue. (See page 14 for more on this topic.)

STARTER PALETTE

This palette of 14 colors will be sufficient for all landscape subjects. If you prefer to begin with a smaller range, you could omit burnt sienna, burnt umber, and the two greens, since the latter are easily mixed from blue and yellow. In some cases, alternatives have been given, either because two colors are very similar or because the pigments produced by different manufacturers vary slightly. The most essential colors are marked with an asterisk (*).

| Cadmium red/ Winsor red* | Alizarin crimson* | Lemon yellow/ cadmium yellow pale* | Cadmium yellow/ chrome yellow* | Yellow ochre/ raw sienna | Burnt sienna | Burnt umber |

| Hooker's green dark/ viridian | Sap green | Ultramarine/ French ultramarine* | Cobalt blue | Cerulean blue* | Prussian blue/ Winsor blue/ Antwerp blue* | Payne's gray* |

EARTH COLORS

For muted-color landscapes, you might try using only the earth colors shown here. These, together with a few very expensive reds and blues produced from natural sources, were the mainstay of artists prior to the development of chemical pigments during the nineteenth century.

| Terre verte | Aureolin | Yellow ochre | Sepia | Burnt Umber |

| Burnt sienna | Raw sienna | Indian red | Indigo |

PAINTING WITH THREE COLORS

An exercise often set by art teachers is to produce a painting using only three colors. In fact, such a combination yields an amazing variety of mixtures. In this painting by Hazel Soan, alizarin crimson, yellow ochre, and ultramarine have been used to produce a warm color scheme. For a cooler one, you might try lemon yellow, cerulean blue, and cadmium red.

Alizarin crimson Yellow ochre

Ultramarine

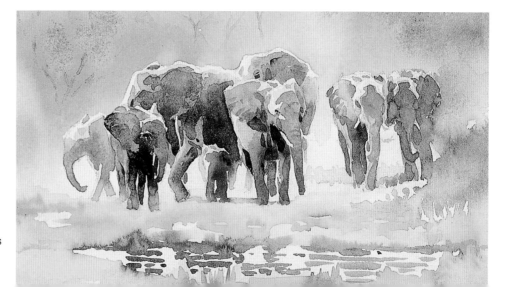

Painting using only three colors

Watercolor Papers

Watercolor paper can be bought either in pad form or as separate large sheets that can be cut to size. For studio work the sheets are a more economical choice, and they allow you to vary the proportions of the work, whereas sketchbooks come in standard-sized rectangles. Watercolor paper is available in a variety of weights, or thicknesses, and in three different textures: smooth, known as Hot-pressed (or HP for short); medium, known as Cold-pressed (CP); and Rough. Paper thickness is expressed in pounds and refers to the weight of a ream of paper (500 sheets). The lightest paper is around 60 lbs (130 grams per square meter (gsm)), which is very flimsy, and the heaviest is 300 lbs (640 gsm) or over, depending on the manufacturer. Light paper should always be stretched before use or it will buckle when wet paint is applied. Most watercolor pads contain 140-lbs (300-gsm) paper, which can buckle slightly but is usually sturdy enough for sketches and small-scale work. However, if you are using sheets of this paper and are working on a large scale, it is wise to stretch it first, especially if you like to work with wet, sloppy paint.

PAPER TEXTURES

The best all-rounder, and thus the most commonly used paper, is Cold-pressed, which has enough texture to hold the paint in place but also allows for fine brushwork and detail. Rough paper breaks up the brush marks, which can be very effective, but it takes some practice to learn how to use the paper to its best advantage. Smooth paper causes the paint to puddle and slide around, although it can be excellent for detailed work, when the paint used is fairly dry.

Smooth (Hot-pressed) paper has almost no texture, so wet paint will cause puddles. This can be exciting if you want to achieve effects such as backruns (see page 17).

Cold-pressed paper has a distinct texture, although this is not sufficient enough to interfere with the fluidity of the brushstrokes.

Rough paper has a pronounced texture, enabling the paint to settle on the raised grain to create broken-color and textured effects. It is not suitable for fine detail work.

WATERCOLOR SKETCHBOOKS

Watercolor sketchbooks typically contain 10 or 12 sheets of 140-lbs (300-gsm) paper and are available in a variety of sizes and paper textures. Those with a central spiral binding are especially useful for outdoor work because they let you take a painting across both pages.

STRETCHING PAPER

Stetching your paper before painting will give you a smooth, flat surface to work on. This surface will stay flat as you work, and the finished painting will dry flat.

1 Soak the paper on both sides by immersing it in a bath or large bowl.

2 Leave for a few minutes to allow the fibers to expand, then hold it up by one corner to drain off the excess water.

3 Place the paper on a board and remove any air bubbles by rubbing it gently all over with a sponge.

4 Cut strips of gummed tape longer than the edges of the paper. Run a wet sponge over them, then stick them down with half the width of the tape on the paper.

Brushes and other equipment

You don't need a large selection of brushes for watercolor work. If you choose the right one, you will often find you can complete an entire picture with it or seldom need more than two or three. The most versatile brushes are those known as rounds, which come to a fine point and can be used to make a great variety of marks, from large, rounded or oval shapes to lines of varying width. They can also be used for washes during the preliminary stages of a painting. Another brush you may find useful is the flat brush, which is good for both washes and dry-brush work (see page 20). It can also be used on its side to create sweeping strokes that are ideal for foliage and grasses. With any brush, spend time practicing to discover what can be done with it, and try holding it different ways because this will affect the brushwork. Holding the brush just above the hairs, for example, offers maximum control, while gripping it lightly near the top of the handle produces much looser, freer strokes.

CHINESE BRUSHES

Chinese brushes don't last as long as good sables, but they are much cheaper, making them ideal as a starter kit. Designed to create the calligraphic effects associated with Chinese art, they are now widely available and are increasingly popular among professional artists.

BASIC BRUSH SELECTION

Sable brushes are the best available brushes, but there are many less expensive alternatives, such as nylon brushes and sable and synthetic mixtures. The brushes shown here are, from left to right: a rigger brush, synthetic flat brush, and three sable rounds. The rigger, so called because it was used by marine artists to paint rigging, is very useful for landscape details such as twigs and grasses.

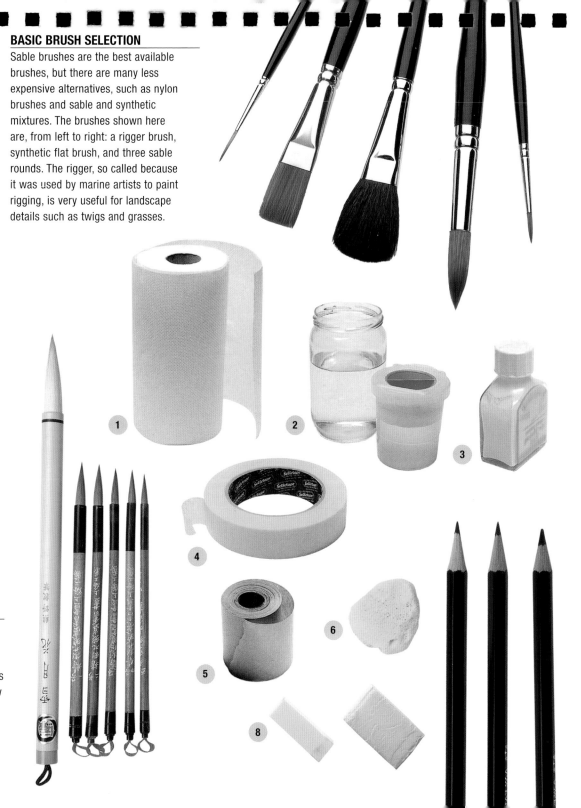

ADDITIONAL EQUIPMENT

The beauty of watercolor painting is that you don't need many extras. You may already own most of the items shown here.

1 Kitchen towels are essential for cleaning up and for lifting out (see page 22).

2 Water pots cost nothing if you recycle old glass or plastic pots. Nonspill pots are a wise investment for outdoor work.

3 Masking fluid is used for reserving small highlights (see page 21). Always use an old brush when applying the fluid, and wash the brush immediately after use.

4 Masking tape can be used to attach paper to a board. Do not use it to stretch paper.

5 Gummed strip is essential only if you intend to stretch paper before use.

6 Small natural sponges are useful when lifting out and for softening edges. You can also use them to apply paint (see page 24).

7 Drawing board. You will need some type of board, but this can be as simple as a piece of plywood, or similar wood, cut to size.

8 Plastic eraser or kneadable eraser. Always have a clean one handy. These are useful for removing unwanted lines and dried masking fluid.

PENCILS

Pencils are needed for sketching. Many grades of pencil are available, but a B is a good all-rounder and is soft enough not to indent the paper.

Color Temperature

Most people know that a primary color is one that can't be mixed from any other colors and that the three primaries are red, yellow, and blue. What is less well known is that there are different versions of each primary, which is why the palette on page 11 contains more than one paint of each color.

What makes these colors so different from one another is what is known as "color temperature." Some colors are perceived as "warm" and others as "cool," and each red, yellow, and blue has both a warm and a cool version. When mixing secondary colors (mixtures of two primaries), it is important to choose the right primaries. For example, alizarin crimson and ultramarine are both warm and, in color, veer slightly toward purple, so a mixture of these will make a good purple; a mix of cadmium red and Prussian or Winsor blue will result in a muddy brown color.

It is important to make use of color temperature in landscape painting. Cool colors—those with more blue—tend to recede, while warm colors—those with more red and yellow—come to the fore. It is for this reason that landscape painters typically use cooler colors for the background of a painting—to produce a sense of space. Warm and cool colors can also play a descriptive role, with warm colors used for sunlit and tropical subjects, and cool blues and grays used for winter scenes.

DIFFERING PRIMARIES

Placing the warm and cool primaries next to each other lets us see the different ways in which colors are perceived. Cadmium red (1) is slightly yellow; alizarin crimson (2) is slightly blue; ultramarine (3) is obviously warmer than Winsor blue (4); lemon yellow (5) is more intense and greenish than cadmium yellow (6), which veers toward orange.

INTENSE SECONDARIES

Here the colors closest together on the wheel have been mixed to produce intense secondaries. The blue-and-yellow mix is cool, and the other two are warm.

MUTED SECONDARIES

The primary colors farthest apart create more muted mixtures, which could be useful for creating shadows.

1 Alizarin red (yellow bias)
2 Alizarin crimson (blue bias)
3 Ultramarine (red bias)
4 Winsor blue (yellow bias)
5 Lemon yellow (blue bias)
6 Cadmium yellow (red bias)

WARM AND COOL CLOUD COLORS

Clouds are seldom just gray; they also have a warm or cool bias. Some useful two-color mixtures are shown at right.

COOL-WEATHER EFFECTS

Here the damp and misty early morning atmosphere has been evoked through the use of cool greens and grays.

SKY BLUES

The sky is often painted first in a landscape, so make sure you choose the correct blue. Here are some suggestions.

1 Warm sky: ultramarine
2 Cool winter sky: Winsor (or Prussian) blue
3 Vivid Mediterranean sky: mix of cerulean and cobalt blue
4 Sky at dusk: mix of Payne's gray and ultramarine

THE IMPRESSION OF HEAT

In this watercolor and colored-pencil drawing, the artist has used a limited palette of very warm colors.

Warm: mix of ultramarine and burnt sienna

Cool: mix of viridian and alizarin crimson

Warm but pale: mix of yellow ochre and cobalt violet

Color Mixing

Only experience will teach you which colors to mix to produce a shade that exists in nature, but there are some facts about color mixing that should help you to avoid mistakes. First, it is vital to remember that the colors mixed in your palette look much darker than when they have dried on the paper. This is because the white of the paper shows through the translucent paint. Always try out a color for a wash on a spare piece of paper and let it dry before applying it. Although you can make it darker or amend the hue by painting another wash over it, a single wash is much more effective and fresher-looking than two or three layers. Second, try not to mix more than three colors, and use only two if possible, because mixing tends to devalue colors to some extent, while overmixing produces muddy hues. Third, bear in mind that although you begin by mixing colors in the palette, you will continue to mix them as you work, by laying one wash or brushstroke over another. You can change colors considerably in this way, even laying light colors over dark, but don't overdo it or the paint will become stirred up and muddy.

PALETTE MIXING

When mixing colors in the palette, start by diluting each one with water until you achieve the required strength. Wash the brush, then pick up one color and add it to the other, trying it out on scrap paper to ensure that the hue is correct.

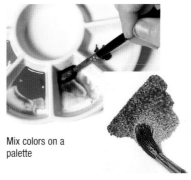

Mix colors on a palette

Try colors on scrap paper

COLOR CHANGES

Don't despair if a color looks wrong once it has dried; it can always be amended by laying on another color. You can even lighten colors to some extent by overpainting with yellow, as most yellows naturally are slightly opaque. The second, and any subsequent colors, should be applied quickly and deftly to avoid stirring up those beneath. Remember that watercolor remains soluble even when dry.

MIXING ON THE PAPER

A lively mixture can be created by letting the colors blend on the paper surface rather than mixing them in the palette. Although they do not mix so thoroughly, each color retaining its identity, the effects can still be exciting and evocative. This method of working is known as "wet-in-wet" (see page 18), and in landscape painting it is typically used for skies and foliage.

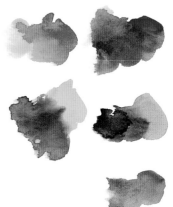

Down stroke
1 Permanent yellow
2 Ultramarine
3 Ultramarine (more diluted)
4 Permanent yellow
5 Cadmium red
6 Raw sienna
7 Olive green
8 Olive green
9 Olive green

Cross stroke
Cadmium red
Permanent yellow
Crimson
Cadmium red crimson (all fairly diluted)
Viridian
Cadmium red (diluted)
Raw sienna
Viridian
Ultramarine

RELATIVE OPACITY

Some pigments are more opaque than others, and it is important to remember this when overlaying colors. Here you can see that the reds and yellows in the top row almost completely cover the wash of pale green, while the colors in the second row and the first two blues in the bottom row let the green show through. The last two colors are much darker in tone and cover the pale wash.

Colors laid over pale green
1 Cadmium red
2 Alizarin crimson
3 Lemon yellow
4 Cadmium yellow
5 Yellow ochre
6 Burnt sienna
7 Burnt umber
8 Viridian
9 Cobalt blue
10 Cerulean blue
11 Winsor blue
12 Payne's gray

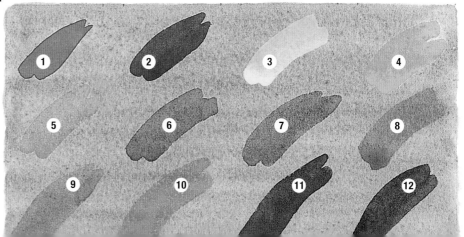

Basic Techniques

Most of the techniques shown on the following pages are those you will be using for the majority of your watercolor landscape paintings, either on their own or in combination. Remember that it is wise to try out techniques on scrap paper before embarking on an actual painting. You can copy the examples shown here or use your own subject matter.

FLAT WASHES

Typically, flat washes are used for covering the whole or a large part of the paper during the first stages of a painting. They can be laid either on dry or wet paper. The latter achieves a more even coverage, but working on dry paper makes the wash easier to control if you want to stop at a certain point, because the paint will stop flowing when it meets dry paper.

1 To lay a wash on dry or damp paper, tilt the board at a slight angle and take the paint evenly from one side to the other. Each new band of color should just touch the one above.

2 Washes can also be laid with a small natural sponge. Here the paper has been dampened to give even coverage, but if you want a more textured effect, try working on dry paper.

3 To take a wash around a complicated edge, work on dry paper and turn the board upside down so that pools of paint don't form over the edges. Another method is to carefully wet the paper only where the wash is to be applied.

GRADED AND VARIEGATED WASHES

A graded wash is one that becomes lighter as it progresses down the paper, while a variegated one contains more than one color. Landscape paintings often start with variegated washes, with a blue or gray color at the top, gradually changing to yellows and greens toward the foreground. Such washes are also ideal for sunset effects.

1 Graded washes are worked on dry paper. Lay the first band of color at full strength; then for the second and each subsequent band, dip the brush into clean water before picking up the color. This will dilute the paint by the same amount each time.

2 If this wash had been worked on dry paper, the stronger color would have run down into the paler areas, losing the graded effect. For stronger tonal contrasts, try dipping the brush twice into the water or laying the second band of color with water alone.

3 You need to work fast with variegated washes, so it is important to mix the colors in advance. Lay the colors in even or random bands, depending on the effect you want to achieve, and don't try to work back onto the paint while it is drying.

4 This type of variegated wash, worked on wet paper, would be ideal for a stormy sky. Lay the palest colors first, then the darker ones, and tilt the board to encourage the colors to flow in whatever direction you choose.

OVERLAID WASHES

Whole paintings can be built up through a series of washes, some laid over each other. With this method, called "wet-on-dry" (see page 18), each wash must dry before the next is added. A hair dryer can be used to speed up the process.

1 Begin with a blue wash for the sky, followed by a variegated wash of red and brown below, leaving a band of white in the middle. After leaving the first washes to dry, paint a band of gold in the center.

2 Overlay the gold in places with green, and paint the hills in the background with a stronger version of the bluer wash used for the sky.

3 Paint the trees using a strong brownish green, which covers the blue of the hills. Use the same color for the shadow along the front of the cornfield. Use the point of a round brush to feather the color, suggesting stalks of corn.

4 To complete the picture, use the dry-brush technique (see page 20) to add texture in the foreground and add details with a fine brush.

SURFACE MIXING

This technique begins with the process of color mixing in the palette but continues it on paper. As soon as one wash or brushstroke is laid over another, the colors will mix on the paper surface. Always remember when you lay the first washes that they will influence any subsequent colors. Don't make them too dark unless you are sure that they will be left to stand as they are.

1 When painting foliage, artists often begin with a yellow wash. This is because it can be overlaid with green and blues, both of which are darker in tone.

2 Here the yellow has been allowed to dry, with blue laid over it and the first color showing through to produce green. Surface mixing produces more subtle effects than does mixing a flat color in the palette.

3 Colors can also be mixed wet-in-wet, as in this example. With this method the colors flow into each other without forming hard edges, making it ideal for painting clouds (see below).

DROPPING IN COLORS

Using the tip of the brush to drop more colors into a still-wet area produces lovely effects. This method can be quite carefully controlled as long as you wet the paper only in the areas where you want the colors to blend. For example, tilting the paper can make the colors run in a certain direction.

1 Working on dry paper, paint the sky blue around the edges of the cloud. When dry, wet the cloud area and drop in yellow, then a warm, dark gray mixture.

2 Tilt the paper—or the board if the paper has been stretched or fastened down—to encourage the colors to settle in pools at the bottom of the cloud.

3 Now drop in pure cadmium red at the base of the cloud, then tilt the paper again to avoid the color running too far upward into the paler areas.

4 Drop in more red and add more color to the foreground if needed. This brilliant red works well for wet-in-wet methods because it becomes diffused, but it would be too bright and assertive if laid over a dry wash.

BACKRUNS

Backruns fall into the category of accidental effects that can be a disaster—or an asset. If you lay down a fairly strong color and then drop a more watery one into it while it is still damp (but not too wet), the first color will "run away" from the water. This results in intriguing cauliflower shapes with jagged edges, which suggest forms such as clouds or distant trees. It is an effect often deliberately sought out.

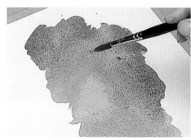

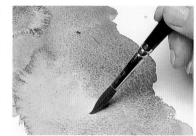

1 The backrun effect depends on the water content of the paint. Here the blue and red used first are about the same strength, but the yellow is more dilute and has begun to flow outward.

2 The effect is encouraged by dropping in more of the watery yellow. Another backrun has been made at the top by adding very watery red to the blue-red mix. The paint will continue to flow outward until dry.

3 You can make dramatic backruns simply by dropping clean water into paint; sometimes this even works if the paint has dried.

4 This cluster of backruns is exciting in itself but is also highly suggestive, perhaps of dandelion heads in a foreground field.

WET-IN-WET

This term simply means applying new paint to a wash that has not yet dried; dropping in color (see page 17) is one version of the method. The effects of wet-in-wet all hinge on the wetness of the paper, and it takes some practice to be able to judge this. The previous wash must be only slightly damp in order to achieve soft edges without the colors flowing into each other in an unpredictable way, so wait until the sheen has diminished.

1 The trees are to be painted wet-in-wet, but the edges must not flow into the sky, so allow the blue sky wash to dry before painting the trees. While still wet, use a tissue to blot away some of the color to suggest form, then add a little brown.

2 Using the tip of a well-loaded brush, gently stroke a second tone onto the damp first layer. Use an uneven, broken line to suggest the clumps of foliage and to provide some texture.

3 While the paint is still damp, add the darkest color and paint in the tree trunks on the dry paper beneath. If you find you have let the paper dry out too much, it can be wetted again using a clean brush.

4 Finally, add detail in the foreground, wet-on-dry, to link in with the tree trunks and contrast with the softness of the cypress trees.

WET-ON-DRY

Painting wet-in-wet is a relatively modern watercolor technique; the early watercolor painters worked almost exclusively wet-on-dry, building up depth of color and tone with a series of overlaid washes and brush marks. One of the attractions of the latter method is that it produces crisp, clean edges and is therefore ideal for a subject such as water or strong sunlight and shadows.

1 This subject was seen in the evening light, meaning the highlights on the water should not be pure white. Thus, after drawing in the boat very carefully, the artist has "knocked back" the white of the paper with a pale wash of red and yellow.

2 After letting the first washes dry, the artist begins to paint the sea, starting at the horizon line and working gradually forward.

3 Great care needs to be taken in reserving the highlights, because these are far from uniform in shape and size. The tip of the brush is used to make calligraphic marks, always making sure that the first layer of paint is dry before the next is applied.

4 Although the color scheme does not vary substantially, warmer colors are now brought in to the nearest wave to bring it forward in space. The surface of the paper is smooth, so the paint puddles slightly to create a backrun (see page 17).

5 Skies are normally painted in first, but here the artist wanted to establish the sea first. The washes are laid around the sail, and the edges of the clouds are softened by removing the pools of paint that have collected above them.

6 The broad brushstrokes have run over the edges of the paper, making it difficult to assess the overall composition, so the picture is temporarily framed with strips of paper for assessment purposes.

7 To paint the tiny lines of shadow formed by the puckering of the sail fabric, the hairs of the brush are slightly splayed out between thumb and forefinger to produce a series of short, parallel marks (see Dry Brush, page 20).

8 The wet-on-dry method has produced a wonderfully evocative description of the turbulent sea and windswept sky, with the shapes made by the highlights playing a major role in the composition.

COMBINED METHODS

Both the wet-in-wet and wet-on-dry methods can be used on their own, but completing a whole painting wet-in-wet is seldom satisfactory because it produces an oversoft, out-of-focus look that lacks impact. It is more usual either to restrict wet-in-wet work to just a sky or the background in a flower painting, for example, or to begin with wet-in-wet washes and gradually build up detail and definition wet-on-dry.

1 Having made a pencil drawing to place the important elements, wet the sky area and flood in a bluish gray. This will run downward until it meets the dry paper. Take a light yellowish wash over the distant land area and paint a band of dark blue to represent the sea.

2 Crisp edges are required for the boat and breakwater, so let the paper dry fully before the first tone is painted for these areas.

3 Having laid a flat wash over the sand area and added second washes to the cliffs, wet-on-dry, start to strengthen the tones of the sand on the left.

4 Lay deep earth colors over the foreground and let them blend, wet-in-wet. Do not premoisten the paper; otherwise, the colors might flow upward into the breakwater.

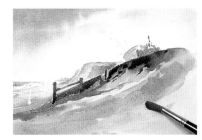

5 Continue the process of building up the foreground by adding blue-gray to echo the color of the sky, along with touches of very dark brown to the breakwater, working wet-on-dry to produce crisp edges.

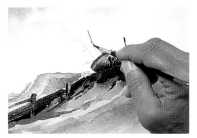

6 Using a very fine brush to paint the mast and rigging on the boat, ensure maximum control by steadying your working hand on your left wrist.

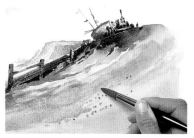

7 Continue to add definition to the boat and breakwater, which form the center of interest, and flick paint onto the foreground to give a hint of texture (see Spattering, page 23).

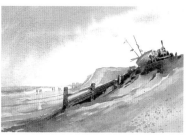

8 Finally, add linear detail to the breakwater, wet-on-dry, and small groups of figures to the middle ground to create atmosphere and provide a sense of scale.

GRANULATION

Some pigments tend to precipitate, or break up, when mixed with water, resulting in a grainy appearance. This can be disturbing if you are trying to lay a perfect flat wash, but it is often encouraged by artists, either to suggest specific textures such as those of tree bark or rough stones or simply to add additional interest to an area of a painting. Colors that tend to granulate are known as sedimentary.

1 Flood ultramarine and burnt sienna onto dampened paper and allow to dry. Dampen the windmill and its reflection and paint a very wet mixture of cerulean blue, yellow ochre, and burnt sienna onto the central area.

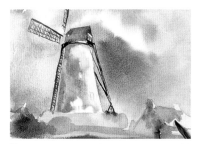

2 Let the paper dry before painting the sails of the windmill with the tip of a fine brush. The banks of the river and the roof of the cottage should be painted in very loosely.

3 When the windmill is dry, paint the windows using very thick, wet paint, tilting the paper so that the paint settles unevenly. Always avoid painting windows as rectangles of solid color, because this doesn't look realistic.

4 Dampen the shaded side of the windmill, then make a swift, dark stroke down the side. Finally, add details to the reflections, wet-on-dry. Notice how the granular quality of the clouds adds extra interest.

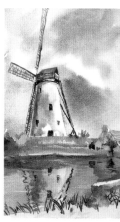

DESCRIPTIVE BRUSHWORK

Brushwork does not always play a large part in watercolor work. If you are working wet-in-wet, or building up a painting with a series of overlaid washes, the marks of the brush are relatively unimportant. However, for wet-on-dry paintings, especially when flowers and foliage form part of the subject, the marks you make play a vital descriptive role, and you can vary them according to the shapes in the subject.

1 Begin with an allover variegated wash, then allow the paper to dry out slightly. To paint the tall tree, make long, upward-sweeping brushstrokes using a medium round brush.

2 In the foreground, paint in flowers, largely wet-in-wet, using yellow dropped into a deep pink wash. Next paint the shadows, varying the brush marks from thick to thin and leaving parts of the yellow wash showing.

3 Add deeper reds to the flowers, using brush marks that suggest the shapes. Paint deep green around the shapes, pushing the color up into the base of the bushes.

4 Continue to build up the painting in the same way, varying the brush marks from area to area. The small flowers on the right should be painted using just one or two small marks for each petal.

DIRECTIONAL BRUSHSTROKES

You can give an exciting feeling of movement to a landscape painting by using long, sweeping strokes that follow a certain direction, perhaps suggesting windblown foliage. In this example, the brushwork plays both a descriptive and a compositional role. Use any brush you feel comfortable with, but you may want to try a flat brush, as the artist has done here.

1 Using a medium-sized flat brush, make rapid strokes following the direction of the foliage clumps. Here the artist has worked with fairly dry paint using a method known as "rough brushing."

2 Use the same technique to lay darker tones on the undersides of the clumps. While the paint is still slightly damp, paint in a few twigs and small branches using a rigger brush (see page 13).

3 To provide a color contrast, include some warm-colored branches, feeding into the foliage masses, and add a few dark accents to both foliage and branches.

4 Notice how the dry paint has spread a little into the sky at the edges of the clumps to suggest the feathery texture of the foliage. Also notice the way the artist varied the width of the brush marks used for the branches.

DRY BRUSH

This technique, which involves working with very little paint on the brush so that the brushstrokes settle mainly on the surface grain of the paper, is most commonly used for grasses and foliage. By splaying out the hairs of the brush between your thumb and forefinger, you can create a brush mark that consists of a series of tiny parallel lines, which can follow any direction you choose.

1 Most of the dry-brush work is to be used for the foreground grasses, but here the artist has also used this method for the sea, dragging gray-blue lightly across the paper with a round brush.

2 Having painted a wash for the sand and allowed it to dry, take a flat brush, with the hairs slightly splayed out, and make upright, slightly curving strokes to paint in the marram grass.

3 When the first layer is dry, build up subsequent layers in the same way, dry-brushing progressively darker colors over the original yellow. To create a more subtle effect, work each new layer before the previous one has dried fully.

4 To complete the painting, use white gouache (opaque watercolor) to create highlights on the sea, then scratch out linear highlights on the grasses with a craft knife (see Scratching Out, page 23).

RESERVING WHITE PAPER

The untouched freshness of white paper is the best way to create brilliant highlights in watercolor work. This does involve planning the painting in advance so that you know exactly where the lights are to be, but this is not difficult if the white areas are relatively large, as in this example. If you are working wet-in-wet, remember to leave the highlights as dry paper so that the paint does not flow into them.

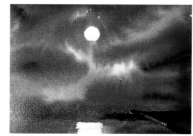

1 Leave the moon and reflection as dry paper, with clean water taken carefully around the edges. Next, flood a wet wash of deep blue over the damp areas and help it around the moon and reflection using the tip of the brush.

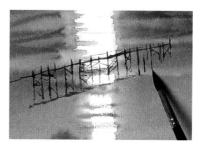

2 With the paper still damp but not too wet, add the horizon using a deep green-gray color.

3 The rest of the painting is worked wet-on-dry. Paint in the pier and its reflection using delicate strokes made with the point of a round brush.

4 Finally, touch in the boats with deep blue-gray. Notice that backruns (see page 17) have formed at the back of the sea and on the horizon, which is very effective in a loose, free painting such as this.

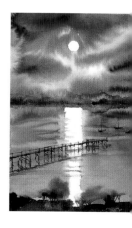

RESERVING HIGHLIGHTS WET-ON-DRY

For a subject that has large areas of highlights, such as this Mediterranean scene, it is best to work wet-on-dry because this makes it easier to control the paint. It is wise to make a drawing first to establish the locations of main areas of light.

1 Lay a blue-gray sky wash around the tops of the buildings. Using a flat brush, block in some shadows and the hull of the boat.

2 The first dark areas of water should be painted with a medium round brush, taking the color around the white reflections. Use the side of the brush to paint the palm trees.

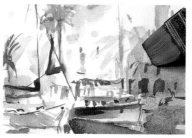

3 Build up the water. Using bold strokes will give the impression of a slightly disturbed surface. Reserve areas of white paper for the reflections of the buildings.

4 Here, the white of the reflections is too emphatic, so overlay very pale blue washes to make them slightly darker than the buildings themselves.

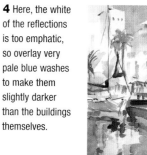
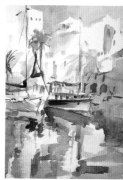

MASKING FLUID

For small highlighted areas or intricate shapes that are difficult to paint around, masking fluid (see page 13) is invaluable. This is painted on before colors are applied, and removed when the subsequent washes have dried. Masking fluid is permanent when dry, so use an old brush or coat the brush hairs with petroleum jelly before dipping it into the fluid.

1 Paint masking fluid over the sun's rays and the light-catching ripples in the water. When dry, lay pale washes of yellow and blue over the whole picture area.

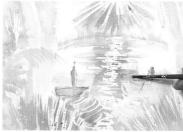

2 Gradually strengthen the color using stronger blues and yellows, then paint in the boys in their boats, together with their reflections.

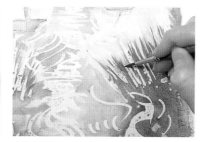

3 Paint the surrounding grasses and palm fronds in very dark greens to make a frame for the sunlit areas of water.

4 Having completed the foliage, allow the painting to dry, then remove the masking fluid by rubbing it with a finger. Lay washes of deep blue-green over the shadowed areas of water on the left and the right to "knock back" the whites.

SCUMBLED MASKING

Typically, masking fluid (see page 21) is removed to reveal clear white shapes, but you can achieve interesting effects by scuffing it with a kneadable eraser so that it forms rubbery strands but is not actually removed. You can paint over the masking and repeat the process several times to create a textured surface ideal for suggesting turbulent water or wind-tossed foliage.

1 First paint the sky and hill. Lay a light yellow wash in the immediate foreground and, when dry, paint masking fluid over the entire area of water. When this in turn is dry, scuff it in the direction of the river's flow.

2 Paint a strong blue wash over the masking, pushing the paint well into the hollows between the rubbery strands. Brush in the distant trees.

3 Scuff the masking again so that more of the paper is exposed, and wash over with a more dilute version of the blue used previously. Paint in the shaded sides of the trees and rocks.

4 When dry, remove the masking fluid completely and make sweeping brushstrokes in a pale color to emphasize the flow of the river. Strengthen the tones on the rocks and trees so they contrast with the whites.

LIFTING OUT

This is an easy and enjoyable method that is ideal for painting clouds and creating soft, diffused highlights. To achieve the effect of light clouds, lay a blue wash and wipe over it while still wet. In this example, a paper towel has been used, but you can also lift out paint using a sponge or blotting paper.

1 Lay a loose, uneven wash over the sky, and lift out cloud shapes by pressing with a paper towel. Different amounts of color can be removed by varying the pressure.

2 Paint a pale wash over the sea, then drag a piece of towel across it from one side to the other to create varying bands of color.

3 Having painted the distant headland, lay deep gray-greens over the foreground area, and lift out some of the color to suggest foam and pools of water.

4 Finally, add touches of definition to the foreground, working wet-on-dry. Note that the clouds are remarkably realistic and took very little time to achieve.

LIFTING OUT SMALL HIGHLIGHTS

When you want a soft highlight—for example, on a tree trunk or clump of foliage—it is often better to lift the highlight out rather than to paint around it; this will create hard edges when the wash dries. A slightly damp brush is the most suitable implement to use in this case because it allows more precise control than a paper towel or a sponge.

1 Lay a yellow-ochre wash over the entire area and, while it is still very wet, lift out the highlights with a brush in the areas where the light strikes.

2 Allow the wash to dry before laying a first tone on the branches. Note that the lifted-out areas are a very pale yellow rather than pure white. This is because not all of the paint has been removed.

3 Continue to build up the forms of the trunk and branches, then paint over the highlighted area above the main branch.

4 Now that rich, dark colors have been added, the highlights appear dramatic by contrast.

Advanced Techniques

Although the term "advanced" is used for the methods shown on the following pages, none of them are actually difficult. They differ from the basic techniques only in that they are optional, but do try out as many as you can, because some of these special methods provide the ideal means of dealing with tricky areas of a landscape.

NEGATIVE PAINTING

Painting around a series of shapes in order to define them is known as negative painting, and to do this successfully, you need a careful drawing to ensure that you can build up in methodical layers. It is helpful to think of this method as painting backward; it is a tricky technique, but essential for painting light against dark.

1 Begin by masking off the small "sky holes," where light shines through the clumps of foliage; then lay a flat yellow-green wash. When the first wash has dried, identify the main light areas and take a second tone carefully around them, varying the strength so that it is slightly darker at the top.

2 Now bring in stronger, cooler greens, with more blue added, and paint around the leaves in the second foliage layer. When dry, remove the masking to reveal the carefully shaped sky holes.

3 A third layer of leaves is created in the same way, with small, very dark brush marks used for some of the more distant negative shapes.

SCRATCHING OUT

Small, linear highlights can be made by scratching into dry paint with a sharp knife or blade. This method, also known as "sgraffito," is often used for foreground grasses, as in the dry-brush demonstration shown on page 20. You will need to use heavy paper, and remember that more paint cannot be added after having finished scratching, as this will scuff the paper.

1 For this painting, use strong, dark colors to help the scratched highlights show up. Paint the foreground with opaque white (see page 26), making swirling marks to suggest the uneven snow.

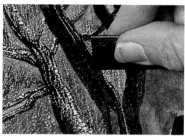

2 After scratching out the tree pattern on the hill with upward and downward strokes, use the corner of a blade to scratch out the contours of the trunk.

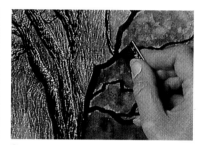

3 Continue to scratch highlights, but leave the undersides of the branches black to create a three-dimensional feel.

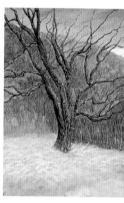

4 Use longer strokes of the blade above the snow-covered grass to suggest the frosty stems of the bushes. More opaque white added in the foreground will help build up the snow effect.

SPATTERING

Flicking or spattering paint onto a surface is a method often used to suggest texture or simply to add interest to an area of a picture. The seascape shown on page 19 has a little spattered paint in the foreground, suggesting rough sand or pebbles. For a coarse spatter, simply load a watercolor brush and flick the paint on, but for a finer effect a toothbrush or bristle brush gives a more satisfactory result.

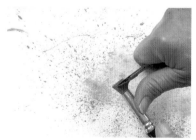

1 Spattering can't be controlled easily, so begin by masking out the sky area with a piece of torn paper. Spatter greens and yellows onto the paper by running a knife over the bristles of a stenciling brush.

2 Once the first application of paint has dried, lay on more paper masks and spatter red paint from a toothbrush, again running a knife over the bristles.

3 Lift the masks to reveal spattered red areas suggestive of a poppy field. Use a brush to paint some flowers in the foreground, reinforcing this effect.

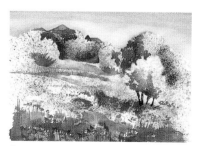

4 Note the pleasant contrast between the conventional brushwork used for the foreground and sky and the lively, highly textured effect of the field and trees.

SPONGE PAINTING

Entire paintings can be created using a sponge rather than a brush. However, the results can look rather woolly and undefined, so sponging is usually restricted to certain areas of a painting.

1 Paint the trunks and branches with a brush, laying a loose band of color to indicate the ground. Begin to sponge the foliage, starting with light yellows and greens and building up to dark hues in the shadowed areas.

2 Lay a yellow wash over the background, allowing the wet paint to pick up some of the sponged color. This will soften the effect so that the sponging looks less obvious and does not dominate the picture.

3 Continue to build up the dark tones with the sponge, switching to a brush if the sponge proves too unwieldy for small areas.

4 If more pronounced highlights are required, sponge on a little white gouache, or gouache tinted with watercolor. More subtle highlights can be created by lifting out (see page 22) with a damp sponge.

OPAQUE PAINT SPATTER

White foam on waves is notoriously hard to paint using watercolor, but there are two methods that are helpful. One is the scuffed masking-fluid technique outlined on page 21; the other is to spatter thick white gouache (opaque watercolor) or white acrylic over watercolor. Here opaque spatter is combined with the scratching method shown on page 23.

1 Lay on a variegated wash of gray-green and yellow; then, while it is still slightly damp, brush in the underside of the wave using strong, curving strokes.

2 To create a sense of movement, scratch vigorously into the wet paint with a blade before laying on more color. Scratching into wet rather than dry paint creates dark lines where the paint runs into the scuffed indentations.

3 Load a brush with thick white gouache, then run a finger over the end to release the paint. Spatter from one point to give a pivotal direction to the plume.

4 After more scratching at the top of the wave, strengthen the shadowed underside with undiluted Payne's gray.

MIXING WITH SOAP

Mixing watercolor with soap thickens it so that it holds the marks of the brush, behaving more like one of the opaque painting media, and the paint dries with a slight mottled effect. Gum arabic, the medium used in the manufacture of watercolor, can also be used to add body to the paint, but this is less readily available than soap—and is more expensive.

1 Begin the painting in the normal way, with blue paint mixed with water alone. Paint the shadows first to establish the main forms.

2 Load the brush with a strong mixture of yellow ochre, then rub this into a bar of soap. Apply firm upward strokes, following the direction of the rock face.

3 The next step is painting the dark shadows in the crevices. Retain the suds already on the brush; do not add more.

4 With the cliffs complete, rinse the brush thoroughly, then paint the grass at the top a warm olive green. Finally, darken the sea with dark rather than dry paint, leaving specks and lines of white.

SCUMBLING

This is a technique most often associated with opaque paints, but it can also be achieved using watercolor; it works best on a rough paper. The basic method is to mix up rather dry paint, load the brush, then push the paint onto the paper using a twisting, dabbing motion, repeating the process until you have an interesting and varied texture.

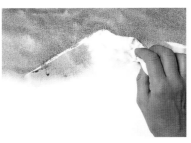

1 Clean, clear highlights are needed to contrast with the scumbled texture in the foreground and the loose wash for the sky, so mask out the sharp edge of the mountain before laying on the sky wash.

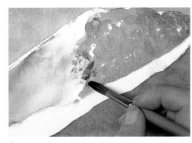

2 The mountain shadows are painted using the same colors as the sky. When dry, scumble light brown onto the rocks and the peppered snow beneath.

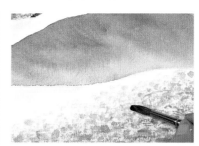

3 Now work the trampled snow in the foreground by scumbling a blue-gray mixture. Repeat the process several times, patting and twisting the brush head.

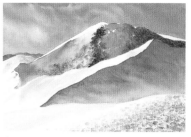

4 Remove the masking fluid and strengthen the shadows with blue-gray. Take care not to make the edges too straight; otherwise, you will destroy the effect of the undulating ground.

SALT SPATTER

Scattering crystals of salt into wet paint is an exciting way to create texture. The crystals soak up the wet paint and, when removed, leave a pattern of small snowflakelike marks. The effects are never quite predictable, because much depends on the wetness of the paint.

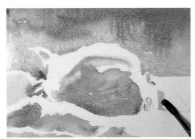

1 The sky and the main shadows on the rocks are blocked in first.

2 Yellow ochre is added and allowed to blend wet-in-wet. Working quickly, before the washes have begun to dry, scatter the salt crystals over the surface of the rocks. It is actually possible to watch the color separating away from the salt as the pigment is absorbed.

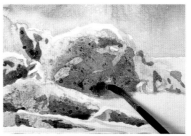

3 When dry, dust off the salt and paint a wet wash of darker color onto the shaded areas. Drop in more salt.

4 Again leave the work to dry before removing the salt and touching in the final details. The salt produces an attractive suggestion of texture without being overspecific.

WAX RESIST

This is another good technique for creating texture and is often used for buildings, old stones, and weathered trees. Oil and water don't mix, and wax is basically oil, so if you scribble with a household candle and then paint over it, the color will slide off the wax, producing a mottled surface. For more intricate color effects, wax crayons or oil pastels can be used for the resist.

1 Beginning with a pale yellow wash, allow to dry; then rub wax into the light-struck areas before building up the trees and foreground with darker colors. Use a flat brush to make bold vertical brushstrokes.

2 With the first washes still wet, use the candle to reinforce the central area; then extend the resist over the light colors and tree trunks.

3 Paint over the waxed areas with deep green, and strengthen the tree trunks with gray and blue. Notice how the paint slides off the wax where it has been applied thickly.

4 Finally, introduce a warm brown over the forest floor and up into the tree trunks on the left. The finished painting produces an unusual effect, appearing more like a pastel or oil painting than a watercolor.

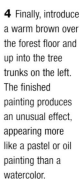
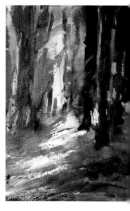

OPAQUE WATERCOLOR

White gouache paint (the opaque version of watercolor) is sometimes used on its own for small highlights, but it can also be mixed with watercolor to make a semi-opaque paint that retains much of the translucency of pure watercolor but does not have the chalky quality typical of gouache itself. It is ideal for subtle weather effects in landscape painting.

1 Begin by scumbling the sky with a watercolor and gouache mixture. The building and trees are then painted in pure watercolor, and random variegated washes, again of pure watercolor, are laid over the dark area below.

2 For the foreground, mix white gouache with yellow and green watercolor and apply with a flat brush, using broad horizontal strokes. The opaque paint helps this area to come forward in space.

3 Having built up the trees with ultramarine and a little alizarin crimson, touch in highlights using a mix of gouache and watercolor. Notice the granular effects of the watercolor wash (see Granulation, page 19).

4 The contrast of thin and thick paint creates an attractive surface texture. The trick to using this method successfully is to reserve the use of opaque paint for the light colors, using watercolor alone for the dark tones.

WATERCOLOR AND ACRYLIC

Mixing watercolor with white acrylic produces an effect similar to that of white gouache, only with a slightly less chalky surface. Some artists prefer acrylic because it is less likely to compromise the translucency of the watercolor. However, bear in mind that acrylic paint cannot be removed when dry, although you can alter incorrectly placed highlights by painting over them with watercolor.

1 Lay a blue wash of pure watercolor for the sky, then draw in branches with a very fine brush to establish the structure of the tree.

2 Still using pure watercolor, paint the middle tone of the leaves, making small individual brush marks. Acrylic will be used for the highlights, so you can work from dark to light to a greater extent than for a normal watercolor.

3 For the highlights, where the light strikes the leaves, mix white acrylic with red and yellow watercolor. Use watercolor alone for the darks.

4 Finally, introduce more lights and darks, again using acrylic for the highlights. Use a small brush throughout the painting to create a stippled effect.

WASH-OFF

This is an unusual and exciting technique, which, although not difficult, can be rather slow. It involves painting a design with thick gouache paint, covering the whole surface with India ink, and then holding the paper (which should be stretched) under running water. This washes off the soluble paint and any ink that covers it, leaving only the ink in the unpainted areas to form a negative image.

1 First stain the paper with watercolor so that you can see what you are doing. Now apply thick gouache with a flat brush.

2 Continue to build up gouache colors, then cover the whole painting with black ink. Here the artist has scrubbed it on, so in places it will mingle with the paint.

3 Pour hot water onto the surface, washing off some of the gouache and ink that covers it. Use a sponge to coax off any stubborn bits.

4 In a complete wash-off, all of the sky area would have been removed, but here large areas of the original gouache remain, with the small patches of black adding interest.

PEN AND WASH

This technique has a long history and was frequently used for both illustrations and landscape paintings during the eighteenth and nineteenth centuries. Many different types of drawing pen are now available, and there is also a wide range of inks, some waterproof and others water-soluble, for use with dip pens. You can either make the pen drawing first, as here, or begin with loose washes and then draw on top when dry.

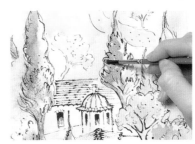

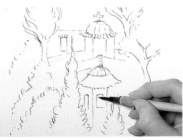

1 Make the drawing using a dip pen with waterproof ink, keeping the lines fairly loose and free. A light pencil drawing can be made first as a guide—a wise move if you are new to this method.

2 Lay a series of light washes over the separate areas of the composition, working slightly wet-in-wet and allowing the washes to blend.

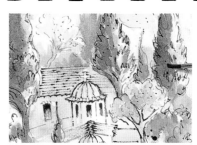

3 Build up the colors with additional washes. Let the colors overlap the lines in places to avoid the effect of a "filled-in" drawing.

4 Once the colors are all in place, add more pen drawing to the foreground. The effect is delightfully lively and spontaneous.

PENCIL AND WATERCOLOR

Pencil and watercolor produce a softer effect than pen and wash and are ideal for more atmospheric landscapes that don't require sharp detail. You can use ordinary graphite pencils of a relatively soft grade—4B or even 6B—or conté or carbon pencils. For more elaborate effects, colored pencils can be combined with watercolor, which offers a way to save an unsuccessful painting.

1 Begin by making a light drawing using carbon pencil. This is intended only as a guide; more pencil can be added as the painting progresses. Next, lay a deliberately rough, uneven wash for the central sky area.

2 The color scheme here is a simple one, based on the contrast of cool blue-gray and warm browns and yellows. Having laid additional washes, the lines should be strengthened with pencil, which is also used to establish small areas of dark tone.

3 The colors are now built up all over the painting in long sweeping strokes that echo the line drawing. It is important to maintain a consistent approach in mixed-media work.

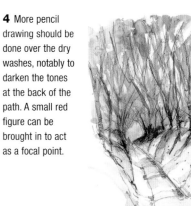

4 More pencil drawing should be done over the dry washes, notably to darken the tones at the back of the path. A small red figure can be brought in to act as a focal point.

WATERCOLOR AND PASTEL

These two media have very different surface characteristics: Pastel is opaque and dense, while watercolor is thin and translucent. However, they can be combined successfully to create images of considerable depth and subtlety. The watercolor is usually laid first, then overpainted with the pastel.

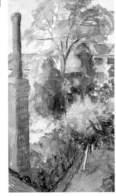

1 A freely worked but quite detailed watercolor establishes the composition and acts as a base for the pastel work.

2 Loose, grainy pastel strokes are laid over the dried watercolor to build up the foliage textures. Take care to follow the general directions of the original brushstrokes.

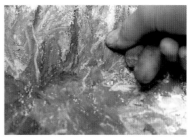

3 In the foreground, where the pastel has been thickly worked, introduce some oil pastel to vary the textures. Overpaint the soft pastel with the oil pastel and partially blend, using a finger.

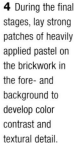

4 During the final stages, lay strong patches of heavily applied pastel on the brickwork in the fore- and background to develop color contrast and textural detail.

Projects

The photographs and their associated paintings are loosely grouped into the categories listed here so that you can quickly find a subject that interests you: Skies; Sea and Shorelines; Rocks and Cliffs; Rivers and Lakes; Mountains, Hills, and Valleys; Buildings in Landscapes; Woodlands.

For example, if you enjoy painting textures, you might complete several in the Rocks and Cliffs group, and if you like to paint water, you have a wide choice from both Sea and Shorelines and Rivers and Lakes.

Sunset over Sand

This photograph has beautifully captured the sunset, its reflection in the wet sand, and the silhouette of the peninsula, but the artist has used a more muted palette in order to create a softer effect.

PAINTS
Yellow ochre
Gamboge (hue)
Cobalt blue
Indigo
Cerulean blue (hue)
Payne's gray
Naples yellow

MATERIALS
Cold-pressed paper,
 140 lbs (300 gsm),
 large sheet
HB pencil
Large mop brush
Small containers
Sable brushes, #12,
 #8, and #4

TECHNIQUES USED
Dropping in colors,
 page 17
Wet-in-wet, page 18
Wet-on-dry, page 18
Masking fluid,
 page 21

1 Stretch the paper over a strong board. Use a #12 large brush to wash the top of the painting with a mixture of cobalt blue, cerulean blue, and a little indigo. While still wet, flood the middle area with a wash of Naples yellow and a little gamboge, and add a wash of the blue at the bottom of the work. While still very wet tilt the board, lifting the right hand side to allow the paint to run away freely—laying the board flat again when you are pleased with the effect.

2 When dry, draw outlines very lightly in HB pencil.

3 Allow the work to completely dry. Use a #8 brush to paint the distant sea with a mixture of cerulean blue and a little cobalt blue. Allow to dry before washing a strong mixture of indigo and cobalt blue with a little Payne's gray over the middle of work and across the base. Allow to dry a little before using #4 and #8 brushes (inset) to add touches of Naples yellow to the middle ground, suggesting the sunlight reflected in the water. Repeat at the base of the work but very freely and with a #12 brush. When dry, use a small brush to paint a little masking fluid over the Naples yellow in the middle ground to suggest sunlight on the sand.

6 Allow to completely dry and then add lines of blue into the sea area using a #4 brush, and generally tidy up the picture.

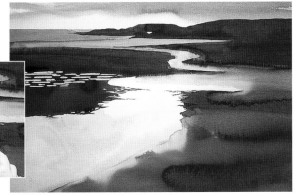

4 Use a #8 sable brush to work a strong mixture of Payne's gray, indigo, and cobalt blue, over the distant headlands and the dark shadow and sand areas. Leave some small areas free of paint to suggest the light on the sand. Allow to dry and paint another layer over the same areas. Allow to dry. Using a #4 sable brush and Naples yellow, touch in light highlights on the sea and the wet sand—these can be interpreted fairly freely. A mixture of cobalt blue, indigo, and a little Payne's gray can cover the large areas of water and sand, using a #12 brush (inset).

5 When dry, rub off the masking fluid. Strengthen the dark blue areas with a strong mixture of cobalt blue, indigo, and a little Payne's gray, using a #12 brush. Allow to dry a little, then add patches of Naples yellow to the foreground. Lift and tilt the board to allow the paint to flow freely until it feels right—not for the faint-hearted!

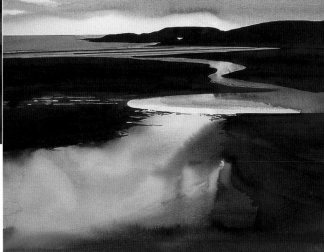

Sunburst

Here, the main difference between the photograph and the painting lies in the color scheme, which is much warmer in the painting. The artist has also emphasized the sunburst by using yellow and blue-violet, a pair of complementary colors.

PAINTS

Winsor blue
Venetian red
Dioxazine violet
Naples yellow

MATERIALS

Watercolor board
Masking fluid
Tissue
2-in. (5-cm) flat brush
Round brushes,
 #10 and #3

TECHNIQUES USED

Graded and
 variegated washes,
 page 16
Overlaid washes,
 page 16
Masking fluid,
 page 21
Lifting out, page 22

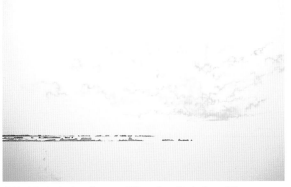

1 Mark in the horizon line, one-fifth up from the bottom of the picture, then mask out the rims of the sunlit clouds. While the masking fluid dries, use the small round brush to block in the rocks with a mix of Winsor blue and Venetian red.

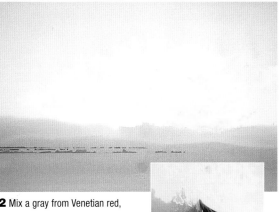

2 Mix a gray from Venetian red, Winsor blue, and a touch of dioxazine violet, and use the large flat brush to wash over the whole paper. Lift out color with a wet tissue around the sunburst and graduate to a darker wash above. Use the tip of the large round brush to carry the wash up to the edge of the clouds below the sunburst (inset).

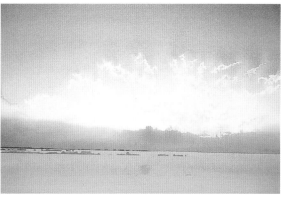

3 Paint a darker graded wash of the same mix over the sky using the large flat brush, and allow to dry.

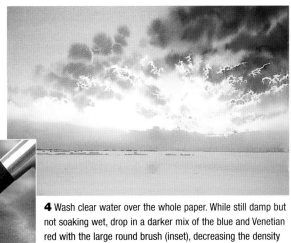

4 Wash clear water over the whole paper. While still damp but not soaking wet, drop in a darker mix of the blue and Venetian red with the large round brush (inset), decreasing the density of the paint as you work down toward the sunburst. When dry, remove the masking fluid.

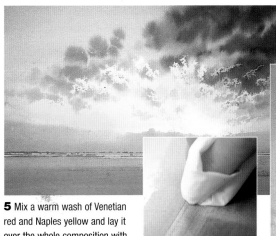

5 Mix a warm wash of Venetian red and Naples yellow and lay it over the whole composition with the large flat brush, adding clear water as you go up and around the sunburst. Carry the warm wash down over the sea, then wipe off some paint on the sea with a damp tissue to reflect the sunburst (inset). When dry, add a few horizontal strokes with the blue mix.

6 With the dark cloud mix and the small round brush, paint in the rocks, increasing the intensity as you come toward the foreground. Add a few more strokes across the sea with the large flat brush.

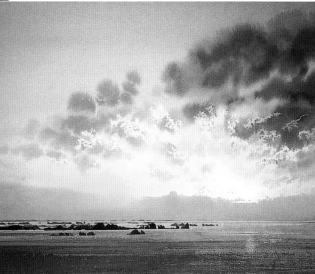

Winter Sunset

The artist's main change was to reduce the tonal contrasts to give a quieter, less dramatic scene that is more in keeping with the medium of watercolor.

PAINTS

Raw sienna
Cobalt violet
Cobalt blue
Permanent rose
Ultramarine
Permanent magenta
Burnt sienna

MATERIALS

Cold-pressed paper,
 140 lbs (300 gsm)
 pre-stretched
2B pencil
Round brushes,
 #3, #5, and #8
#1 rigger brush
Pastel pencils
 (optional)
Eraser

TECHNIQUES USED

Wet-in-wet, page 18
Wet-on-dry, page 18

1 Draw the composition in pencil, then prepare pools of color for the initial washes (inset). The mixes are: raw sienna; cobalt violet; cobalt blue; raw sienna and cobalt violet; raw sienna and permanent rose (two versions, one stronger); cobalt blue and cobalt violet; ultramarine, permanent magenta, and a touch of raw sienna; and cobalt blue, permanent magenta, and a touch of raw sienna (for the clouds).

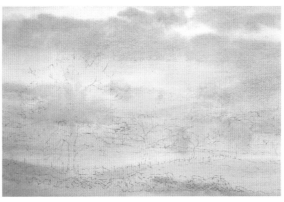

2 Wet the paper all over; then once the sheen has disappeared, apply all the colors quickly, beginning with the lightest.

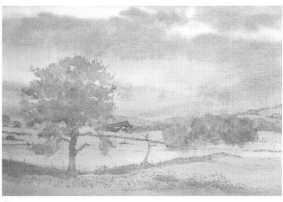

3 As the paper starts to dry, strengthen all the colors slightly. Continue the process once fully dry, using the same colors and constantly changing the mixtures on the brush. Work wet-in-wet to retain the soft, misty look of the scene, and cover the entire area of the painting to ensure a gradual buildup.

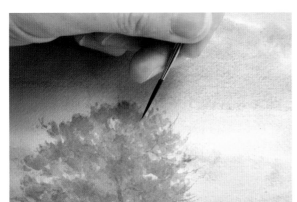

4 Now begin to define the detail. A rigger brush is ideal for painting twigs and small branches. To create convincing tapered brushstrokes, position as shown here, then draw upward and away, finishing with a flick of the wrist.

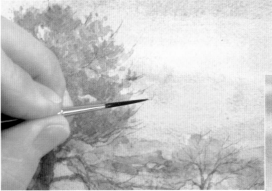

5 Make up two more mixes for the trees, fence posts, and other dark-toned details using ultramarine and burnt sienna in different proportions; apply using the rigger brush. Varying the amount of each color gives both warm and cool mixtures (burnt sienna is a warm color) and gives a more natural feel.

6 You may want to add some final highlights and shadow with pastel pencils. These combine well with watercolor, and can be rubbed off if the effect is not satisfactory. Finally, erase all traces of the pencil lines, as these will show through the predominantly pale colors.

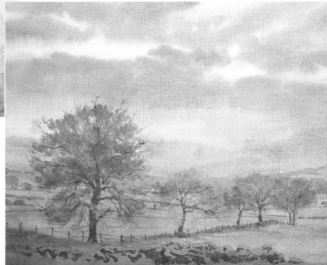

Tuscan Mist

The artist has retained the overall feel of the photograph, but he has made a stronger focal point of the villa by omitting some of the trees in the foreground and middle ground, which may have distracted the viewer.

PAINTS

Winsor blue
Cerulean blue
Dioxazine violet
Venetian red
Burnt umber
White gouache

MATERIALS

Watercolor board
Pencil
2-in. (5-cm) flat brush
Round brushes,
 #10 and #3
Tissue

TECHNIQUES USED

Overlaid washes,
 page 16
Wet-on-dry, page 18
Lifting out, page 22
Opaque watercolor,
 page 26

1 Sketch the composition in pencil, taking care with the placing of the villa and horizon line.

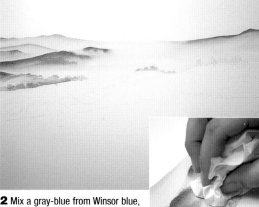

2 Mix a gray-blue from Winsor blue, cerulean blue, dioxazine violet, and a touch of Venetian red, and use the large round brush to paint along the horizon line, quickly adding clear water at the bottom, where the band of mist is to be. When dry, paint the next layer of hills, gradually adding a little burnt umber to the mix for the nearer hills. Finally, lift out excess color from the misty valleys with a tissue (inset).

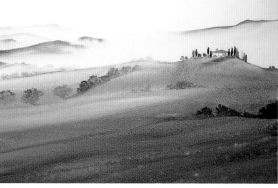

3 Paint in the bushes and trees in the foreground and middle ground, together with the details of the villa. When dry, take the mix of blues and burnt umber over the lower half of the picture, adding more burnt umber in the foreground.

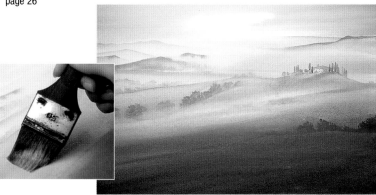

4 Mix up a wash of Winsor and cerulean blue with dioxazine violet, adding white gouache to produce a pale, opaque blue. Using the large flat brush, take this over the whole picture (inset). Blend in clear water where the villa emerges from the mist, and thin the color down in the foreground. While still wet, add thicker drifts of mist. Once the paper has begun to dry, strengthen the details with the small round brush.

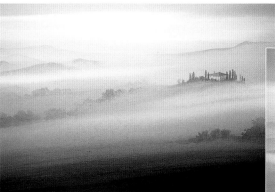

5 Touch up the details, strengthening the tops of the villa and trees. When dry, wash over the whole picture with water, using the large flat brush. Lift out more mist where needed and blend more burnt umber into the foreground. Use a thinner burnt umber to add a warm glow to the sunlit side of the villa.

6 Finally, touch up a few trees and add some streaks and texture to the earth in the foreground.

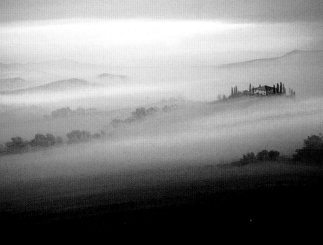

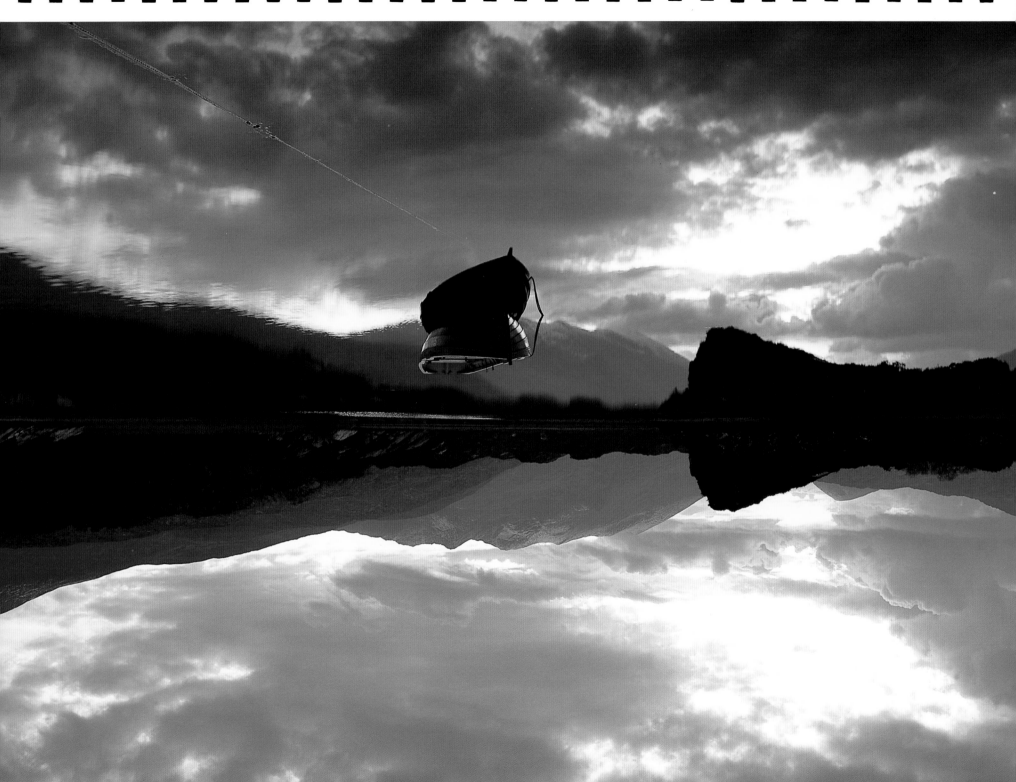

Tranquil Waters

The artist has avoided the very dark tones that appear in the photograph, because these don't suit the medium of watercolor. He also played down the color contrast, using a palette of harmonizing colors to give the scene an atmosphere of tranquillity.

PAINTS
Raw sienna
Cobalt violet
Cobalt blue
Permanent magenta
Ultramarine
Permanent rose

MATERIALS
Cold-pressed paper,
 140 lbs (300 gsm)
2B pencil
Masking fluid
Synthetic brush
Dip pen or pointed
 stick
Kitchen towel
Round sable brushes,
 #3, #5, and #8

TECHNIQUES USED
Overlaid washes,
 page 16
Wet-in-wet, page 18
Masking fluid,
 page 21

1 Draw the composition in pencil, paying special attention to the shapes of the boat and its reflection. Apply masking fluid using the synthetic brush. Wash out the brush at intervals to prevent the fluid from drying out and clogging the hairs. For the small highlights on the boat, use a dip pen or a small pointed implement such as a cocktail stick. Take care with the placing, because these define the boat's form.

2 The first stages are painted wet-in-wet, which involves working fast, so prepare large pools of the following colors and mixes in advance: raw sienna; cobalt violet; cobalt blue; raw sienna and cobalt violet; cobalt blue and permanent magenta with a touch of raw sienna (make two versions of this, one stronger than the other); and ultramarine and permanent magenta with a touch of raw sienna. Moisten the paper all over and apply the colors using a large brush.

3 Leave the first washes to dry completely, then develop the distant hills with stronger versions of the same colors. The edges of the hills need to be relatively hard, so don't let the colors of the hills in the foreground flow into the distant ones. Paint the boat and reflection in similar blue-grays.

4 Now begin to darken the tones, using the same colors as before. Take care not to introduce very dark tones at this stage, because these could give an incorrect balance. When dry, remove the masking fluid by rubbing with a finger, and soften some of the edges with a clean, damp brush. Blot with a kitchen towel to absorb any moisture.

5 Wet the whole area of the water again and strengthen the tones. Concentrate on those in the immediate foreground so that they balance the dark hills and their reflections. Add some darker color to the front part of the boat, but don't overdo it; the boat should not appear too prominent. Add the mooring rope to the boat.

6 Soften some of the sharper edges of the darker areas—especially those set against the lights of the sky and reflections—by overpainting with cobalt violet mixed with a touch of raw sienna. Enhance the color at the bottom of the sky with a mix of raw sienna and permanent rose.

Rock Stacks

Here, a subtly different composition has been achieved by moving the figure and kayak closer to the main rock stack and by omitting the rock breaking the surface in the center of the photograph.

PAINTS
Raw sienna
Permanent rose
Ultramarine
Light red

MATERIALS
Rough watercolor
 paper, 140 lbs
 (300 gsm),
 pre-stretched
3B pencil
Masking fluid
Round sable brushes,
 #4, #7, and #12
#2 rigger brush
Toothbrush

TECHNIQUES USED
Wet-in-wet, page 18
Dry brush, page 20
Masking fluid,
 page 21
Lifting out, page 22
Spattering, page 23

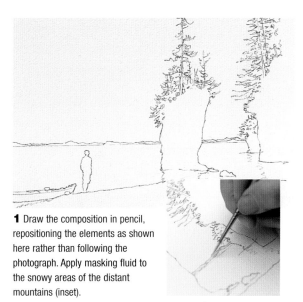

1 Draw the composition in pencil, repositioning the elements as shown here rather than following the photograph. Apply masking fluid to the snowy areas of the distant mountains (inset).

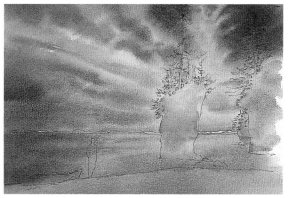

2 Lay a very pale wash of raw sienna over the whole scene. Working quickly, apply mixtures of permanent rose and ultramarine in various strengths, wet-in-wet, for the sky, sea, and shore. Try to follow the photograph as closely as possible for the cloud formations and variations in tone for the sky and sea areas.

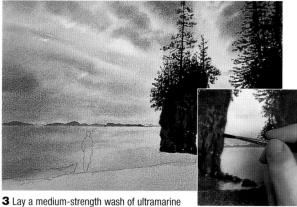

3 Lay a medium-strength wash of ultramarine and light red over the tree-clad rock stack, then introduce a darker mix of the same colors, wet-in-wet, for the rock face. Paint in the trunks and branches of the pine trees with the rigger brush, then dry-brush the foliage with the #4 sable (inset). Paint in the rest of the cliffs and trees using the same process, remove the masking, and paint the distant mountains with a pale mix of ultramarine and permanent rose. Use a dark mixture of ultramarine and light red for the cliff reflections, softening the edges with clean water.

4 Paint in the figure and the hull of the kayak with various shades of ultramarine and light red. Use the rigger to add detail to the top of the boat, then use the same brush, cleaned with water, to lift off the highlight at one end.

5 Use a toothbrush to spatter masking fluid over the foreground to suggest small highlights on the pebbles. When dry, wash clean water over the beach area and apply various mixtures of light red and ultramarine wet-in-wet.

6 Leave to dry, remove the masking, and apply a wash of permanent rose mixed with raw sienna over the foreground. This will give a warmer feel to the beach, helping to bring it forward and create depth. Use a toothbrush to apply a dark spatter of ultramarine and light red over the pebbles, then soften the edges of the cliffs, pebbly beach, and figure with a damp #4 brush, cleaning it regularly during the process.

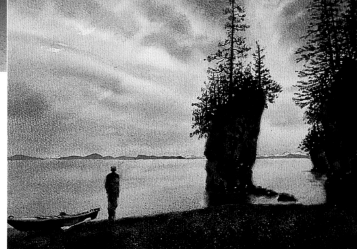

Gondola at Rest

The artist has been faithful to the photograph, but he has altered the overall color to produce a more golden glow. By lightening the tone of the background building, he has pushed it back in space, thus focusing attention on the foreground, with an emphasis on the gondola and the light sparkling on the waves.

PAINTS

Raw sienna
Cadmium orange
Cobalt violet
Permanent rose
Cobalt blue
Permanent magenta
Ultramarine
Burnt sienna
Cadmium red

MATERIALS

Cold-pressed paper,
 140 lbs (300 gsm),
 pre-stretched
2B pencil
Masking fluid
Synthetic brush
Dip pen
Round sable brushes,
 #3, #5, and #8
Blade

TECHNIQUES USED

Graded and
 variegated washes,
 page 16
Overlaid washes,
 page 16
Directional
 brushstrokes,
 page 20
Masking fluid,
 page 21

1 Draw the composition in pencil, including the background buildings, then lay a variegated wash. Start with a mix of raw sienna and cadmium orange at the top of the sky and gradually weaken the color, introducing cobalt violet toward the bottom. These washes establish the warm colors underlying the whole image.

2 Reserve the highlights on the dark band of water and the nearer edge of the gondola by applying masking fluid with the synthetic brush. Rinse out the brush at regular intervals to prevent the fluid from drying out and clogging the hairs. Use a dip pen or a small pointed implement such as a cocktail stick to create the finer lines.

3 When the masking is fully dry, lay another variegated wash on the sky. This time use cadmium orange and permanent rose at the top, grading down to cobalt blue and permanent rose, plus a touch of raw sienna. Use a stronger version of the second mix for the dark band of water and the mooring posts.

4 When dry, paint the distant landscape using a mid-toned mix of cobalt blue and cobalt violet, and the silhouetted buildings with cobalt blue and a touch of raw sienna. Lay a first wash over the gondola using the same colors as for the mooring posts and dark water in Step 3. When dry, remove the masking fluid from the water area but leave on the gondola (inset).

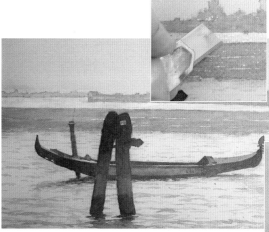

5 Gradually darken the mooring posts and gondola, using various mixes of cobalt blue, permanent magenta, raw sienna, and ultramarine. Use weaker washes biased toward blue to achieve the ripples in the water. For the darker parts of the gondola, use a mix of ultramarine and burnt sienna with a touch of cadmium red, varying the proportions slightly to give a rich, varied dark tone. When dry, use a blade to scratch out a few ripples to add sparkle to the water (inset).

6 Remove the masking from the gondola and strengthen the foreground area of water slightly. Add any final detail, such as the distant mooring posts. When painting ripples in water, try to follow the shapes with your brush and remember to make the colors weaker toward the back and gradually reduce the size of your brush mark.

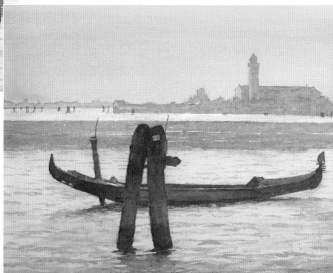

Castle at Dawn

This subject is very much one after the artist's own heart, as he specializes in sea and shore paintings, so he has made few changes to the composition. What gives the painting its strength and impact, however, is his treatment of the sky, which has simplified into broad diagonal sweeps of cloud, with an opposing diagonal formed by the smaller cloud at the top.

PAINTS

Naples yellow
Yellow ochre
Cobalt blue
Cerulean blue
Phthalocyanine blue
Indigo
Payne's gray

MATERIALS

Watercolor paper,
 140 lbs (300 gsm),
 pre-stretched
Round sable brushes
 #12, #8, and #4
Large mop brush
HB pencil
Small piece of
 toweling

TECHNIQUES USED

Wet-in-wet, page 18
Wet-on-dry, page 18
Lifting out, page 22

1 Flood the whole sheet with a generous wash of Naples yellow and a touch of yellow ochre using the mop brush. While still very wet, add a wash of a mix of cobalt blue and cerulean blue with the same brush, tilting the board slightly to help the paint to flow.

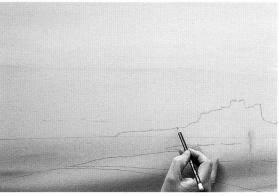

2 Allow to dry completely before using the pencil to sketch the outline of the castle.

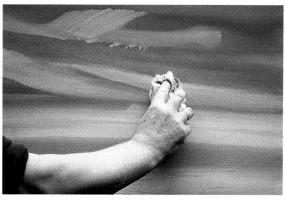

3 Flood the whole work with a wash of cobalt blue and cerulean blue with a touch of phthalocyanine blue. Allow to dry a little, then wipe areas allowing the undercolors to show through using a small piece of toweling—it takes a degree of courage to do this!

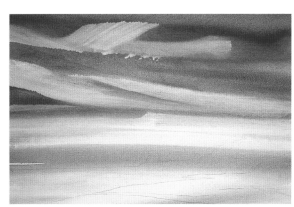

4 As the wet paint dries, the hard edges soften into a dramatic sky.

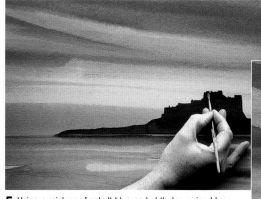

5 Using a mixture of cobalt blue and phthalocyanine blue with a little Payne's gray, paint in the castle using all three of the round brushes. Add a watered-down wash of the same colors in the foreground, allow to dry, and add washes of indigo and Payne's gray, as well as Naples yellow. Using the #4 brush, add highlights and detail using Naples yellow and Payne's gray. Very often just a subtle line will give strength to edges of shapes.

6 The artist has captured the atmosphere of the original photograph while making it very much his own.

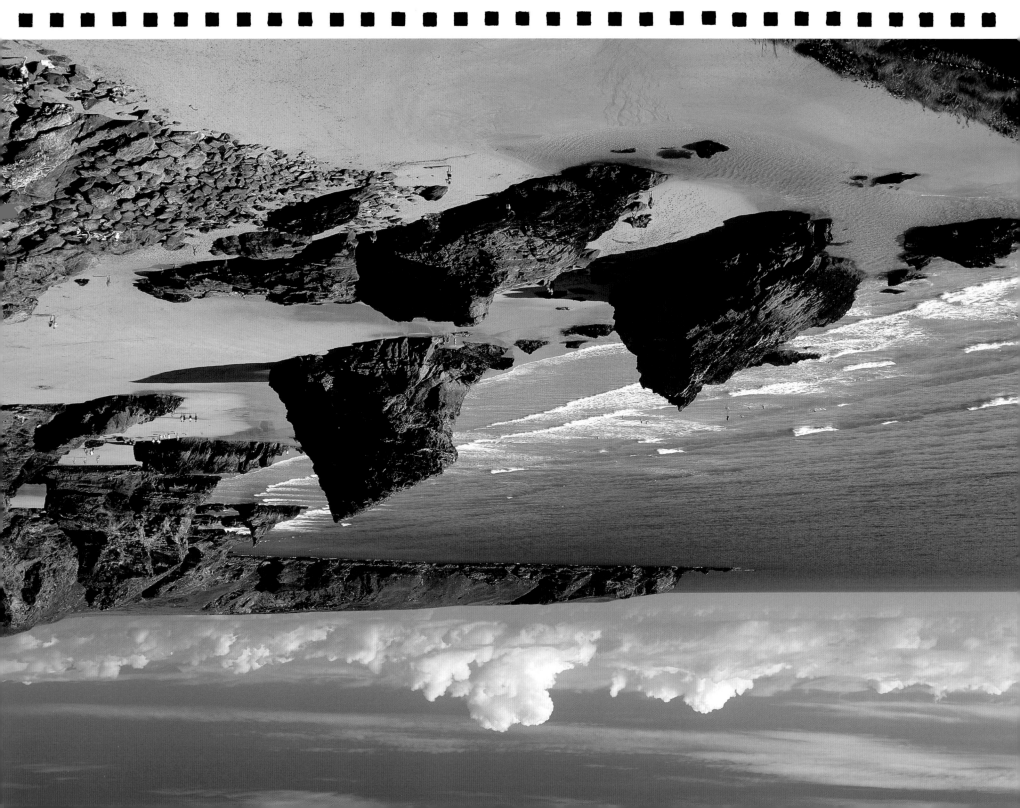

Cornish Beach

The artist added sailboats and birds and slightly enlarged the figures on the beach. He used his own knowledge and experience to create the central rock, which in the photograph was too dark to see in full.

1 Draw the composition in pencil, simplifying the shapes and omitting some of the smaller rocks to avoid a cluttered look. Mask out the birds and boats before laying on the first wash.

2 Mix up ultramarine and cerulean blue for the sky, and paint the wash directly onto dry paper. Work carefully around the white cloud patterns using a 3-in. flat squirrel-hair brush. Add cadmium red to the mix and stroke this tone into the lower areas of the sky. Paint the sea using the ultramarine-and-cerulean-blue mix, dragging the brush lightly over the paper to leave small white flecks.

3 Lay a wash of yellow ochre and cadmium orange on the beach, taking the color up over the central rock and cliffs at the top right-hand corner. Work quickly, using a large brush on dry paper—this will produce a fresh look and the paint will dry with a more even finish. Before the wash is dry, float a dilute wash of cadmium red into the foreground beach area. This adds color variation and echoes the warm tones of the sky.

4 Mix ultramarine, titanium white, Mars black, and cadmium red for the background mountains and for the shadow areas on the rocks. Lay in the color boldly, taking care to reserve the highlighted areas. Drop touches of dilute cadmium red and orange into sections of the mountains and rocks while still wet. Add yellow ochre to the mix, then stroke in the grassy hill on the left foreground area. Then, while moist but not wet, add contrast to the rocks using touches of Mars black.

5 Remove the masking and add touches of cadmium orange and red to the hulls of the boats. Define the birds by painting in the wing tips with Mars black, using a bamboo brush or small round brush. Add the figures on the beach with quick one-stroke brush marks.

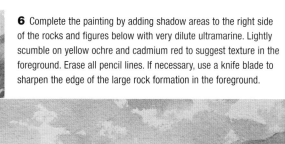

6 Complete the painting by adding shadow areas to the right side of the rocks and figures below with very dilute ultramarine. Lightly scumble on yellow ochre and cadmium red to suggest texture in the foreground. Erase all pencil lines. If necessary, use a knife blade to sharpen the edge of the large rock formation in the foreground.

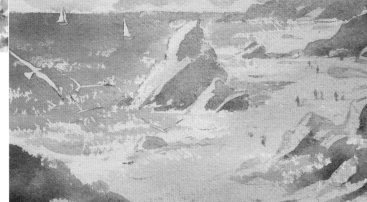

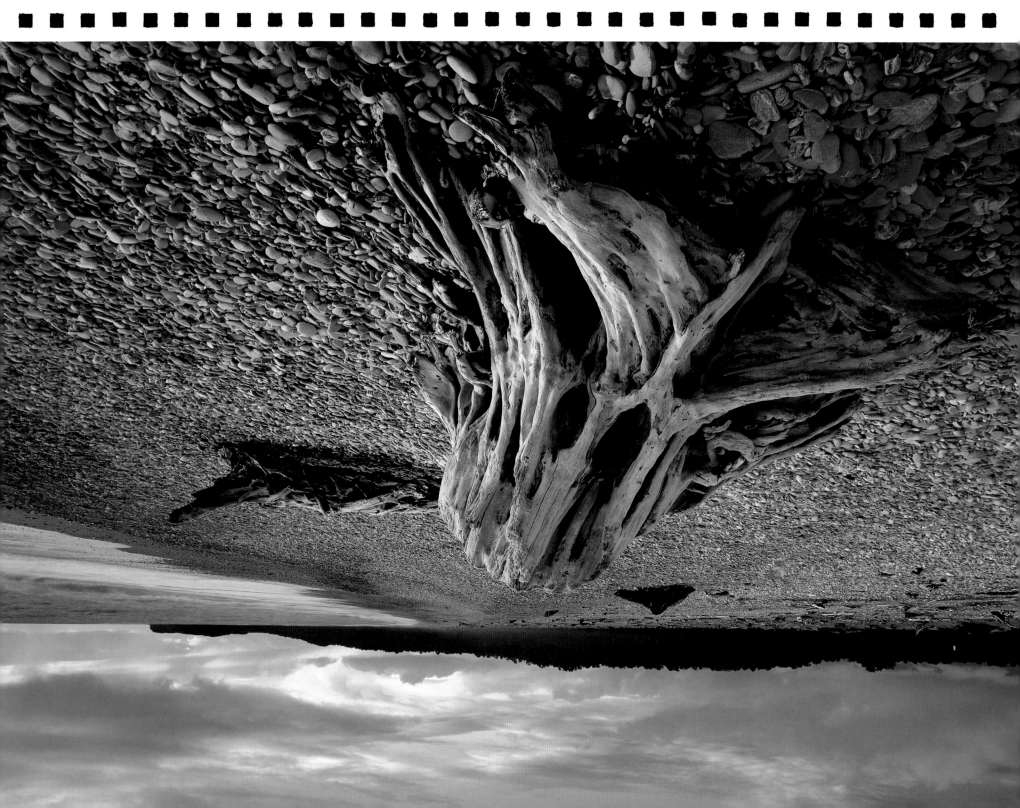

Driftwood and Pebbles

Apart from the omission of a dark triangular piece of driftwood behind the main stump, the composition of this painting closely follows the photograph. The main change lies in the color scheme used for the painting, which is lighter and brighter, creating a sunlit atmosphere rather than a brooding one.

PAINTS

Raw sienna
Cadmium red
Ultramarine
Burnt umber
Alizarin crimson
Cobalt blue
New gamboge

MATERIALS

Cold-pressed
 watercolor paper,
 140 lbs (300 gsm),
 pre-stretched
Mechanical pencil
 with HB lead
Masking fluid
2-in. (5-cm) flat brush
Round brushes, #8
 and #10
Toothbrush

TECHNIQUES USED

Wet-in-wet, page 18
Masking fluid,
 page 21
Spattering, page 21
Backruns, page 27

1 Make a fairly detailed pencil drawing, taking care with the tree stump, which is quite complicated in form and is the primary subject of the painting. To capture the underlying warmth of the scene, mix up a pale wash of raw sienna and cadmium red, then use to wash over the whole surface with the large flat brush (inset). While still wet, drop in more of the same mix on the right side of the stump, the center foreground stones, and sections of the sky.

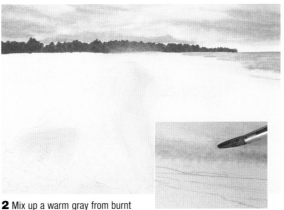

2 Mix up a warm gray from burnt umber, ultramarine, and alizarin crimson, wet the sky and sea area, and drop the color mix onto the wet surface, using sweeping strokes that mimic the windswept cloud shapes (inset). While still damp, wash in small areas of cobalt blue near the top center, and add pure ultramarine to the bottoms of the clouds. Paint the water with the same colors, then add more ultramarine and burnt umber, with a touch of new gamboge to dab in the tree line.

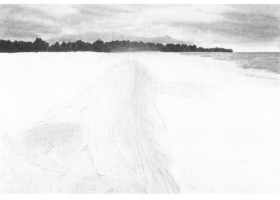

3 Protect the sunstruck areas of the tree stump with masking fluid, applying it as you would paint. Allow to dry before laying a thin wash of ultramarine on the left side of the main stump, some areas of the right side, and all over the secondary stump.

4 Paying careful attention to the structure of the stump as it appears in the photograph, begin to build up the mid-tones in the shadows and hollows with burnt umber cooled with ultramarine. When dry, add more darks using a stronger mix of the same colors.

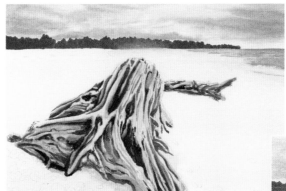

5 Complete the stump by going back into the shadows and whorls and adding deeper-toned marks where needed. Before painting the beach, which is to be spattered, protect the edges of the stump with masking fluid and cut a separate mask from a piece of heavy paper roughly the same shape and size as the stump. It need not be exact, because the masking fluid will protect the edges.

6 Use pale burnt umber to wash in the edge of the beach, then protect the sky and sea with paper and use a toothbrush to spatter masking fluid on the upper beach area. For the mid-distance, spatter on larger droplets with a brush and dot in the larger stones in the foreground. Lay an uneven wash of burnt umber over the beach area, deepening tones in places with a stronger version of this mix with ultramarine. Spatter some of this color over the distant and mid-distance beach, let dry, and remove all the masking, tinting the white shapes if they stand out too much.

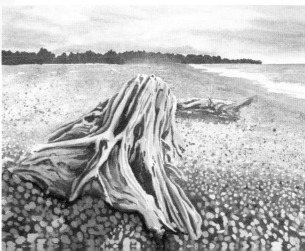

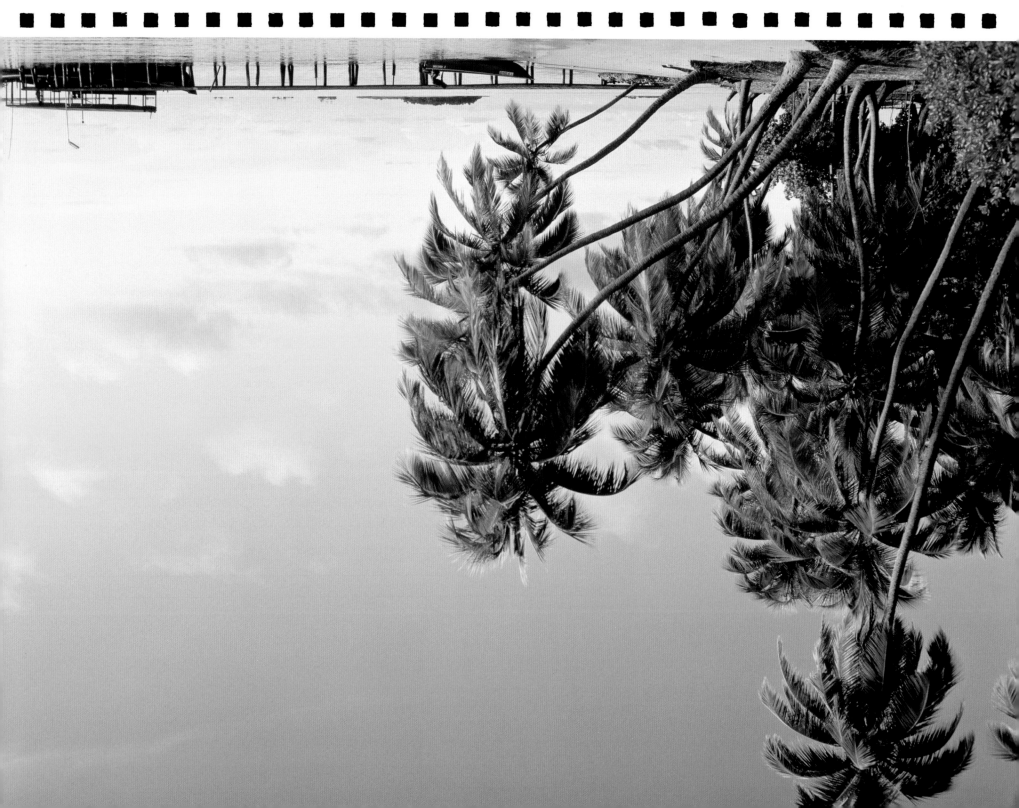

Palm Tree Beach

This photograph has captured the delicate pinks and yellows of a calm late summer afternoon, but the artist has created a different feel for the painting by using slightly heavier colors for the sky.

PAINTS

Raw sienna
Winsor yellow
Permanent rose
Ultramarine
Cobalt blue
Winsor yellow deep
Cadmium orange
Burnt sienna
Light red
Cerulean blue
Winsor blue
Cadmium red

MATERIALS

Rough watercolor
 paper, 140 lbs
 (300 gsm),
 pre-stretched
3B pencil
Masking fluid
Round sable brushes,
 #12, #8, and #3
Rigger brush
Sharp blade

TECHNIQUES USED

Wet-in-wet, page 18
Wet-on-dry, page 18
Masking fluid,
 page 21
Scratching off,
 page 23
Salt spatter, page 25

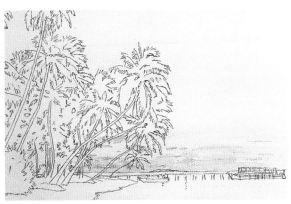

1 Draw the composition in pencil, rendering the palm trees in some detail and paying close attention to the placing of the low horizon line. Apply an allover pale wash of raw sienna to help create a sunny feel.

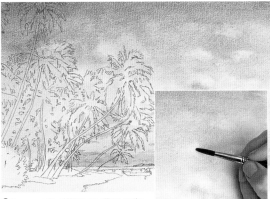

2 Lay a wash of Winsor yellow at the bottom of the sky and then use a mix of permanent rose and ultramarine to paint in the distant clouds. When dry, wash over the whole sky area with clean water, apply first a weak solution of permanent rose and then a mixture of ultramarine and cobalt blue. Make the color darker at the top and leave the cloud areas clear. Use a mix of ultramarine and permanent rose for the cloud shadows, then lift out some of the pale cloud tops with a dry brush (inset).

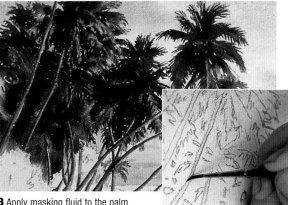

3 Apply masking fluid to the palm trunks and to any areas of light breaking through between the palms (inset). When dry, wash clean water over the trees and wash in Winsor yellow deep and cadmium orange for the yellowing leaves. For the green leaves, use mixtures of ultramarine and Winsor yellow deep in various strengths, painting the thinner fronds with the rigger brush. Leave to dry before removing the masking and painting in the trunks with cadmium orange.

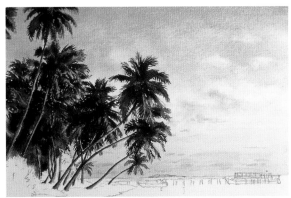

4 Allow to dry again, then use a mix of burnt sienna and ultramarine for the shadow sides of the trunks, blending the light and dark tones together with a just-damp rigger.

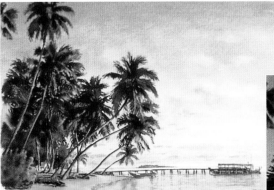

5 Paint the foreground bush with a mix of Winsor yellow and ultramarine. Lay a wash of raw sienna over the sand, and paint the palm roots and earth with mixes of light red, cadmium orange, and ultramarine. For the sea area, use a wash of cerulean blue, Winsor yellow, and Winsor blue, making the color darker toward the foreground. While still damp, use the mix for the trees to paint some of the reflections, and add a few small waves with a darker mixture of the sea color. Paint in the distant island using a mix of ultramarine and Winsor yellow deep. Mix ultramarine with a touch of burnt sienna for the boat.

6 Paint the small boat with a mix of cadmium red and ultramarine, and the figure with a burnt sienna and ultramarine mix. Use the same mix for the jetty. Paint the reflections and lift out a few white highlights on the ripples with a sharp blade. Add some cadmium-orange highlights in front.

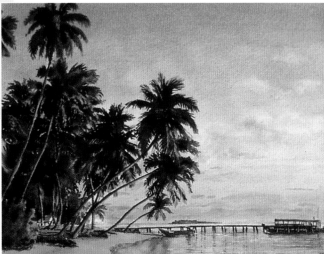

Tropical Beach

The composition of the photograph is well balanced, so the artist has followed it closely. She has, however, given a stronger sense of rhythm and movement to the painting through the use of opposing diagonals. The angle of the boat is balanced by the diagonal brush marks used for the sky, which in turn follow the opposite direction to the trunks of the palm trees.

PAINTS
Raw sienna
Cadmium orange
Ultramarine blue
Cobalt blue
Alizarin crimson
Burnt sienna
Cadmium lemon
Cobalt turquoise

MATERIALS
Cold-pressed
 watercolor paper,
 140 lbs (300 gsm),
 pre-stretched
HB pencil
Cotton buds
Masking fluid
Piece of wire
Round sable brushes,
 #7, #10, and #3

TECHNIQUES USED
Flat washes,
 page 16
Variegated washes,
 page 16
Wet-in-wet, page 18
Directional
 brushstrokes,
 page 20
Scratching off,
 page 23

1 Mix up a generous amount of dilute raw sienna and cadmium orange, and paint an allover flat wash to produce a warm ground color. When dry, carefully draw in the image with the HB pencil. Then make two fairly large puddles of paint—one of ultramarine and cobalt blue, the other of ultramarine blue and alizarin crimson. Wet the sky area, and paint a variegated wash using diagonal brushstrokes, starting with the purple mix at top left. Introduce the blue mix, adding more water gradually so that the sky becomes lighter at the horizon.

2 Let dry, then lift out the small clouds with a damp cosmetic bud, again following the diagonal direction. Use a new bud whenever it becomes soiled. Paint a warm gray over the rocks and foliage with a mix of ultramarine and burnt sienna. When dry, mask out some highlights on the volcanic rock, the trees growing out of the rocks and the rigging on the boat. Use the small brush for the fine detail.

3 Mix up pools of color using different combinations of ultramarine, alizarin crimson, and raw sienna. Mix cool greens from ultramarine and cadmium lemon. Wet the rocks and foliage along to the palm trees. Work the colors wet-in-wet, letting them blend into one another. Once dry, remove the masking fluid, wet the paper again with clean water, and add another wet-in-wet wash of warm purples to tone down the white of the paper where the highlights are.

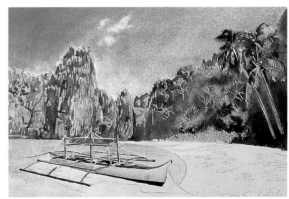

4 Wet the paper around the boat and paint the sea area with cobalt turquoise. When dry, paint the boat with loose brushstrokes, taking care not to be overly detailed. For the warm-colored shadow on the left-hand side of the boat, work wet-in-wet, using a mix of raw sienna, alizarin crimson, and cobalt blue.

5 For the shadows on the beach, make two separate purple mixes—one of alizarin crimson and cobalt blue, another of alizarin crimson and ultramarine. Wet the paper around the shadows with clean water, then drop in the colors wet-in-wet. When dry, soften the edges toward the front with a wet cosmetic bud.

6 To provide a balance of tones, more darks are needed in the foliage under the palm trees. Rewet the area with clean water and blend in darker purples made from ultramarine, alizarin crimson, and raw sienna. Work wet-in-wet from right to left. Finally, when dry, use a sharp blade to clean up any highlights, such as that on the prow of the boat.

Glacial Lake

The artist has made important alterations to color and to the general treatment. The clouds are harder-edged, echoing the crisp shapes of the mountains, and the latter have been simplified to create a more powerful impact.

PAINTS
Cerulean blue
Cobalt blue
Sap green
Payne's gray

MATERIALS
Cold-pressed paper,
 300 lbs (640 gsm)
HB pencil
Round brushes, #10
 and #7
1-in. (2.5-cm) flat
 brush
#4 rigger brush
Gum arabic

TECHNIQUES USED
Graded and
 variegated washes,
 page 16
Wet-on-dry, page 18
Descriptive
 brushwork, page 20
Spattering, page 23

1 Draw the composition in pencil, then apply a pale wash of cerulean and cobalt blue over the top of the sky and foreground using the #10 round brush. Leave the white areas unpainted for the clouds.

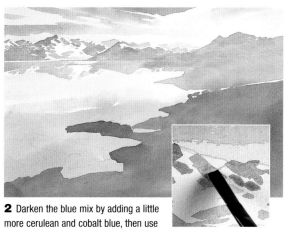

2 Darken the blue mix by adding a little more cerulean and cobalt blue, then use the flat brush to "cut out" the shapes of the shadows on the mountains (inset). Use the same mix for the darker mass on the right of the picture. Introduce a little sap green into this area, then darken the mix using Payne's gray. Use the #10 round brush to wash in the darker foreground.

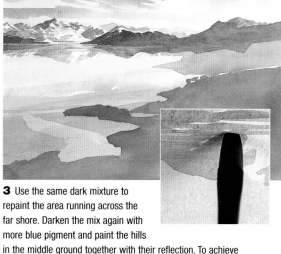

3 Use the same dark mixture to repaint the area running across the far shore. Darken the mix again with more blue pigment and paint the hills in the middle ground together with their reflection. To achieve the broken reflections, use the edge of the flat brush to pull out the paint horizontally (inset).

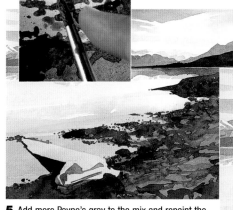

6 Using the rigger brush, darken the areas between the stones as well as the linear textures and splits on the piece of driftwood. Add a little gum arabic to help intensify the dark colors.

4 Darken the mix again by adding Payne's gray. Using the flat brush, paint in the band of hills that run across the middle ground. Switch to the #10 round and use the same mix lightened a little with water to consolidate the shoreline in the foreground. The shape of the driftwood is delineated by working around it with the dark mix.

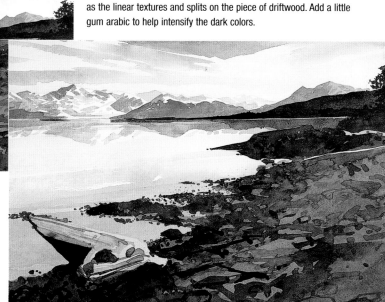

5 Add more Payne's gray to the mix and repaint the shoreline in the foreground, leaving areas of the lighter wash showing. Paint the silhouetted tree at far right with small brush marks and suggest the scattered rocks and stones by broken applications of color. For the waterweed, spatter paint by loading the #7 brush and tapping it with a finger (inset).

Rocky Shore

The main differences between the photograph and the painting are the suppression of detail and the emphasis on the movement of the clouds, but another significant factor is the judicious cropping and repositioning of the rocks in the foreground.

PAINTS

Mars black (acrylic)
Titanium white
 (acrylic)
Ultramarine
Yellow ochre
Cadmium red
Cadmium orange

MATERIALS

Cold-pressed
 watercolor paper,
 140 lbs (300 gsm)
HB pencil
Kitchen towel
3-in. (7.5-cm) flat,
 squirrel-hair brush
1-in. (2.5-cm) flat
 brush
Small bamboo and
 linen brushes

TECHNIQUES USED

Dropping in colors,
 page 17
Wet-in-wet, page 18
Lifting out, page 22
Watercolor and
 acrylic, page 26

1 Draw the entire image in pencil, paying special attention to the overall pattern of the clouds against the blue backdrop. The clouds form an important part of the composition and help to create a sense of movement, so try to give the impression of movement and direction.

2 Wet the sky area, then blot out the whites at the tops of the clouds. Using a mixture of Mars black, titanium white, and ultramarine, float in the gray undertones. While still wet, drop in a fairly strong mix of ultramarine and titanium white at the top of the sky. The water mirrors the sky in the image, so use the same mix for the sea, floating on a darker shade toward the top. To paint the sea, wet the area and apply a wash of ultramarine, titanium white, and Mars black. Let this dry, then rewet the paper and apply a darker wash of the same mix. Paint another wash over the top area of the sea in the distant background.

3 When the first washes are dry, rewet the whole of the beach and background cliff area, then float in the ochre tones using a mixture of yellow ochre, cadmium red, and titanium white (the last two are used sparingly). While still damp, add touches of dilute cadmium red and cadmium orange mixed with white to provide variations in color. Do so quickly, using a large brush.

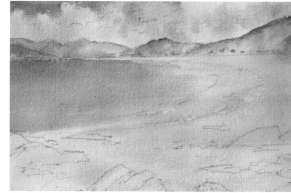

4 Paint in the background cliffs and hills using a mix of ultramarine, Mars black, and a touch of white. Add stronger color toward the tops to separate the land from the sky and to suggest form. Do not copy the photograph slavishly; instead, focus on the overall patterns and eliminate any unnecessary detail.

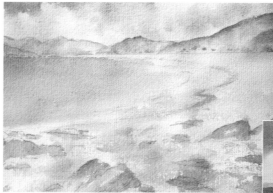

5 For the foreground rocks, mix washes of ultramarine, Mars black, and titanium white. Add touches of cadmium red and yellow ochre as the wash dries.

6 Build up the colors of the rocks and darken the tones using mixes of ultramarine, Mars black, and titanium white. As the wash dries, add stronger cadmium red and yellow ochre. Draw in a few line details with a bamboo brush or small watercolor brush, avoiding too much detail; an overly detailed foreground tends to act as a block to what is beyond. To darken the sea, rewet the paper and apply the ultramarine, Mars black, and titanium white mix, this time adding more black.

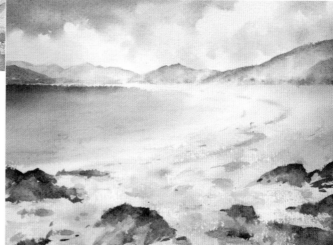

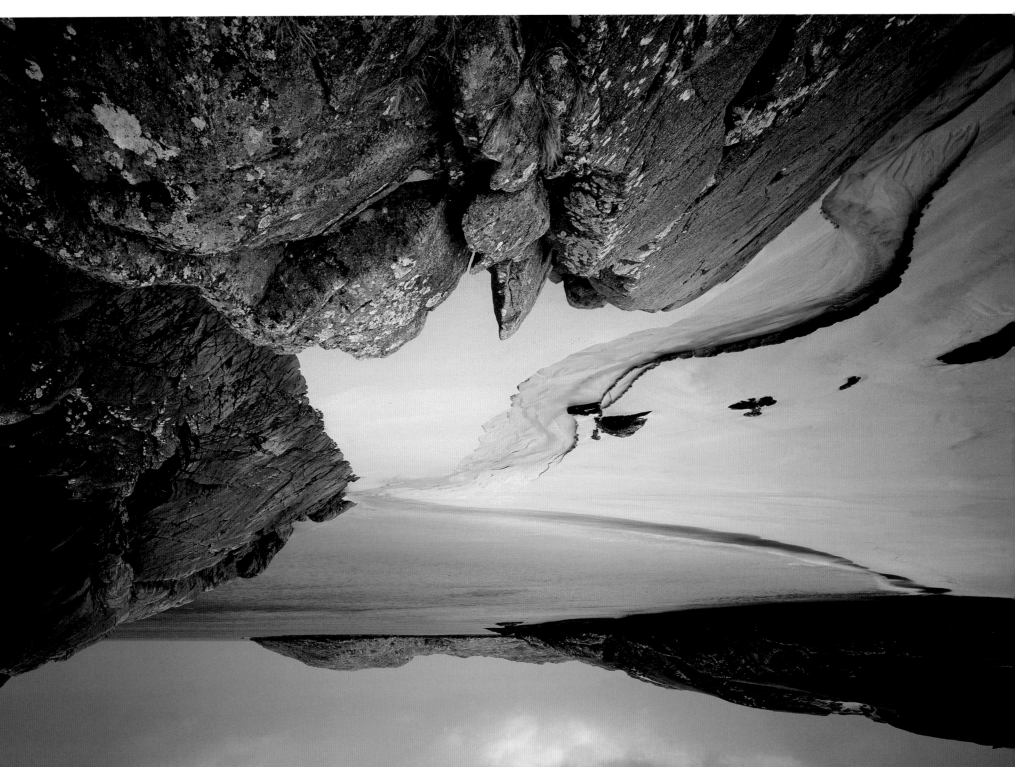

Early Morning Calm

The artist has retained the essential composition of this photograph, as the crisp lines work just as well in watercolor as they do in the photograph, and the muted colors add a beautifully relaxed feel.

PAINTS
Cobalt blue
Alizarin crimson
Raw sienna
Phthalocyanine blue
Raw umber
Burnt sienna
Lemon yellow
Ultramarine

MATERIALS
Cold-pressed paper,
 140 lbs (300 gsm),
 pre-stretched
#8 squirrel mop
 brush
4B pencil

TECHNIQUES USED
Flat washes, page 16
Wet-in-wet, page 18
Wet-on-dry, page 18
Lifting out, page 22

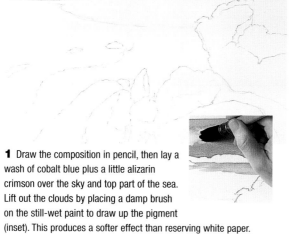

1 Draw the composition in pencil, then lay a wash of cobalt blue plus a little alizarin crimson over the sky and top part of the sea. Lift out the clouds by placing a damp brush on the still-wet paint to draw up the pigment (inset). This produces a softer effect than reserving white paper.

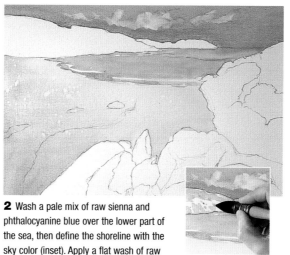

2 Wash a pale mix of raw sienna and phthalocyanine blue over the lower part of the sea, then define the shoreline with the sky color (inset). Apply a flat wash of raw sienna plus a little alizarin crimson to the beach. While still wet, drop in some cobalt blue and alizarin crimson on the left side. Wash raw sienna over the distant headland, leaving small white patches.

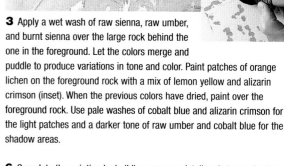

3 Apply a wet wash of raw sienna, raw umber, and burnt sienna over the large rock behind the one in the foreground. Let the colors merge and puddle to produce variations in tone and color. Paint patches of orange lichen on the foreground rock with a mix of lemon yellow and alizarin crimson (inset). When the previous colors have dried, paint over the foreground rock. Use pale washes of cobalt blue and alizarin crimson for the light patches and a darker tone of raw umber and cobalt blue for the shadow areas.

6 Complete the painting by building up more detail and strong shadows on the rocks with mixtures of raw umber and cobalt blue. Use small, variously shaped marks that describe the pitted surface, then wash burnt sienna over the left edge of the foreground rock.

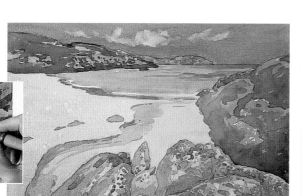

4 Wash cobalt blue over parts of the distant headland and darker areas of the sea. Paint a mix of cobalt blue and alizarin crimson over the lighter cliff areas of the headland on the left. Use a very pale mix of cobalt blue and alizarin crimson for the stream running through the sand, and apply various mixes of raw umber, cobalt blue, and burnt sienna to the large rocks on the right (inset).

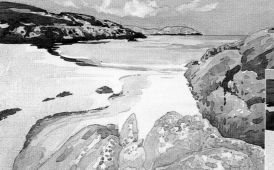

5 Paint a pale wash of cobalt blue and alizarin crimson over the left side of the beach, then begin to add detail to the rocks, starting with pale washes of cobalt blue and alizarin crimson, then raw umber and cobalt blue, followed by various mixes of raw umber, burnt sienna, and cobalt blue. The darkest cracks in the rocks are painted with a strong mix of burnt sienna and ultramarine. Use the same color to add dark shadows to the distant headland.

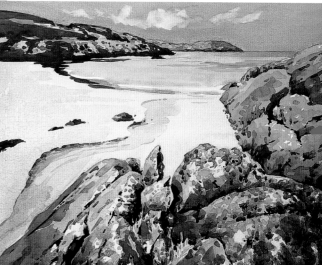

Fishing Village

In the photograph, the sun shines directly onto the village, creating wonderfully sharp lines. The artist has made a powerful focal point of this by concentrating on the details of the buildings and the boats while retaining the warming, golden quality of the light on the surrounding shoreline.

PAINTS
Raw sienna
Cobalt violet
Cobalt blue
Permanent magenta
Ultramarine
Burnt sienna
Cerulean blue
Raw umber
Cadmium red

MATERIALS
Cold-pressed paper,
 140 lbs (300 gsm)
2B pencil
Masking fluid
Small synthetic brush
Dip pen or pointed
 stick
Round sable brushes,
 #3, #5, and #8

TECHNIQUES USED
Wet-in-wet, page 18
Wet-on-dry, page 18
Directional
 brushstrokes,
 page 20
Masking fluid,
 page 21

1 Draw out the composition in pencil, then apply masking fluid to highlights and lighter areas of painting using a synthetic brush. Rinse out the brush at regular intervals to prevent the fluid from drying out and clogging the hairs. Use a dip pen or a small pointed implement such as a cocktail toothpick for any very fine linear highlights.

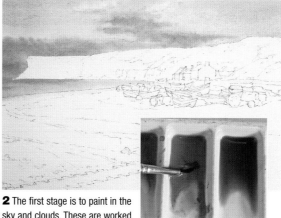

2 The first stage is to paint in the sky and clouds. These are worked wet-in-wet, so mix up large pools of the following colors and mixtures (inset): raw sienna; cobalt violet; cobalt blue; cobalt blue and permanent magenta with a touch of raw sienna (two versions, one stronger than the other); and ultramarine and permanent magenta with a touch of raw sienna. Moisten the paper for the sky and the distant spur of water, and apply each color in turn, working from light to dark.

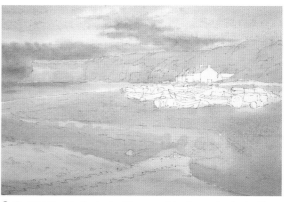

3 Mix the colors for the land while you wait for the washes to dry. Use mixes of burnt sienna; raw sienna and cobalt violet; and burnt sienna and raw sienna. Moisten the land area, leaving the foreground sea as dry paper, and apply the washes over the whole area. When dry, remove the masking and paint in the foreground water using the same mixes as in Step 2 for the sky.

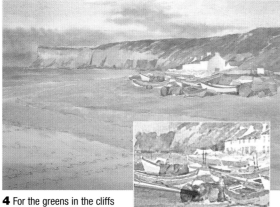

4 For the greens in the cliffs and the reds in the boats, mix up the following additional colors: raw sienna and cerulean blue; raw sienna and cobalt blue; raw umber and ultramarine; raw sienna, ultramarine, and burnt sienna; raw sienna and cadmium red; and cadmium red and a touch of cobalt blue. Apply these colors to dry paper, working from front to back, and let the colors blend wet-in-wet in each separate area (inset).

5 Build up the colors and add detail where necessary, working wet-on-dry and using the colors mixed previously.

6 After adding details to the foreground water, add an additional wet-in-wet application of color to unify this passage and provide a slightly darker "cushion" at the bottom of the painting.

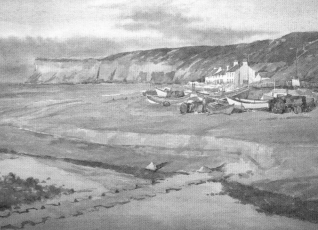

Lighthouse at Low Tide

The composition of this painting is based closely on the photograph, but the foreground has been simplified to provide stronger lead-in lines that effectively push the lighthouse back in space.

PAINTS
Ultramarine
Cobalt blue
Titanium white
 (acrylic)
Mars black (acrylic)
Quinacridone violet
Phthalocyanine blue
Yellow ochre

MATERIALS
Cold-pressed
 watercolor paper,
 140 lbs (300 gsm)
HB pencil
Masking fluid
Synthetic brush
Kitchen towel
3-in. (7.5-cm) flat
 squirrel-hair brush
1-in. (2.5-cm) flat
 brush
Small bamboo and
 linen brushes
Eraser

TECHNIQUES USED
Wet-in-wet, page 18
Masking fluid,
 page 21
Watercolor and
 acrylic, page 26

1 This is a very busy image with a lot of distracting detail that you will need to simplify, so when drawing the composition, look for the main shapes and long, sweeping lines. When the drawing is complete, apply masking fluid to the lighthouse and background buildings using the synthetic brush. Rinse out the brush at regular intervals to prevent the fluid from drying out and clogging the hairs.

2 Wet the whole of the paper and lay on mixtures of ultramarine and cobalt blue mixed with titanium white. While still damp, add a darker wash of the same color at the top of the sky. Sponge the area lightly using a kitchen towel to absorb any excess moisture.

3 If the paper is too dry, rewet the land area; then paint the water and wet sand rapidly with a large flat brush. To achieve the purplish undertone, mix Mars black, titanium white, and quinacridone violet, used in equal proportions. For the darker purplish tones, add more black.

4 Leave to dry completely, then rewet the land area with clean water and brush in phthalocyanine blues and rich green tones (mixed using phthalocyanine blue and yellow ochre). While still slightly damp but not too wet, use a bamboo brush to lay in blacks and darker tones.

5 Remove the masking and add touches of tone and color to define the structures. The buildings are quite distant and must not appear to come forward in space, so take care not to overemphasize the colors.

6 Finally, erase any pencil marks with a soft eraser. The effect of recession is enhanced by avoiding a strong white for the lighthouse, making it less of a focal point.

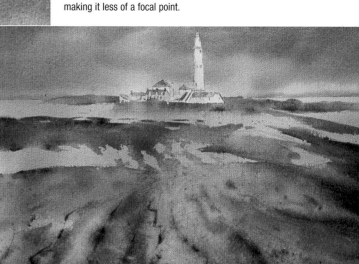

Beach Huts

In the artist's rendition, he has subdued the colors and tonal contrasts to give a gentler feel that is better suited to a watercolor treatment. He has also brought more interest into the foreground by using complementary colors—yellows and mauve-grays—for the sand.

PAINTS

Raw sienna
Winsor yellow
Winsor yellow deep
Cadmium orange
Cadmium red
Ultramarine blue
Cobalt blue
Light red

MATERIALS

Rough watercolor
 paper, 140 lbs
 (300 gsm),
 pre-stretched
Round sable brushes,
 #3, #7, and #12
Rigger brush
Masking fluid
3B pencil

TECHNIQUES USED

Variegated washes,
 page 16
Dropping in colors,
 page 17
Wet-in-wet, page 18
Masking fluid,
 page 21
Scratching off,
 page 23

1 To give the composition a sunny feel, lay a wash of raw sienna over the whole surface, introducing a watery mixture of cobalt blue and light red into the bottom right-hand side. After the background color has dried, sketch the image with the 3B pencil.

2 For the sky, lay a very dilute cobalt-blue wash and then introduce a stronger mixture of cobalt blue and ultramarine blue wet-in-wet, allowing some wispy clouds to show through as the lighter color.

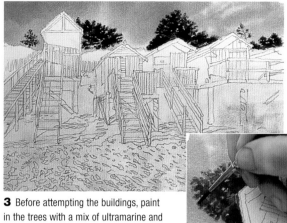

3 Before attempting the buildings, paint in the trees with a mix of ultramarine and Winsor yellow deep, dropping in darker versions of the same colors wet-in-wet to give them form. When dry, soften the edges with a just-damp brush.

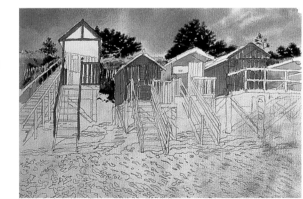

4 Reserve the fencing with masking fluid and, when dry, apply the basic colors of the beach huts using a well-loaded brush. Use a mixture of cadmium red and cadmium orange for the red huts, and Winsor yellow and cadmium orange for the other two.

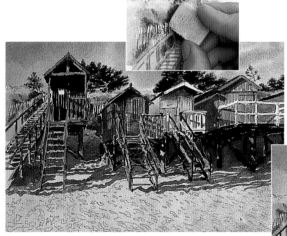

5 With the masking fluid still in place, paint the grassy bank with loose wet-in-wet mixtures of raw sienna, light red, and ultramarine to give a spontaneous effect. When dry, remove the masking fluid with a kneaded eraser (inset) and build up the huts, supports, and fencing using combinations of light red, ultramarine, and cadmium orange in varying strengths. For the shadows across and below the huts, omit the orange, as a cooler color is required here.

6 Paint the sand indentations with the same mix of light red and ultramarine used for the shadows, taking care to make the marks larger in the foreground to create a perspective effect. Let dry and then give the sand an overall wash of clean water before adding some raw sienna wet-in-wet. Use a sharp blade to scratch out a few small linear highlights on the fencing.

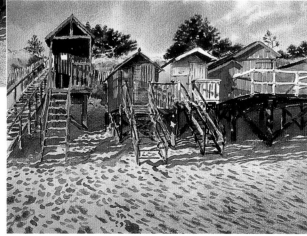

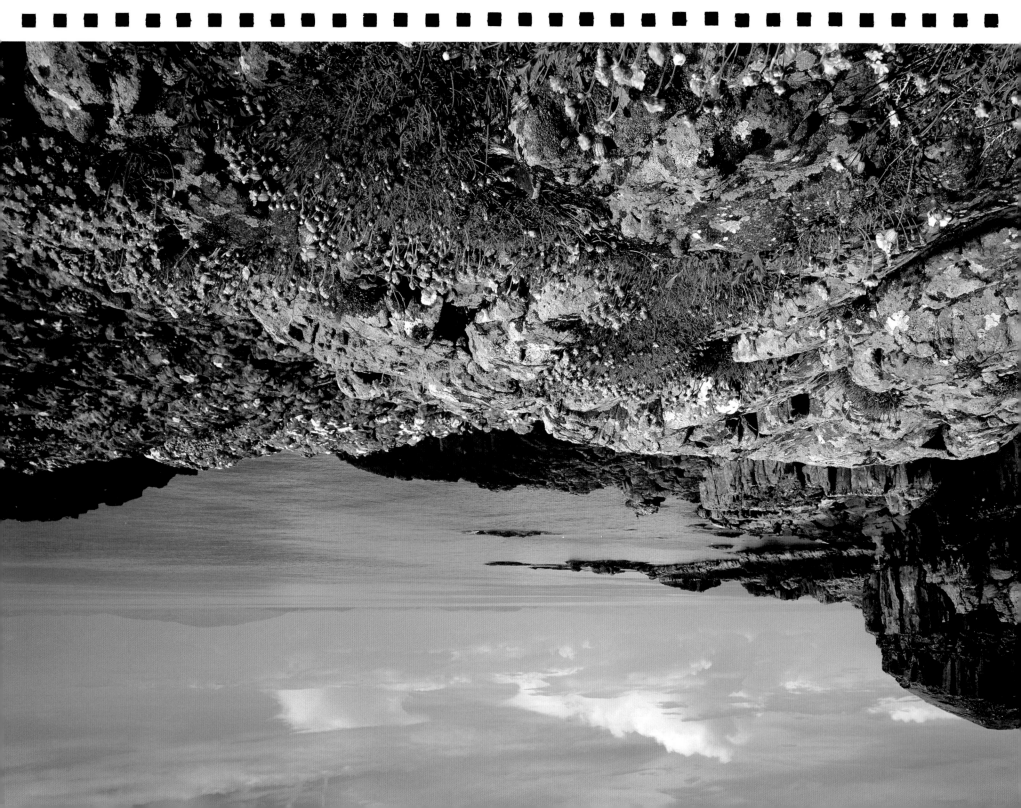

Flower-strewn Rocks

An important change has been made to the composition, which was to slope the rocks downward in the center so that they frame the sea, which has become a more triangular shape.

PAINTS

Winsor blue
Venetian red
Cerulean blue
Burnt umber
Sap green
Permanent rose
White gouache

MATERIALS

Watercolor board
Pencil
Masking fluid
Flat brushes,
 1 in. (2.5 cm) and
 2 in. (5 cm)
Round brushes,
 #10 and #3
Dip pen
Ruler
Tissue
Salt

TECHNIQUES USED

Dropping in colors,
 page 17
Descriptive brushwork,
 page 20
Dry brush, page 20
Lifting out, page 22
Spattering, page 23
Salt spatter, page 25

1 Draw the composition in pencil and mask out the flowers in the foreground.

2 Mix up a wash of Winsor blue, Venetian red, and cerulean blue, and paint in the islands on the horizon. Next, lay in the sky and sea using the large flat brush. Lift off the clouds with a crumpled tissue (inset). Drop in shadows at the bottom of the clouds using some of the blue wash with the addition of a little red.

3 Once the first wash for the sea has dried, build up the area with the same color mixture. Use both flat brushes to achieve a range of brushstrokes. To create a sense of texture in the distant ground, drag the large brush across the board using a dry-brush technique. For closer ripples, use the side of the smaller flat brush (inset). Finally, to create fine distant lines, dip the pen into the watercolor mixture and use a ruler to draw lines toward the horizon. Lift out the reflection of the clouds with a damp tissue.

4 Paint in the shadow areas of the middle-ground cliffs with a dark blue wash. Then use mixes of blue, burnt umber, and sap green to paint in the grass and the sunlit rocks. Use a combination of flat washes and a dry-brush technique, and add details with the pen as for Step 3.

5 Mix a light gray wash from Winsor blue and Venetian red, with a higher proportion of red than previously, and use the large flat brush to paint the rock surface, making loose, sweeping strokes. Sprinkle on salt, then drop in greens and pinks while still wet. Place tissues over the sea and sky areas to protect them, then spatter permanent rose from a well-loaded round brush to create a spontaneous effect. Let dry, then brush off the salt.

6 Mix a darker version of the previous gray wash, and dry-brush more texture onto the foreground rocks with the large flat brush. Add cracks and shadows with the small round brush, then use a darker green to paint in leaves and stems. Remove the masking fluid and paint the flowers with different strengths of permanent rose. Finally, add sparkles to the sea by spattering on white gouache with the large round brush.

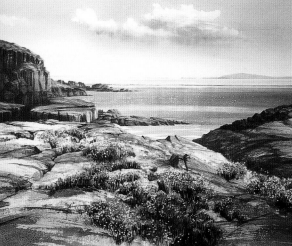

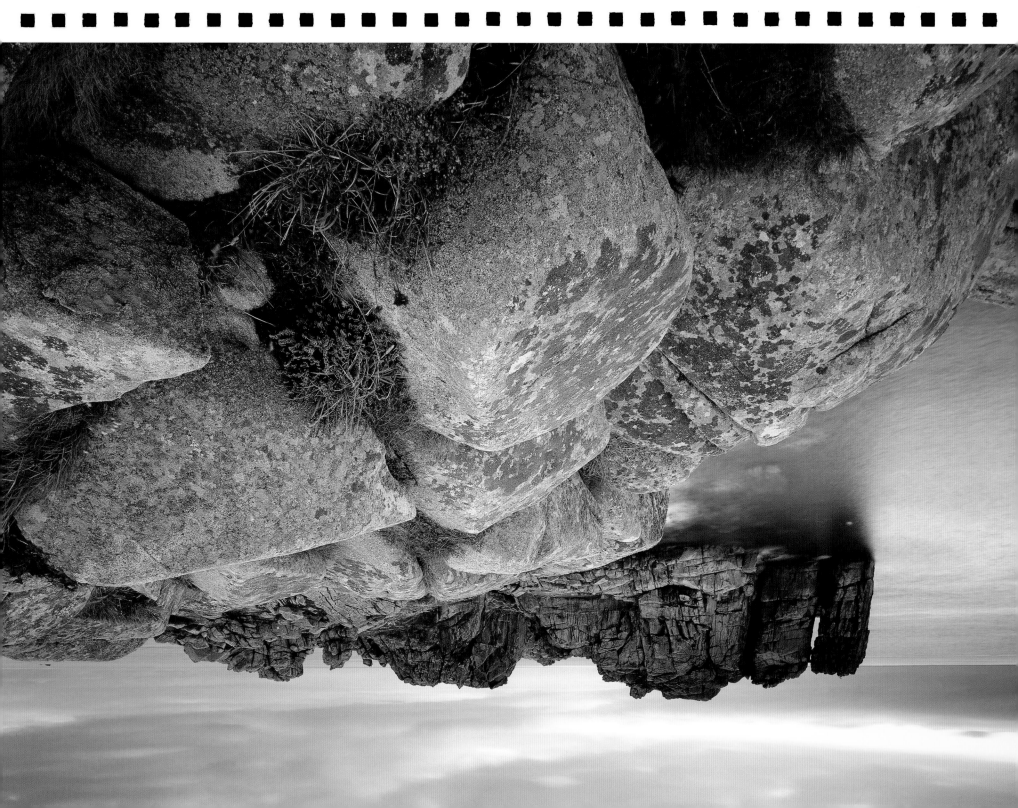

Brittany Coast

This composition follows the photograph closely, with small but significant alterations to detail. To achieve more sense of space, the artist has treated the background rocks in broader terms, giving them a slightly out-of-focus look that makes them recede.

PAINTS
Raw sienna
Permanent rose
Ultramarine
Light red
Cadmium orange
Viridian
Winsor yellow deep

MATERIALS
Rough watercolor
 paper, 140 lbs
 (300 gsm),
 pre-stretched
2B pencil
Masking fluid
Round sable brushes,
 #12, #8, and #3
Rigger brush
Toothbrush
Kneaded eraser

TECHNIQUES USED
Flat washes, page 16
Wet-in-wet, page 18
Wet-on-dry, page 18
Lifting out, page 22
Masking fluid, page 21

1 Using a 2B pencil, sketch in the horizon lines and the rocks, then apply an overall pale wash of raw sienna and let dry.

2 Wet the sky area with clean water, leave until nearly dry, then lay on washes of permanent rose, ultramarine, light red, and raw sienna in various mixtures and strengths for the cloud areas, encouraging the colors to blend wet-in-wet (inset). Don't labor this process. It is not essential to copy the original cloud shapes precisely.

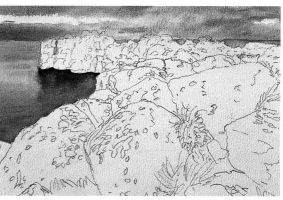

3 Lay a wash of raw sienna over the sea, introducing a mixture of raw sienna and permanent rose wet-in-wet for the pink areas. Use a mixture of ultramarine and raw sienna for the reflections and shallows. When dry, wash a diluted mix of viridian over the reflection and shallow areas.

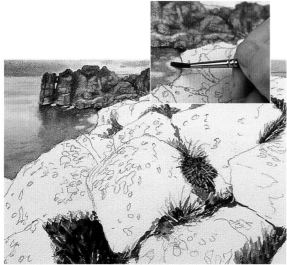

4 Paint the background rocks with a mixture of ultramarine and light red, and the lichen with a mixture of raw sienna and cadmium orange, dabbing it on with the #3 brush wet-in-wet. Use a darker mixture of ultramarine and light red for the shadows and, when dry, lift out the lighter areas using a damp brush and clean water. The finished background rocks should have a soft, out-of-focus feel to them, which will help give the painting more depth. Use the lifting-out method again to suggest areas of foam around the base of the cliffs (inset).

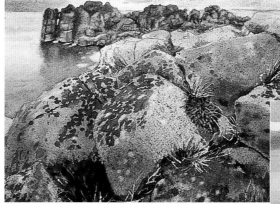

5 Mask out some of the thin stalks of the coastal flora on the rocks. When dry, paint in the grasses with mixtures of raw sienna, light red, ultramarine, and Winsor yellow deep, using permanent rose for the pink heather. Wet the area of the foreground rocks and lay a wet-in-wet wash of ultramarine and light red. When almost dry, use a stronger mixture of the same colors and spatter it on with a toothbrush, working one rock at a time.

6 Continue building up the rocks with washes of light red and ultramarine. Use various mixtures of light red, ultramarine, and Winsor yellow deep to paint in the lichen patterns and colorations on the rock surfaces. Remove the masking fluid using a kneaded eraser and paint in the strands of grass with washes of raw sienna, softening the edges while you work.

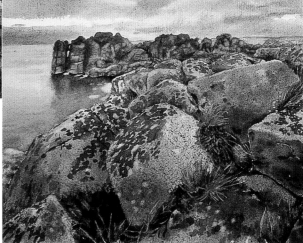

Utah Landscape

In this photograph, bright sunlight picks out the shapes and forms, providing a wealth of detail. The artist has simplified the image to achieve a powerful composition with a strong tonal pattern.

PAINTS
Yellow ochre
Naples yellow
Dioxazine purple
Brown madder
Cobalt blue
Cerulean blue
Payne's gray
Sap green
Raw umber

MATERIALS
Cold-pressed paper,
 300 lbs (640 gsm)
#10 round sable
 brush
Gum arabic
¼-in. (6-mm) flat
 brush
Small piece of
 cardboard
1-in. (2.5-cm)
 decorator's brush

TECHNIQUES USED
Flat washes, page 16
Overlaid washes,
 page 16
Backruns, page 17
Negative painting,
 page 23

1 Use a #10 sable brush to wash a light ochre mix of yellow ochre and Naples yellow over the entire image except for the sky and river. Introduce a little dioxazine purple at the bottom of the area and a little brown madder to the middle ground. Leave to dry.

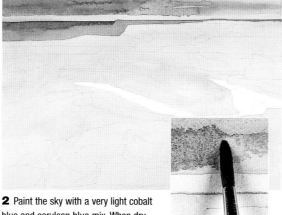

2 Paint the sky with a very light cobalt blue and cerulean blue mix. When dry, darken this mix using dioxazine purple, Payne's gray, and cobalt blue, along with some gum arabic. This, once dry, will allow the washes to be manipulated if water is added. Paint the dark landmass on the horizon. Lighten the mix, and paint the bank of clouds. Lighten again and paint in the wall of cliffs below the dark landmass. While the paint is drying, add more paint to give backruns, to give the effect of clouds (inset).

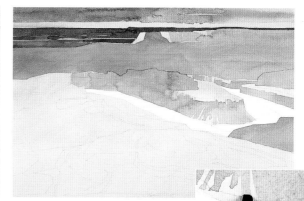

3 When dry, rework the distant rock faces using a darker version of the purple-and-blue mixture. Next, mix a dull orange from brown madder and yellow ochre with a little added dioxazine purple and wash in the far canyon using a flat ¼-in. (6-mm) brush. Brighten the mix with more brown madder and yellow ochre, then paint in the far side of the river. Use the edge of the flat brush to create a series of fissures and strata on the rock (inset).

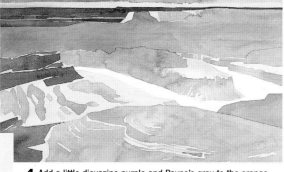

4 Add a little dioxazine purple and Payne's gray to the orange color, and paint the duller gray mountains and canyons on the left. Use the same color for the flattish slab of rock in the foreground. Use the chisel shape of the flat brush to paint around the slight contours that catch the light (inset).

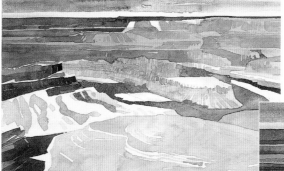

5 Paint the area of vegetation along the banks of the river using a mix of sap green and Payne's gray. Paint the river itself with cerulean blue, using Payne's gray and dioxazine purple to add shadow. Create the deep color in the vertical rock fissures using a deep orange mix of brown madder, yellow ochre, and raw umber. Apply this using the edge of a small piece of cardboard, which is better than a brush for achieving straight vertical lines.

6 Add more shadows to the cliffs using the flat brush and a mix of raw umber and Payne's gray. Add texture to the area by spattering a dull orange mix using a 1-in. (2.5-cm) decorator's brush. Complete the image by adding more detail to the cliff walls, as well as shadows to the flat rock in the foreground.

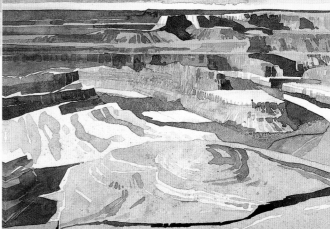

Boulders in Lake

The artist has given more prominence to the mountain by playing down the reflection and omitting most of the foreground rocks. The placing of light and dark tones is important in the painting, with the dark trees on the left balanced by the patches of deep blue in the sky and water.

PAINTS
Mars black (acrylic)
Ultramarine
Yellow ochre
Cadmium red
Titanium white
(acrylic)

MATERIALS
Cold-pressed
watercolor paper,
140 lbs (300 gsm)
HB pencil
Masking fluid
3-in. (7.5-cm) flat
squirrel-hair brush
1-in. (2.5-cm) flat
brush
Small round bamboo
and linen brushes
Eraser

TECHNIQUES USED
Dropping in colors,
page 17
Wet-in-wet, page 18
Masking fluid,
page 21

1 The first step is to block in the main shapes with a pencil, making sure that the overall proportions are correct. Don't introduce too much detail, but make sure the drawing is accurate enough to give you a guide to place the masking fluid used for the rocks and tree trunks. Apply the fluid and allow to dry.

2 The sky sets the tone for the entire painting and is painted in first, using a 3-in. (7.5-cm) flat brush. Dampen the entire sky area with clear water, then float in the gray tones with a mix of Mars black, titanium white, and a touch of ultramarine. Follow this with ultramarine, taking care to preserve the white areas. While the sky dries, paint in the lake area using the same method. Make sure you paint around the reflected mountain.

3 Wet the mountain area, then apply a controlled wash of yellow ochre mixed with a touch of cadmium red. While the area is still slightly damp, use a 1-in. (2.5-cm) flat brush to indicate shadow and to give the mountain some depth. Repeat the process for the reflected mountain.

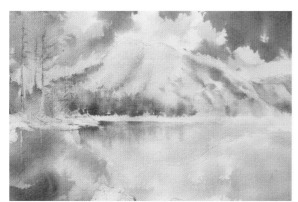

4 Next, dampen the background and foreground areas and paint in the pines using a green tone consisting of yellow ochre mixed with ultramarine. Add Mars black to the pigment to achieve darker tones in the foreground trees. Repeat the process for the reflected trees.

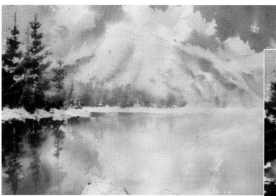

5 Remove the masking fluid with an eraser to reveal the tree trunks and rocky areas before laying in a light yellow ochre wash over the rocks. While still damp, mix some darker tones using Mars black, titanium white, and ultramarine, and float pigment into the darker shadow areas to give dimension and depth.

6 Finally, paint the tree trunks and use a small round brush to touch up any areas that may need greater definition.

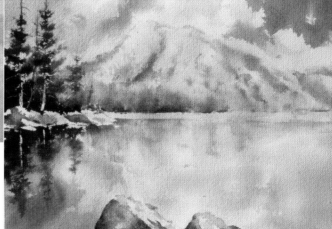

Mesa Arch at Sunrise

This photograph beautifully captures the way the sunrise makes the underside of the arch glow a brilliant deep orange. The artist has chosen to subtly alter the composition by focusing on the striking landscape beyond the arch, balancing the colors to suit the medium of watercolor.

PAINTS
Winsor blue
Venetian red
Dioxazine violet
New gamboge

MATERIALS
Watercolor board
Round brushes, #7
 and #3
2-in. (5-cm) flat brush
Dip pen
Masking fluid

TECHNIQUES USED
Overlaid washes,
 page 16
Masking fluid,
 page 21
Scumbling, page 25
Salt spatter, page 25

1 Sketch the scene in pencil and then mask out all the highlights—the sides of the rock faces lit by the sun and the light areas in the middle distance.

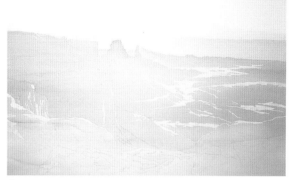

2 With a pale wash mixed from Winsor blue, Venetian red, and a touch of dioxazine violet, lay in the distant hills and mountains in separate layers, allowing each to dry before adding the next. Use the #7 round brush to paint in the details of each horizon, and blend in with the 2-in. (5-cm) flat brush.

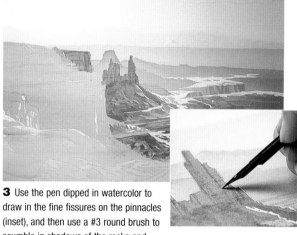

3 Use the pen dipped in watercolor to draw in the fine fissures on the pinnacles (inset), and then use a #3 round brush to scumble in shadows of the rocks and strata in the middle distance, making the colors stronger toward the foreground. When dry, remove the masking fluid from the centre only.

6 Using the #7 round brush, scumble texture onto the foreground rocks, then use both the smaller brush and the pen to paint in the cracks, the darker shadows of the foreground rocks, and the roof of the cave with a dark mix of blue and red. Use the 2-in. (5-cm) flat brush to paint over the lower foreground rocks with a dark mix of Winsor blue and Venetian red, adding a little water to lighten the rocks on the left. As the paper starts to dry, sprinkle in some salt to create texture. When dry, brush away the salt, remove the masking fluid, and add more washes of Venetian red and new gamboge. Several layers will be needed to create depth of color.

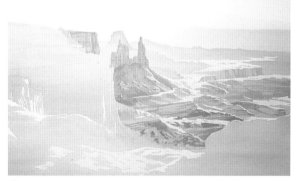

4 With the 2-in. (5-cm) flat brush, wash clear water over the top of the painting and then lay a thin wash of Venetian red over the bottom half, blending the two in the middle. This will soften and unify the middle distance.

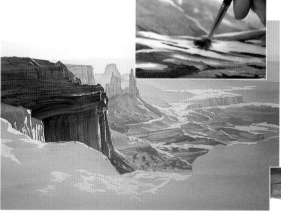

5 Scumble and dry-brush a darker mix of the Winsor blue and red mixture over the left-hand cliff to suggest darker shadows, overhangs, crevices, and vegetation (inset), then wash over the whole cliff with a layer of the darker mix. When dry, remove the masking fluid and wash Venetian red alone over the whole cliff area.

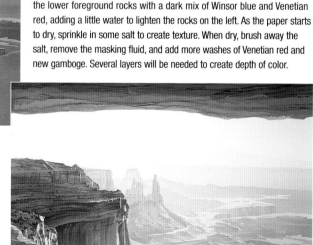

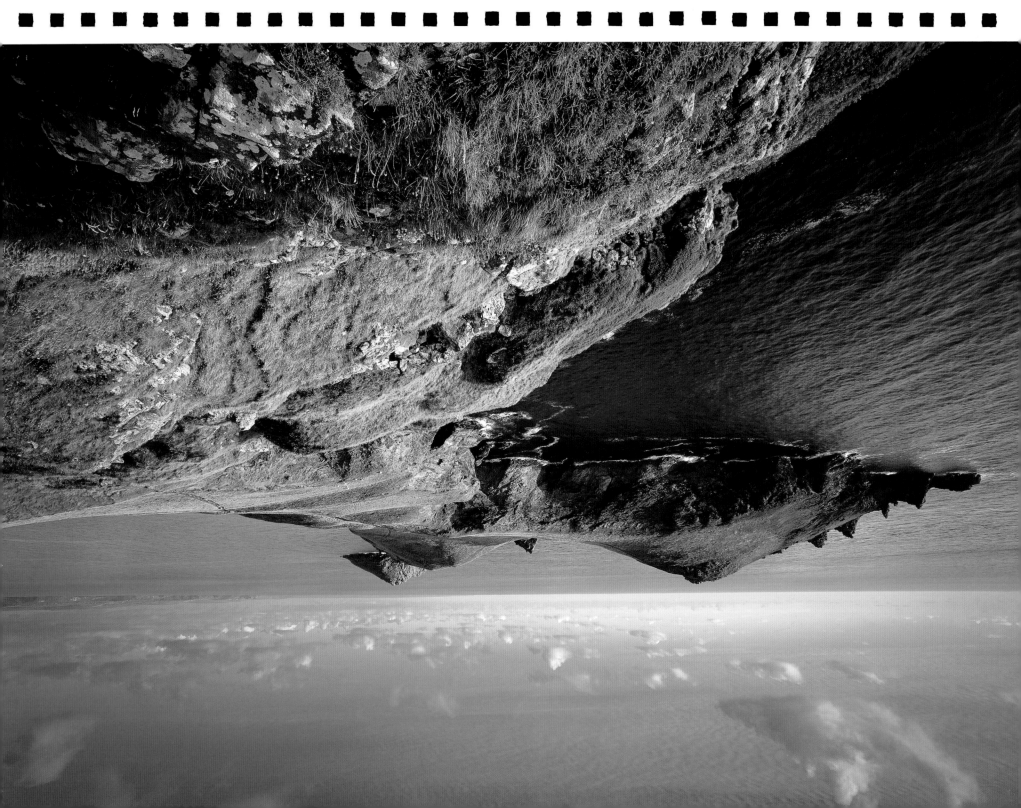

Rocky Headland

The artist has chosen to concentrate on the pattern of sunlight and shadow on the rocks that is so striking in this photograph, and has echoed this in the sea, by bringing in more light–dark contrasts. The decisive brush marks used to describe the ripples give a strong sense of movement, and the dark tones provide a balance for those on the foreground rocks.

PAINTS

Cobalt blue
Alizarin crimson
Burnt sienna
Raw sienna
Ultramarine
Phthalocyanine blue
Lemon yellow

MATERIALS

Cold-pressed paper,
 140 lbs (300 gsm),
 pre-stretched
#8 squirrel mop
 brush
4B pencil

TECHNIQUES USED

Wet-in-wet, page 18
Wet-on-dry, page 18
Descriptive
 brushwork, page 20
Reserving white
 paper, page 21

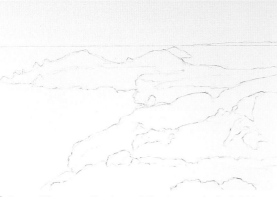

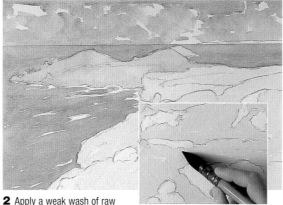

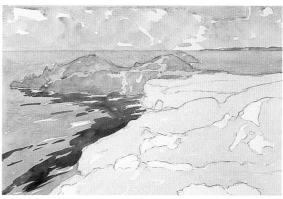

1 Draw out the composition in pencil, then lay a wash of cobalt blue over the sky and sea areas. Reserve some patches of white paper for the whites of the clouds and small wavelets. While still wet, drop in alizarin crimson and burnt sienna on the undersides of the clouds.

2 Apply a weak wash of raw sienna over the distant rocks (inset). While still wet, drop in a little ultramarine to produce soft green mixtures. Paint more raw sienna over the middle and foreground areas, leaving the rocks unpainted so that they stand apart from the grassy background. Paint a second wash over the sea, starting from the horizon and working downward. Begin with cobalt blue, then drop in a mixture of raw sienna and phthalocyanine blue in the middle and foreground to produce a greener hue in these areas.

3 Add some definition to the distant rocks with a wet-in-wet mix of alizarin crimson and ultramarine. Next, paint the distant strip of land on the horizon with a weak mix of burnt sienna and phthalocyanine blue. Use a strong mix of ultramarine and alizarin crimson for the dark ripples at the edge of the sea, then paint the grassy area in the distance with a weak wash of raw sienna and phthalocyanine blue. Repaint the foreground rocks with lemon yellow.

6 To complete the painting, touch in final details where needed, and add some patches of raw sienna in the middle ground and foreground, followed by small areas of dark brown mixed from burnt sienna and ultramarine. Finally, paint in the darkest areas of shadow using a mix of alizarin crimson and ultramarine.

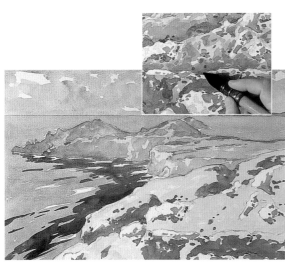

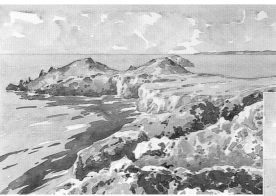

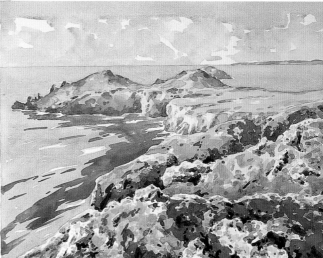

4 Paint the shadows on the rocks with a mix of ultramarine blue and alizarin crimson. Begin to build up the grassy areas with raw sienna and phthalocyanine blue, applying the paint loosely with the tip of the brush (inset). Make a weak mix of ultramarine with a touch of burnt sienna, and wash over parts of the bare rocks; then add a little more detail on the distant cliffs with crimson and ultramarine. Paint in some dark greens on the grassy rocks with raw sienna and phthalocyanine blue.

5 Add some heavier shadows in the middle ground and foreground using a mix of alizarin crimson and ultramarine, and paint areas of lichen on the bare rocks with a mix of lemon yellow and raw sienna.

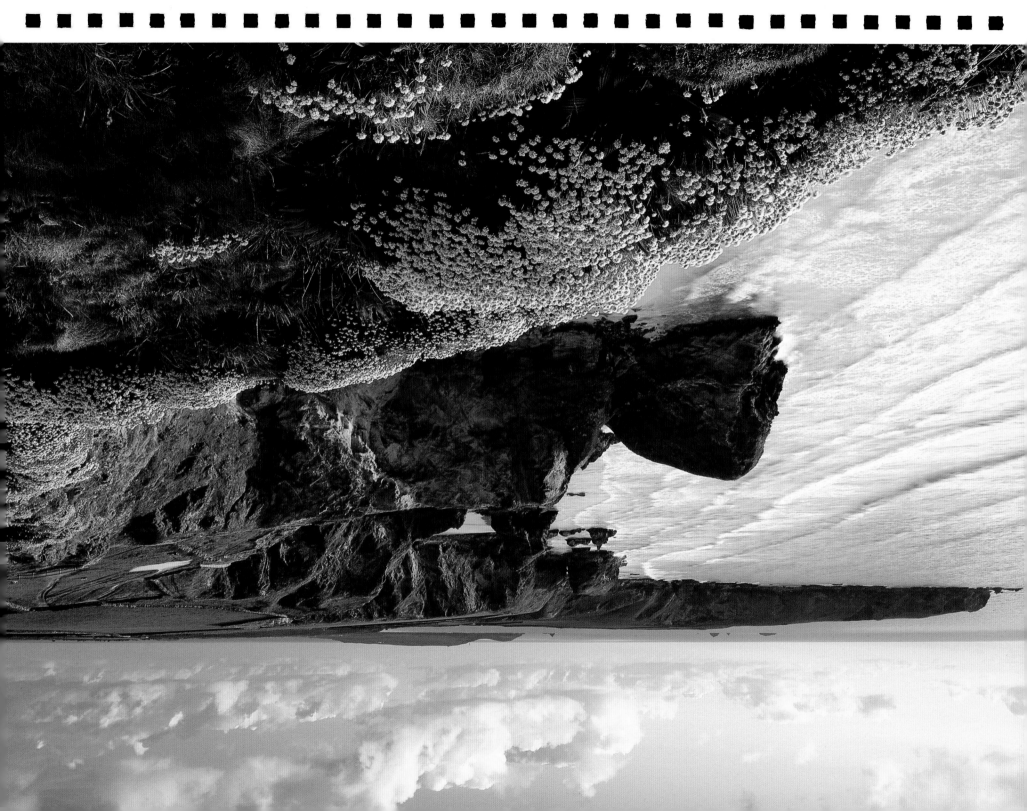

Celtic Seascape

The artist has accentuated the wide sweep of the cliffs, while making the dark rocks in the center the focal point. She has also lightened the sky in order to focus more attention on the land.

PAINTS
Winsor blue
Venetian red
Sap green
Permanent rose
Naples yellow

MATERIALS
Watercolor board
Round brushes, #10, #7, and #3
2-in. (5-cm) flat brush
Dip pen
Masking fluid
Tissues

TECHNIQUES USED
Dropping in colors, page 17
Wet-in-wet, page 18
Dry brush, page 20
Masking fluid, page 21
Lifting out, page 22
Salt spatter, page 25

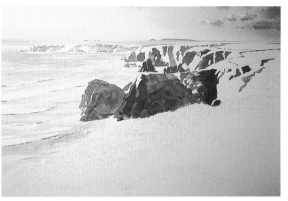

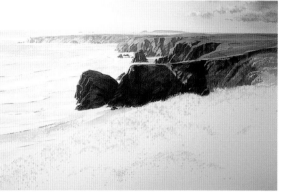

1 Sketch the scene and mask out all the thrift (sea pink) flowers. For the sky, apply a thin wash of Winsor blue and Venetian red with the 2-in. (5-cm) flat brush, making it a little darker at top right and grading to almost clear water to the left. Add a brushstroke of warm color mixed from Naples yellow and permanent rose with the #7 brush to suggest the glow of the evening sky, then lift out the tops of the clouds with a balled-up tissue and add shadows using a mix of the sky color and the warm mix. Paint the sea with the sky mix, using the flat brush to make loosely curved, dry-brush strokes.

2 Using a darker mix of the Winsor blue and Venetian red sky color, block in the shadows of the cliffs, making them lighter on the distant headlands and darker toward the foreground to create recession. Paint fairly loosely with the #7 round brush.

3 Mix sap green with some of the warm orange sky wash and paint in the grassy fields and cliff tops. Take the orange wash over the whole of the land area, and work it into the cliffs to create successively darker shadows and richer coloring.

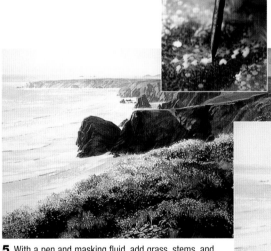

6 The distant headland is under cloud, so add shadows over this area and the adjacent sea with the #10 round brush and a dark mix of Winsor blue and Venetian red. Touches like these add both atmosphere and authenticity to a painting.

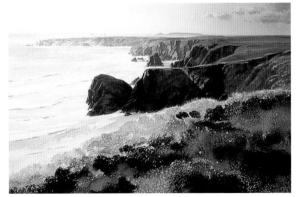

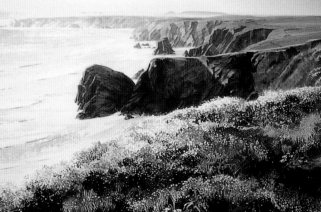

4 Now paint the foreground, blending the sap-green mix, the orange, Naples yellow and some very dark sap green wet-in-wet, and then drop in some permanent rose around the masked-out thrift. Sprinkle on some salt and allow to dry.

5 With a pen and masking fluid, add grass, stems, and stalks around the flowers (inset), and when dry, add another layer of yellows and greens together with darker shadows. When this is dry, remove all the masking fluid and brush off the salt. Then paint in the thrift using permanent rose in different densities.

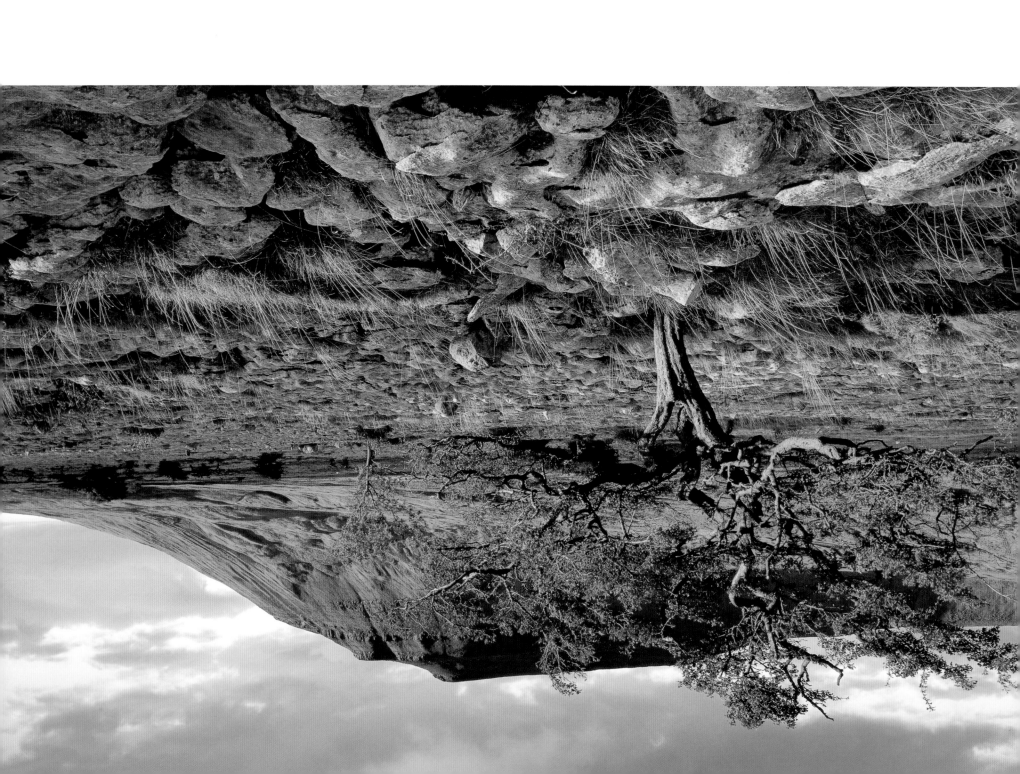

Sun-kissed Hills

The artist has made little change to this composition, apart from simplifying the middle ground and omitting the small tree toward the right. Stronger light–dark contrasts on the rocks and grasses create a lighter, sunnier feel.

PAINTS

Cerulean blue
Ultramarine
Alizarin crimson
Aureolin
Burnt sienna
Phthalocyanine blue
Raw sienna
Raw umber

MATERIALS

Cold-pressed paper,
 140 lbs (300 gsm),
 pre-stretched
#8 squirrel mop
 brush
4B pencil

TECHNIQUES USED

Overlaid washes,
 page 16
Wet-on-dry, page 18
Descriptive
 brushwork, page 20

1 Draw the main composition in pencil, then wash a mix of cerulean blue and alizarin crimson over the sky. Leave gaps for patches of blue sky. Use the same wash for the rocks in the middle ground and foreground, applying the color in individual brush marks rather than as flat color (inset).

2 Next, lay a pale wash of cerulean blue for the patches of blue sky and wash a mix of aureolin and alizarin crimson over the mountain. Paint the areas of sunlit grass with aureolin, plus a little alizarin crimson. Lay a second wash of burnt sienna on the mountain, then begin to build up the dark shadows with a mixture of phthalocyanine blue and alizarin crimson (inset).

3 Wash aureolin over the tree trunk and branches, and paint the tree foliage with a mix of raw sienna and burnt sienna, using small brushstrokes.

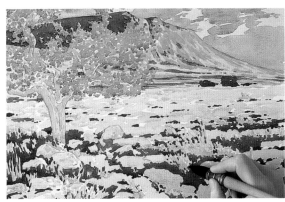

4 For the dark areas around the foreground rocks, use a dark green mix of raw umber and burnt sienna, building up the shadows gradually with differently shaped brushmarks. Add more streaks of burnt sienna to the mountainside, and bring in a darker tone to the tree foliage using a mix of alizarin crimson and raw sienna. Be sure not to obscure the "negative shapes," where the mountain shows through gaps in the foliage clumps.

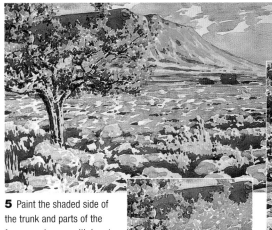

5 Paint the shaded side of the trunk and parts of the foreground grass with burnt sienna. Next, add the shadows on the rocks with a mix of ultramarine and alizarin crimson (inset).

6 Finally, use a dark mix of ultramarine and alizarin crimson for the strong shadows on the tree trunk and branches, and apply a light wash of burnt sienna on the tree trunk and grass.

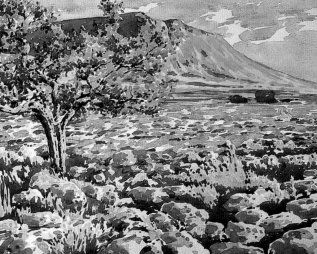

Enchanted Forest

This composition is based closely on the photograph, but the artist has made important changes to elements within it. Much more prominence has been given to the central clumps of foliage and the stream, whose swirling eddies lead the eye into the picture.

PAINTS

Sap green
Hooker's green
Cadmium yellow
Lemon yellow
Yellow ochre
Ultramarine
Cobalt blue
Raw umber
Chinese white
Lamp black

MATERIALS

HB pencil
Salt crystals
Masking fluid
Piece of fine wire

TECHNIQUES USED

Dropping in colors, page 17
Backruns, page 17
Wet-in-wet, page 18
Masking fluid, page 21
Spattering, page 23

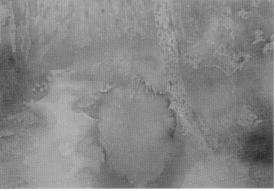

1 Lightly draw the scene with an HB pencil. The palest tones in this subject are yellow, so start by laying a light wash of lemon yellow over the whole surface, and then begin to build up darker areas with a very fluid mix of lemon yellow and cadmium yellow (inset). Drop in sap green, working wet-in-wet so that the two colors blend gently.

2 Loosely define the edges of the stream with slightly darker sap green, and then drop more watery green into the central area where the large fern will be. This creates a backrun, with jagged edges that give a suggestion of foliage without being too precise. Let dry, and then reserve the pale yellow highlights with masking fluid, using delicate, varied brush marks that describe the shapes.

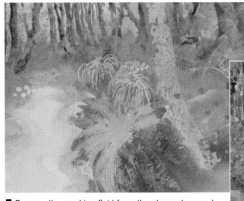

3 A subject like this invites an inventive use of watercolor to achieve interesting textures that compensate for the limited color range. Using a toothbrush, spatter a mixture of sap green and raw umber over the foliage areas. Then scatter salt crystals in the right-hand foreground (inset) and let dry. Be patient, as it takes some time for the salt to absorb the watercolor.

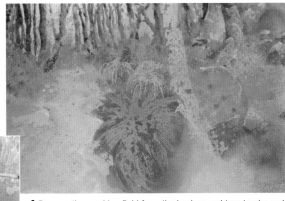

4 Remove the masking fluid from the background tree trunks and paint them with varied mixes of sap green and burnt umber, working wet-in-wet to avoid hard edges. Add brushstrokes of yellow ochre to the stream and throughout the foliage and let dry. Mask out the fern fronds (inset) to reserve them as a mid-tone, using a piece of wire dipped into the masking fluid to obtain fine detail. When dry, paint on a darker mix of sap green and raw umber.

5 Remove the masking fluid from the stream to reveal highlights of the original pale yellow wash, and start to paint the water and shadow area, using mixes of sap green and both the browns, with a little cobalt blue added where cooler colors are needed. When dry, remove the masking fluid from the central fern. Working wet-on-dry, paint fern details using mixes of the greens.

6 Remove the masking from the foreground tree trunk and paint it with mixes of sap green, burnt umber, white, and black. Continue to paint the fern fronds with varying mixes of sap and Hooker's green.

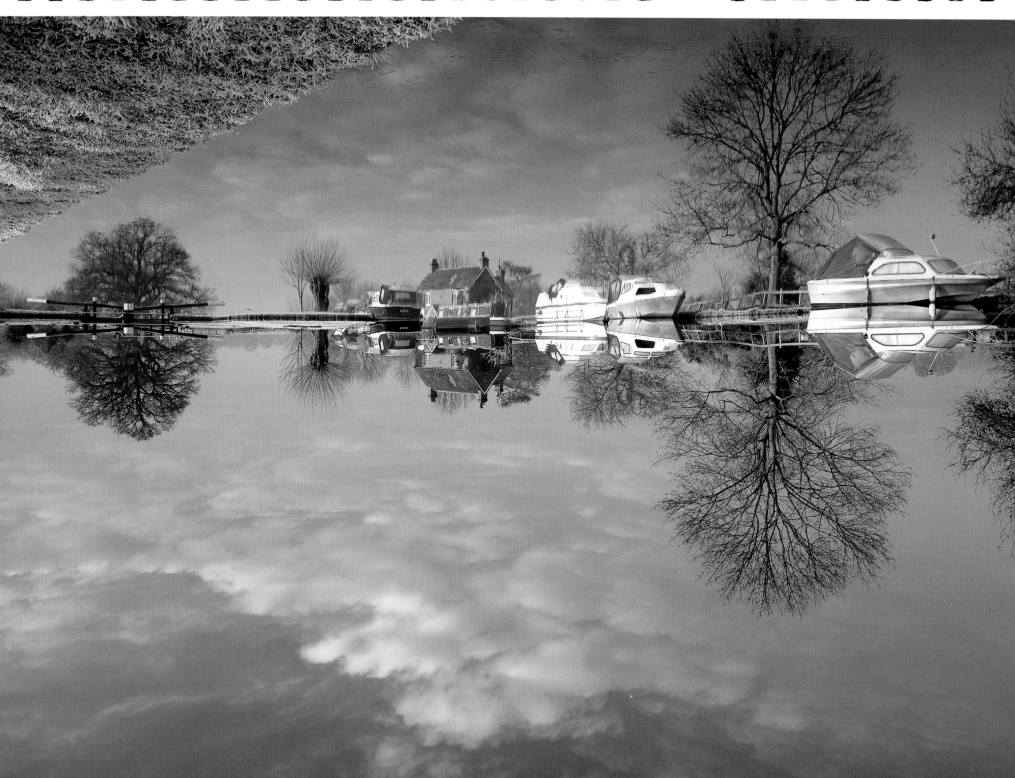

Sunshine and Frost

The composition of this photograph is pleasing, and has not been changed, though the artist has given a stronger sense of space by slightly muting the colors and tones of the boats and buildings. Detail in the trees has been played down so that they read as simple shapes.

PAINTS

Cobalt violet
Cobalt blue
Cerulean blue
Permanent magenta
Raw sienna
Ultramarine
Raw umber
Burnt sienna
Cadmium red

MATERIALS

Cold-pressed paper,
 140 lbs (300 gsm),
 pre-stretched
2B pencil
Masking fluid
Synthetic brush
Dip pen
Round sable brushes,
 #3, #5, and #8

TECHNIQUES USED

Overlaid washes,
 page 16
Wet-in-wet, page 18
Masking fluid,
 page 21

1 Draw the composition in pencil, then apply masking fluid to the highlight areas using a synthetic brush. Rinse out the brush at regular intervals to prevent the fluid from drying out and clogging the hairs. Take care with the placing of the fluid; the shapes and positions of the highlights are very important. Use a dip pen or a small pointed implement such as a cocktail toothpick to create the finer lines (inset).

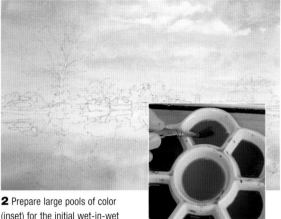

2 Prepare large pools of color (inset) for the initial wet-in-wet washes, using the following colors and mixes: cobalt violet; cobalt blue; cerulean blue and cobalt violet; cobalt blue and cobalt violet; cobalt blue, permanent magenta (with a touch of raw sienna to "gray" the mix slightly); ultramarine, permanent magenta, and a touch of raw sienna; ultramarine and raw sienna (to give a greenish blue). Apply the colors to moistened paper, leaving small areas of dry paper for the white clouds.

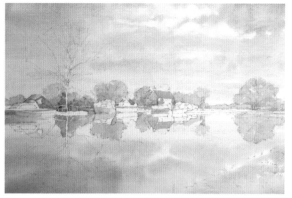

3 Leave the first washes to dry, then prepare more colors for the distant landscape and the nearer trees, houses, and boats. You will need the following mixes for the trees: cobalt violet and raw sienna; cobalt blue and raw sienna; cobalt blue and cobalt violet (this is also used for the boats); and cobalt blue and permanent magenta, plus a touch of raw sienna. For the darker green trees around the house, mix cobalt blue and raw umber, and mix burnt sienna and cobalt blue for the roof of the house. Apply the colors to dry paper, but let them blend within each separate area to give a soft effect.

6 Rewet the lower area of water with a large brush and clean water. Drop in stronger versions of the original sky and water mixes to strengthen the foreground and give a more powerful sense of recession. Add additional washes and detail to the boats, the large trees, and their reflections.

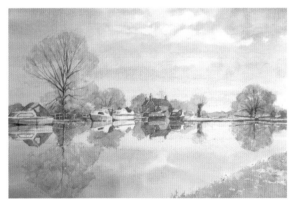

4 Now begin to strengthen the colors, and insert some detail. To paint the large tree on the right, the red barge, and the house, mix burnt sienna and raw sienna (for the sunlit areas on the tree and house); burnt sienna and ultramarine (for shadows and branches); and cadmium red and a touch of cobalt blue (for the barge). Use a fine brush to define the trunks and branches of the trees, and a larger one to paint the foliage over the sky. Use some of the sky mixes for the frosted grass in the foreground; this will help tie together the composition.

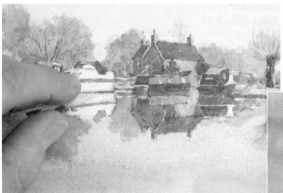

5 Remove all the masking fluid by rubbing gently with a finger. If any highlights appear too glaringly white, glaze over them with weak washes and soften any edges using a damp brush. It is usually best to remove the masking fluid before the painting is finished so that you can make adjustments where necessary.

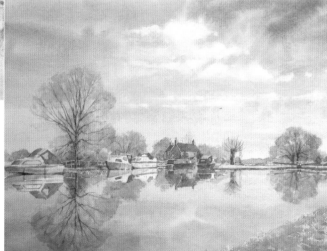

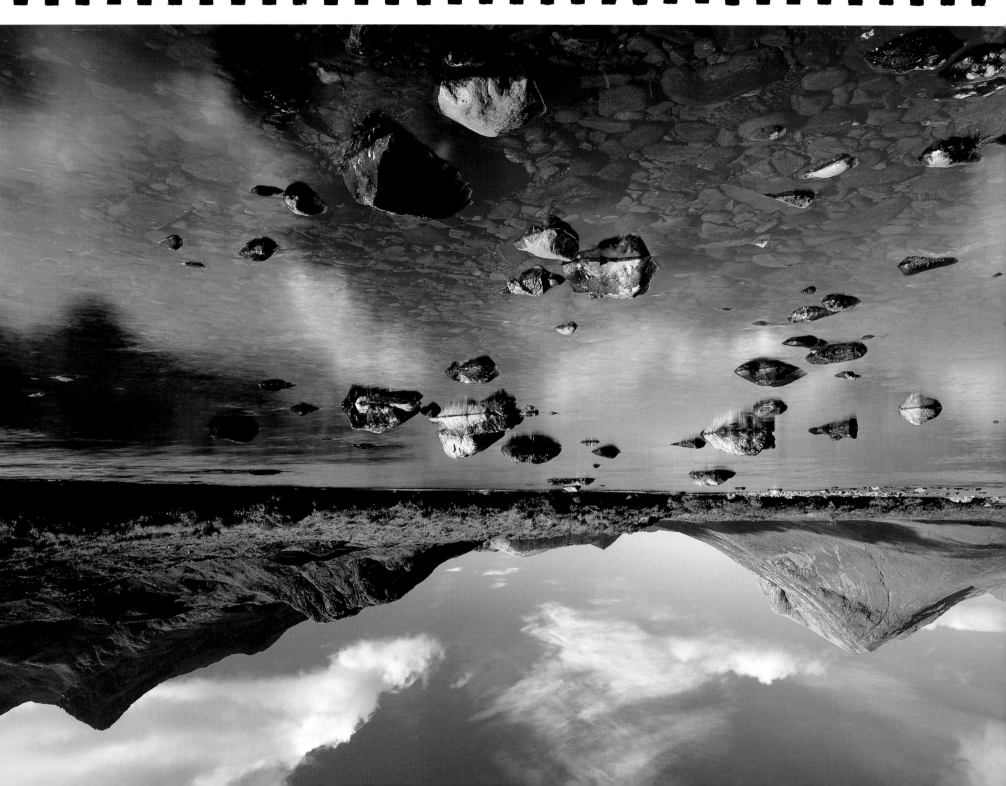

Skye River

Small boats and background buildings have been added to help draw the eye into the painting and seabirds to the right of the boats introduce atmosphere. The shore mosses in the left foreground help to bring the area forward in space.

PAINTS
Ultramarine
Titanium white
 (acrylic)
Mars black (acrylic)
Cadmium red
Cerulean blue
Yellow ochre
Cadmium orange
Cadmium red

MATERIALS
Cold-pressed
 watercolor paper,
 140 lbs (300 gsm),
 pre-stretched
Pencil
Masking fluid
3-in. (7.5-cm) flat
 squirrel-hair brush
1-in. (2.5-cm) flat
 natural-hair brush
#6 bamboo round
 brush
Single-edged razor
 blade
Eraser

TECHNIQUES USED
Dropping in colors,
 page 17
Wet-in-wet, page 18
Reserving white
 paper, page 21
Masking fluid,
 page 21

1 Begin with a pencil sketch, simplifying the main shapes to basic patterns. When the drawing is complete, mask out the birds, boats, buildings, and rocks.

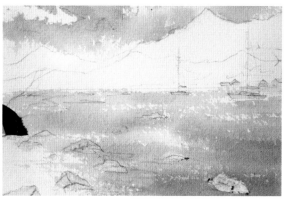

2 Lightly wet the sky and water area and float in a gray tone mixed from ultramarine blue, titanium white, and Mars black on the underside of the clouds and on the right side of the lake. Add cadmium red to the mix and stroke in this warmer color just above the tallest mountain. When nearly dry, mix ultramarine and cerulean blue for the upper sky and lay in the color with broad strokes, taking care to paint around the white cloud patterns. Using the same mix, brush lightly and quickly over the surface of the water with a 3-in. (7.5-cm) brush to achieve the scumbled, broken-color effect that suggests the sparkling surface.

3 Wet the mountain areas and brush in a wash of ultramarine blue with a touch of yellow ochre and titanium white. While this is still moist, add stronger ultramarine and Mars black to the mix and paint the top and shadow areas of the mountain; then add green mixed from yellow ochre and ultramarine to the mountain on the left and over the middle areas of the larger mountain. Mix in more strong ultramarine together with Mars black and use to paint the distant treeline. Drop a touch of cadmium orange into the darker areas.

4 Now paint the reflections using a mix of ultramarine and yellow ochre, working with a large brush on dry paper. Add a little Mars black to the mix and put touches of this darker tone on the distant shoreline for contrast. Using the mix of ultramarine and yellow ochre, lay a broad wash over the rocks to the left to balance the color.

5 Remove the masking from the rocks, boats, birds, and background buildings. Add touches of dilute cadmium red to the boats and buildings. Mix yellow ochre and cadmium orange and paint onto the rocks. When dry, define them with a darker wash of ultramarine blue and Mars black with a touch of cadmium red.

6 Using a bamboo brush, add the finishing details to the boats, masts, birds, and buildings. Then use a sharp blade to scrape out a few white highlights; for example, on the mast and the birds. Finally, erase all the pencil lines.

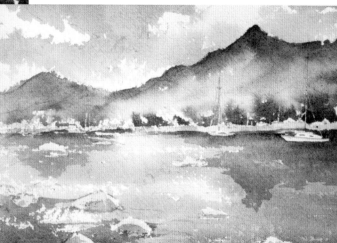

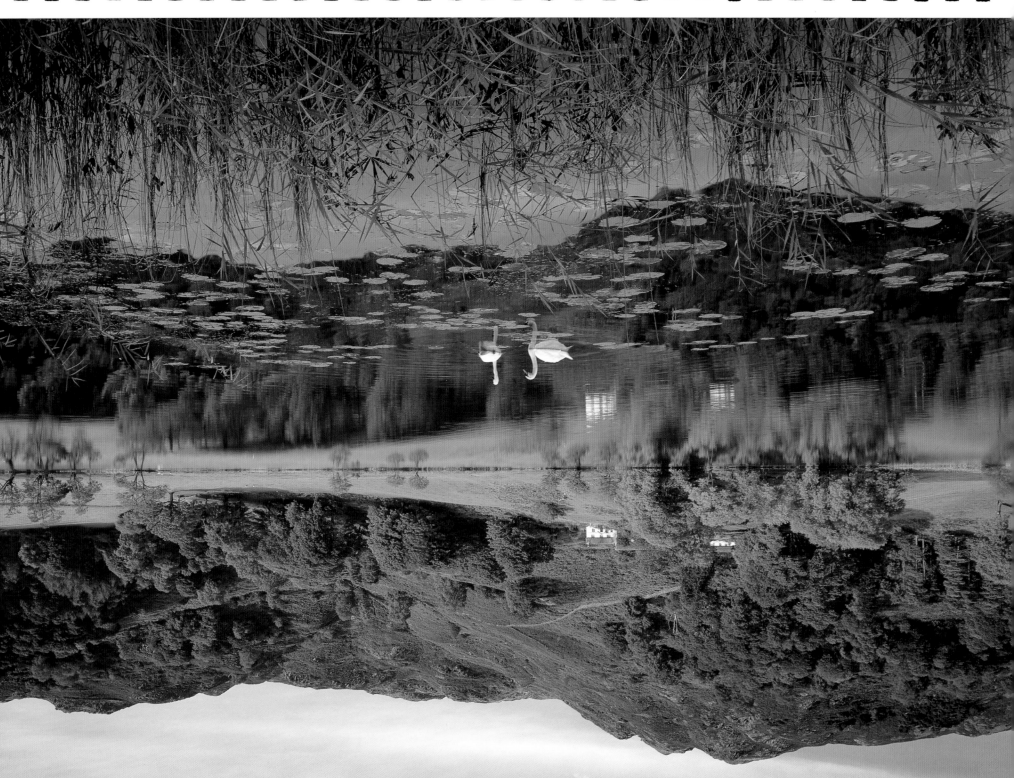

Swans on Lake

Here, the artist's main change was to lighten the overall tones, because these are rather too dark and heavy for a watercolor. Instead of the dominant greens, he has introduced more reds and oranges into the background hills, and he has created a stronger sense of recession by simplifying the clumps of trees.

PAINTS

Cobalt blue
Rose madder
Madder brown
Phthalocyanine blue
Ultramarine blue
Manganese violet
Pure yellow
Indian yellow
White gouache

MATERIALS

Cold-pressed
 watercolor paper,
 300 lbs (640 gsm)
Sable brushes, #12
 and #8
Rigger brush #4

TECHNIQUES USED

Overlaid washes,
 page 16
Dropping in colors,
 page 17
Wet-in-wet, page 18
Wet-on-dry, page 18
Masking fluid,
 page 21
Opaque watercolor,
 page 26

1 Draw the composition in pencil and then carefully mask out the white buildings and their reflections, as well as the swans and some of the lily pads.

2 Paint the sky with cobalt blue, drop in a little rose madder wet-in-wet, and, when dry, begin to paint the background hills using rose madder, Indian yellow, pure yellow, and cobalt blue. Start in the left-hand corner and work with the board tilted from left to right. Let the colors mix on the paper, keeping the mixtures clean and avoiding overbrushing the paint, as this will make the washes muddy. Where there are stands of trees, flick some color into them and blend gently together with the tip of the brush.

3 Using a mix of pure yellow and cobalt blue, paint in the swath of grass at the lake's edge, taking some of this color up into the land above. Drop fluid washes of cobalt blue, pure yellow, and rose madder into the water, working across the surface, but from time to time pulling some of the color down vertically. Strengthen the colors as you work down the paper, and then let dry before painting the nearer stretch of water with the cobalt blue and rose madder used for the sky.

4 Work back into the hills with stronger mixes of the original colors, working wet-on-dry to pull out some of the detail in the land forms. Leave areas of the original washes showing through, and loosely paint a green mixture of phthalocyanine blue and pure yellow into the trees, with touches of madder brown to give more strength to the shadow areas. Keep the trees simple, or they will attract too much attention and come forward in space.

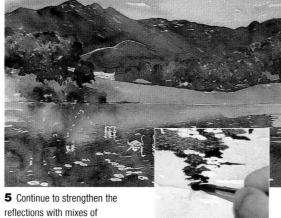

5 Continue to strengthen the reflections with mixes of phthalocyanine blue, pure yellow, and madder brown, painting some wet-in-wet and others wet-on-dry. Paint right down to the edge of the reflection (inset) and, when dry, repaint the blue areas with the same colors as before. Remove the masking fluid from the houses and swans only. Paint in more tree shadows and add a few simple details on the houses with the rigger brush.

6 Lay a light wash of cobalt blue and pure yellow over the whole of the reflection area, working around the swans. Use the rigger on its side to put in the small lakeside trees and reflections, then remove the masking from the lily pads and lay a simple gray-green wash over them, mixed from cobalt blue and rose madder. Paint the reed grasses in the foreground with the rigger and a mix of cobalt blue, Indian yellow, and madder brown, then add highlights to these with white gouache mixed with yellow and blue. Finally, use pure white gouache to paint in the swans' necks and their reflections.

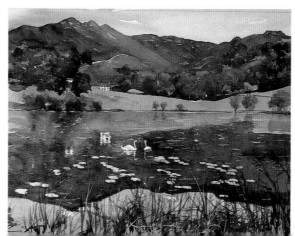

Estuary at Sunset

In the photograph, the sunburst is the obvious focal point, but the artist has played this down to focus attention on the bright stretch of water, which is echoed in the shapes and light tones of the foreground rocks.

PAINTS
Winsor blue
Venetian red
Sap green
Winsor orange
Dioxazine violet

MATERIALS
Watercolor board
Pencil
Masking fluid
2-in. (5-cm) flat brush
Round brushes,
 #10, #7, and #3
Tissue
Salt
Dip pen

TECHNIQUES USED
Dropping in colors,
 page 17
Wet-on-dry, page 18
Masking fluid,
 page 21
Lifting out, page 22
Salt spatter, page 25

1 Draw the composition in pencil and mask out the heather in the foreground using masking fluid.

2 Mix up Winsor blue and Venetian red, and use to paint in the distant hills on the horizon and the mountains on the right. Drop in clear water where the sunburst is to appear. Work on the shadows, rocks, and trees with the same blue-gray mix, using the side of the #7 round brush (inset).

3 Wash over the entire top half of the paper with the blue-gray mix. Add more detail and texture to the rocks where needed, working wet-on-dry with the same wash.

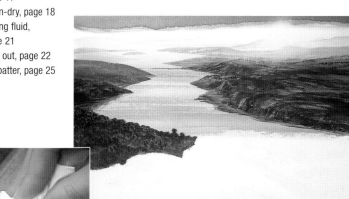

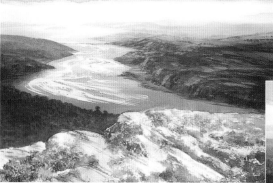

6 Add some of the heather color to the clouds above, then build up the foreground heather and rocks, dropping dark greens into the shadows. Protect the rest of the painting with tissues, and spatter more of the red-and-purple mix into the heather. Add more detail to the rocks with the #3 round brush. When dry, remove the masking fluid from the water.

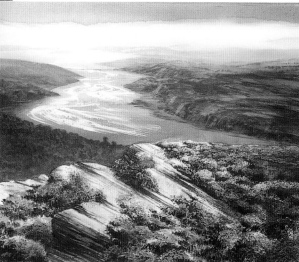

4 Mix some sap green into the blue-gray wash, and take this color over all the land areas, lightening the color as it recedes into the distance. Add more washes to the sky to produce a layered cloud effect. Lift off the sunburst with clear water and a tissue (inset), adding a touch of orange for the glow.

5 Brush the blue-gray over the rocky outcrops in the foreground. While still damp, drop in Venetian red and dioxazine violet, and sap green, and the blue-gray mix. Sprinkle salt into the wet paint and let dry, then remove the masking. Paint on more masking fluid to imitate the currents in the water and, when dry, add more blue to the blue-gray mix and wash over the hills and water. Blend in orange and Venetian red on the hills below the sunburst.

The Lake District

The main theme of the painting is the contrast between the warm golden light on the trees and the cool, distant hills and water, colors that are reflected in the cows. The red cow has been moved slightly to act as a "punctuation mark" beneath the vertical of the water.

PAINTS

Naples yellow
Cerulean blue
Cobalt blue
Permanent rose
New gamboge

MATERIALS

Cold-pressed
 watercolor paper,
 140 lbs (300 gsm),
 pre-stretched
Round sable brushes,
 #20 and #6
Synthetic brush, #14
Small natural sponge

TECHNIQUES USED

Dropping in colors,
 page 17
Wet-on-dry, page 18
Lifting out, page 22

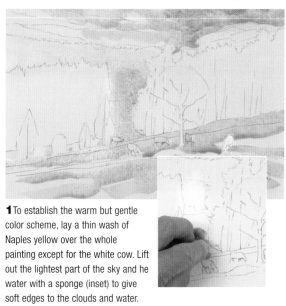

1 To establish the warm but gentle color scheme, lay a thin wash of Naples yellow over the whole painting except for the white cow. Lift out the lightest part of the sky and he water with a sponge (inset) to give soft edges to the clouds and water.

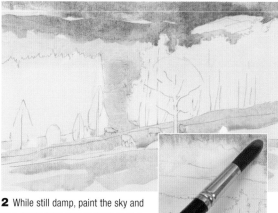

2 While still damp, paint the sky and water with fairly strong cerulean blue (inset), and work some of this color over the foreground to create bands of shadow. Add cobalt blue with a touch of permanent rose for the clouds, and when the paper begins to dry, use the same mixture for the hills, leaving a strip of yellow above them.

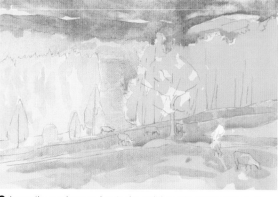

3 Leave the previous washes to dry and then take a strong wash of new gamboge over the trees and foreground, leaving lighter areas here and there. Do not soften the edges of the wash, because it needs to be crisp and clear on the sunlit edges.

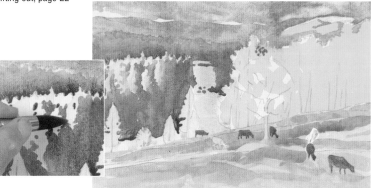

4 Mix a green from new gamboge and cobalt blue, and when the yellow wash is dry, apply this color to all of the trees in shadow, adding more blue to the distant ones and more yellow to the nearer ones (inset). Drop a little permanent rose into the nearest trees to enrich the shadow, and add a touch of the red behind the tops of the trees. Paint the dark cows with the mixture of cobalt blue, new gamboge, and permanent rose, and add some shadows to the white cow with a mix of cobalt blue, painting the grass around it with permanent rose and new gamboge.

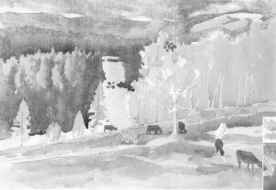

5 Now paint the darker areas of the group of trees on the right with overlaid glazes of permanent rose and new gamboge, preserving the trunks and sunlit clumps as the original yellow.

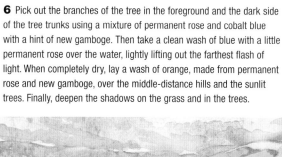

6 Pick out the branches of the tree in the foreground and the dark side of the tree trunks using a mixture of permanent rose and cobalt blue with a hint of new gamboge. Then take a clean wash of blue with a little permanent rose over the water, lightly lifting out the farthest flash of light. When completely dry, lay a wash of orange, made from permanent rose and new gamboge, over the middle-distance hills and the sunlit trees. Finally, deepen the shadows on the grass and in the trees.

Fall Reflections

The main change from the photograph is an overall reduction in strength of the tones, providing a gentler atmosphere. The very strong blues and oranges, although exciting in a photograph, are less suitable for the medium of watercolor.

PAINTS

Cobalt violet
Cobalt blue
Cerulean blue
Ultramarine
Permanent magenta
Raw sienna
Burnt sienna
Raw umber
Aureolin
Viridian

MATERIALS

Cold-pressed paper,
 140 lbs (300 gsm),
 pre-stretched
2B pencil
Masking fluid
Synthetic brush
Dip pen
Round sable brushes,
 #3, #5, and #8
Eraser

TECHNIQUES USED

Wet-in-wet, page 18
Wet-on-dry, page 18
Masking fluid,
 page 21

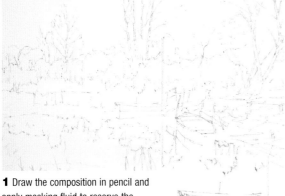

1 Draw the composition in pencil and apply masking fluid to reserve the small linear highlights on the trees and reflections. Use Step 2 as a guide for the areas to be masked. Apply the fluid using the synthetic brush (inset), washing the brush out at regular intervals to prevent the fluid from drying out and clogging the hairs. If you find the lines are not sufficiently fine, use a dip pen or a small pointed implement such as a cocktail toothpick.

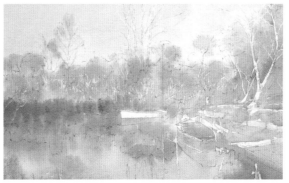

2 Prepare large pools of color for the initial wet-in-wet washes. For the water and sky, you will need cobalt violet; cobalt blue; a mix of cerulean blue and cobalt violet; and a mix of ultramarine, permanent magenta, and raw sienna. Apply the colors to premoistened paper, leaving small areas of dry paper for the clouds. For the trees and reflections, make various mixes of raw sienna, cobalt violet, burnt sienna, raw umber, and permanent magenta plus a touch of cobalt blue. For the grass, use aureolin and raw sienna (for the sunlit area) and mixes of raw sienna, cerulean blue, raw umber, cobalt blue, ultramarine, and viridian. For the shadows and inside of the boat, use mixes of ultramarine, permanent magenta, and raw sienna.

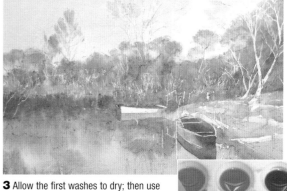

3 Allow the first washes to dry; then use the same colors again, but this time work on dry paper. Let the colors blend wet-in-wet within each separate area. To paint the boats, make new mixes of cerulean blue; raw sienna with a touch of cobalt violet; and cerulean blue, raw umber, and a touch of cobalt violet (inset).

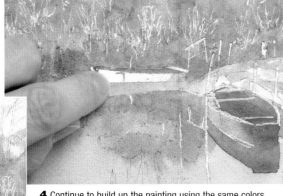

4 Continue to build up the painting using the same colors. Remove the masking fluid and erase some of the pencil lines (inset).

5 Glaze over the more distant boat to make it recede into the distance. Paint in the mast using a fine brush and the colors mixed previously for the boats. Glaze over any other highlights that appear too glaring, because too much pure white looks unnatural in a landscape.

6 In the final stages, all that is needed is a little more detail and definition. Develop the trees against the sky, using the mixes prepared previously for the trees. Paint in small branches and twigs using the small brush and the mixes used in Step 3 for the boats.

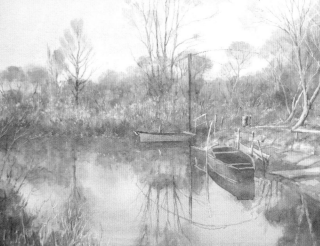

Quiet Reflections

This composition is relatively close to that of the photograph, but important changes have been made in order to project a powerful sense of atmosphere, such as the soft wet-in-wet treatment of the main elements. The artist has also omitted the small white shapes of the clouds and their reflections, so that attention is not taken from the landscape.

PAINTS
Cobalt blue
Permanent rose
Cadmium yellow
Yellow ochre
Violet ultramarine
Indian red
Bright green
Ultramarine blue
Chrome oxide green

MATERIALS
Cold-pressed
 watercolor paper,
 300 lbs (640 gsm)
Round sable brushes,
 #9, #5, and #2
Rigger brush

TECHNIQUES USED
Overlaid washes,
 page 16
Wet-in-wet, page 18
Wet-on-dry, page 18
Masking fluid,
 page 21

1 Using a sharp HB pencil, sketch in the main structure of the landscape, drawing the overhanging branches in more detail. This will offer an accurate guide for the placing of the masking fluid.

2 Mask out all of the carefully drawn shapes in the overhanging trees, together with the corresponding reflections, as well as the light points of the trees. Wet the sky and water areas with a large brush and clean water, and apply two graded washes of cobalt blue, making both weakest in the central area. Let dry.

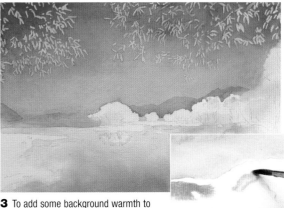

3 To add some background warmth to the distant mountains, the trees behind the water, and the left side of the lake, wet the areas with clean water and drop in permanent rose in varying strengths (inset). Allow the color to bleed. It is important to aim at a soft effect within the wetted areas, but make sure the treetops have a hard edge.

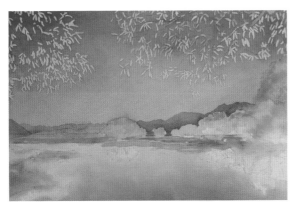

4 Using a #5 brush, work mixes of cadmium yellow and yellow ochre for tree shapes, violet ultramarine for the hills, and Indian red for the foreground marsh area, adding touches of bright green throughout for the sunlit grasses and foliage.

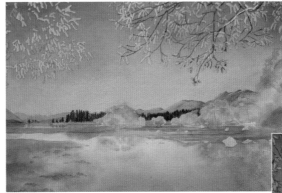

5 Continue building up these colors, working wet-in-wet where you want a soft transition, as in the water reflections or within the tree shapes; work wet-on-dry where hard edges are required. For the dark pine trees, mix ultramarine with chrome oxide green, and use the tip of the brush to paint the little conical shapes, allowing them to dry before adding shadows of ultramarine on the right side. Remove the masking fluid.

6 Using a #3 brush and fairly dry mixes of cadmium yellow and yellow ochre, paint in the individual leaf shapes, adding touches of bright green and Indian red. Then mix a dark brown from ultramarine, violet, ultramarine blue, and cobalt blue, and paint the shadow areas on the trees and rocks. Use a rigger brush and a dilute mix of this color, plus Indian red, to paint the spreading branches and flickering shadows on the leaves, and finally lay a very pale wash of cobalt blue over the water to unite the watery reflections.

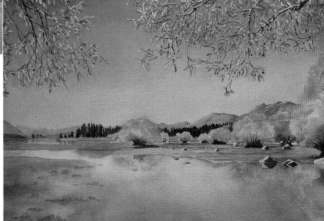

Poppy Fields

Notice how the artist has arranged the poppies in two opposing diagonals so that they lead the eye to the monastery building, increasing the size of the foreground flowers to make them stand out.

PAINTS

Indian yellow
Permanent rose
Quinacridone sienna
Cobalt violet
Cobalt blue
Manganese blue
Aureolin
Peacock blue
Ultramarine
Quinacridone gold
New gamboge
Scarlet lake
Winsor red
Alizarin crimson

MATERIALS

Cold-pressed paper,
 140 lbs (300 gsm),
 pre-stretched
¼-in. (6-mm) flat
 synthetic shader
 brush
1-in. (2.5-cm) flat
 (Aquarelle-type)
 brush
Squirrel quill brushes,
 #8, #6, #4, #2, #1,
 and #00

TECHNIQUES USED

Dropping in colors,
 page 17
Lifting out, page 22
Negative painting,
 page 23

1 The contrast of the deep, rich green of the hillsides and the warm stone of the old monastery makes the building the ideal focal point. It can be helpful to make a tonal study, as shown here, to establish the placing of light and dark shading. When you are sure of the composition, make a careful drawing to ensure that the perspective is correct and that the buildings are in proportion to the rest of the design area (inset).

2 To produce a warm, sunny glow on the monastery, use Indian yellow mixed with permanent rose as the basic mixture; then suggest the texture of the roofs by stippling on quinacridone sienna using a ¼-in. (6-mm) flat synthetic brush. Color the stone surfaces using a mix of permanent rose and cobalt violet; then while still damp, drop in small amounts of cobalt blue to the shaded areas. Paint in the windows and detail with permanent rose. Use a small brush and keep the large washes wet and free; don't worry if they flow into the background, because the dark greens will cover the paler colors.

3 Let the first washes dry before painting in the foliage adjacent to the buildings. Begin with a mix of manganese blue and aureolin. While the paint is still wet, drop in a mix of cobalt blue and aureolin yellow, allowing the two pigments to blend. Then apply cobalt blue with Indian yellow on the shady side of the foliage, again letting the colors blend.

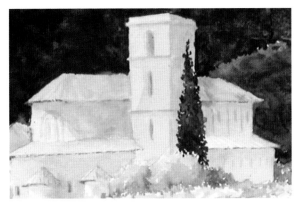

4 Now bring in strong, dark greens. Paint the mid-green of the right-hand hill with a mix of ultramarine and Indian yellow. Use scrubbing movements of the brush to create variations in tone and texture. Use the same technique for the hills on the left, but this time use a mix of ultramarine and new gamboge to give a sunnier green, gradually darkening the mix with the previous green mixture. Behind the monastery building, use a mixture of ultramarine and quinacridone gold, with brushstrokes of peacock blue for variety.

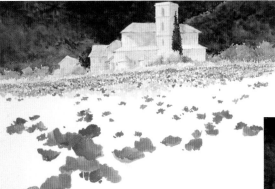

5 Paint the poppies in the foreground with strong scarlet lake, dropping in Winsor red for the darker areas. Dot in the background flowers with scarlet lake and a mix of this and cobalt violet, adding small touches of alizarin crimson for variety and depth. Work the foreground poppies from front to back and those in the background from back to front; this will make it easier to achieve the correct levels of recession and diminution.

6 Paint the field with aureolin, and mixes of aureolin and cobalt blue, and new gamboge with cobalt blue. For the back of the field, use short, overlapping horizontal strokes. For the foreground, make longer brush movements, starting with lighter mixtures and ending with darker mixes of ultramarine with new gamboge, and the same blue with Indian yellow. Use a damp brush to lift out highlights on the large poppies, then use the same brush to redefine the edges of the leaves.

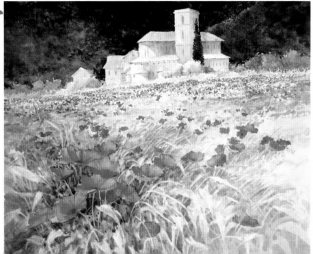

Heather-clad Moors

Here the artist has made important changes to the composition. The main tree has been moved to a less central position, then slanted to link with the other trees. A hint of a path on the left leads the eye to the tree line. A small cottage has been added on the right to provide additional interest.

PAINTS
Quinacridone violet
Cerulean blue
Titanium white
 (acrylic)
Ultramarine
Cerulean blue
Yellow ochre
Cadmium red

MATERIALS
Cold-pressed or
 rough-textured
 paper, 140 lbs,
 pre-stretched
Pencil
Masking fluid
3-in. (7.5-cm) flat
 squirrel-hair brush
1-in. (2.5-cm) flat
 natural-hair brush
#6 bamboo round
 brush
Sponge
Razor blade

TECHNIQUES USED
Wet-in-wet, page 18
Masking fluid,
 page 21
Scratching off,
 page 23
Sponge painting,
 page 24

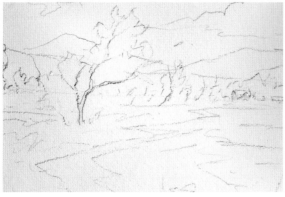

1 Draw the composition in pencil, concentrating on the main shapes and lines of movement. Mask out the small building on the right.

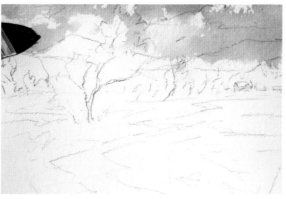

2 Moisten the sky area and lay in the warm red-brown tones. Use a mix of quinacridone violet, cerulean blue, and titanium white. Loosely wash in the blue sky areas with a mix of ultramarine and cerulean blue in varying strengths. Leave white areas to form the clouds.

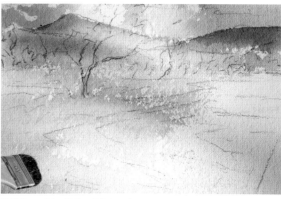

3 Using a 3-in. (7.5-cm) flat squirrel-hair brush, lay a wash of yellow ochre over the mountain area, the middle ground, and the foreground. Leave the large area of purple foliage unpainted. Work on dry paper, pulling the brush rapidly over the surface to leave white specks showing. Before the wash dries, stroke in cerulean blue to define the mountains. Drop some blue into the foreground to achieve a green hue.

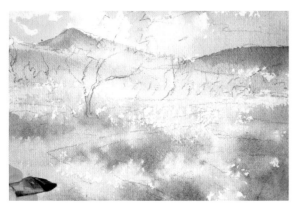

4 Moisten the paper in the foreground. Mix up a wash of quinacridone violet and ultramarine and float this in to achieve the purple foliage. Take care not to cover all the paper.

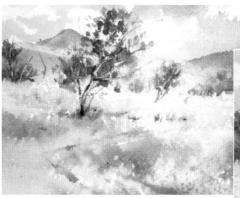

5 Remove the masking from the cottage and paint in the roof using dilute cadmium red. With the tip of a bamboo or small round brush, draw a few broken lines along the right edge of the path. This will help lead the eye into the center of the picture. Finally, use the sponge to add texture to the foreground.

6 Erase the pencil lines; then use a razor blade to gently lift out a few white areas in the foreground and on the large tree and the cottage.

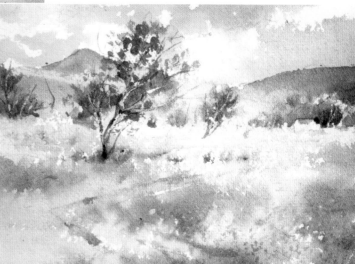

Sunset over Mountains

The photographer's achievement is to capture the play of light on the mountains and hills. The artist has muted the brilliant sunset to give a more subtle glow of color over the hills.

PAINTS
Winsor blue
Venetian red
Dioxazine violet
Naples yellow
Olive green

MATERIALS
Watercolor board
Pencil
Flat brushes,
 2 in. (5 cm) and
 3 in. (7.5 cm)
Round brushes,
 #12 and #3
Tissue
Dip pen

TECHNIQUES USED
Overlaid washes,
 page 16
Wet-on-dry, page 18
Directional
 brushstrokes,
 page 20
Lifting out, page 22

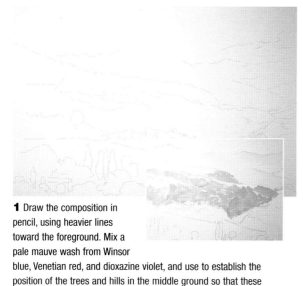

1 Draw the composition in pencil, using heavier lines toward the foreground. Mix a pale mauve wash from Winsor blue, Venetian red, and dioxazine violet, and use to establish the position of the trees and hills in the middle ground so that these don't get lost under subsequent washes.

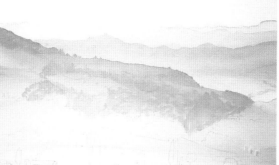

2 With a thin wash of the same color, paint in the successive layers of hills, starting with the most distant and taking the color down to the bottom of the picture. Let each layer dry before adding the next, and blend with clear water at the base. Use the point of the large round brush to draw in the tops of the hills, quickly changing to the 2-in. (5-cm) flat brush as you continue downward.

3 Using the 3-in. (7.5-cm) flat brush (which covers a large area with each stroke and avoids disturbing the layer beneath), lay down Naples yellow, blending in Venetian red as you move downward. Carry this all the way to the bottom. The effect of this wash is to soften and unify the distant hills, but be careful not to overwork. Use the small round brush to work in olive green mixed with some of the mauve wash at the base of the hills (inset).

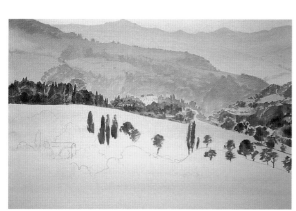

4 Mix olive green with some of the mauve wash and paint in the trees that separate the middle ground from the distant hills. Drop in darker tones for the shadows. Paint the nearer trees with the same mix, using both the large and small round brushes.

5 With the same mix, work over the middle hill and down to the base of the painting. Use the 3-in. (7.5-cm) flat brush to give long, sweeping strokes (inset).

6 With a darker mix of the olive green and mauve wash, build up the trees and buildings in the foreground using the small round brush. Using clear water, a tissue, and the dip pen, lift a rim of light from around the trees at the base of the hills.

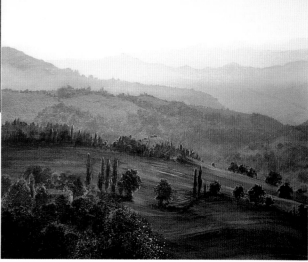

Summer on the Moors

The most notable change from this photograph is the exaggeration of the foreground grasses. The foreground is now full of movement and interest. Notice also how the backruns in the sky echo the shapes of the trees.

PAINTS

Cerulean blue
Naples yellow
Dioxazine purple
Payne's gray
Sap green
Yellow ochre
Cadmium red
Raw umber

MATERIALS

Cold-pressed paper,
 300 lbs (640 gsm)
2B pencil
#10 round brush
Gum arabic
#1 squirrel-hair brush
#4 rigger brush
Plastic painting knife
Small natural sponge

TECHNIQUES USED

Graded and
 variegated washes,
 page 16
Overlaid washes,
 page 16
Directional
 brushstrokes,
 page 20
Sponge painting,
 page 24

1 Draw the composition in pencil. Use the #10 brush to apply a cerulean blue wash to the sky (inset), leaving white paper to form the clouds. When dry, paint a pale wash of Naples yellow over part of the clouds, then leave to dry again before painting in the darker clouds with mixes of dioxazine purple and Payne's gray. Add gum arabic to the mix so that any hard edges can be softened easily by adding water. When the washes begin to dry, create backruns by dropping in clean water using the #10 round brush.

2 Using the #10 brush, lay a variegated wash to establish the color of the landscape. Start with a light mix of sap green and yellow ochre. Toward the bottom of the picture, change the mix to yellow ochre with a little cadmium red.

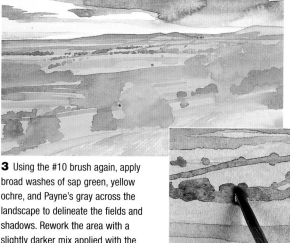

3 Using the #10 brush again, apply broad washes of sap green, yellow ochre, and Payne's gray across the landscape to delineate the fields and shadows. Rework the area with a slightly darker mix applied with the brush to suggest trees, shrubs, and hedgerows (inset).

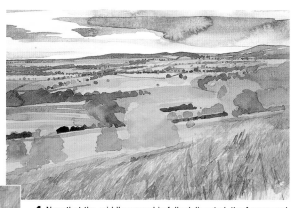

4 Now that the middle ground is fully delineated, the foreground can be built up in more detail. Adding in some gum arabic, use a mix of yellow ochre, cadmium red, sap green, and raw umber to make long, sweeping strokes across the area with the rigger brush. The gum arabic will make the paint more viscous so that the brush marks stay in place. Once dry, create an additional series of lines by reworking the area with a plastic painting knife dipped into the same mix (inset).

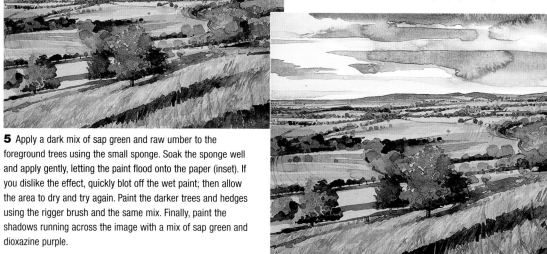

5 Apply a dark mix of sap green and raw umber to the foreground trees using the small sponge. Soak the sponge well and apply gently, letting the paint flood onto the paper (inset). If you dislike the effect, quickly blot off the wet paint; then allow the area to dry and try again. Paint the darker trees and hedges using the rigger brush and the same mix. Finally, paint the shadows running across the image with a mix of sap green and dioxazine purple.

6 Complete the painting by sponging over the trees again, this time using a darker green made by adding more raw umber and some dioxazine purple to the previous mix. Use the rigger brush to add detail, such as the patterns in the fields signifying the crops and tractor wheels.

Folded Mountains

This artist has selected to focus on the central part of the photograph, which has a good sky and foreground, and has made more of the shapes of the clouds so that they echo the sweeping curves of the foreground. To lead the eye into the picture, she has used the road snaking through the strong shape formed by the shadow of the nearest hill.

PAINTS

Cerulean blue
Cobalt blue
Raw sienna
Scarlet lake
Aureolin yellow

MATERIALS

Cold-pressed
 watercolor paper,
 300 lbs (640 gsm),
 pre-stretched
Round synthetic
 brushes, #16 and
 #10
Small natural sponge

TECHNIQUES USED

Graded washes,
 page 16
Overlaid washes,
 page 16
Lifting out, page 22

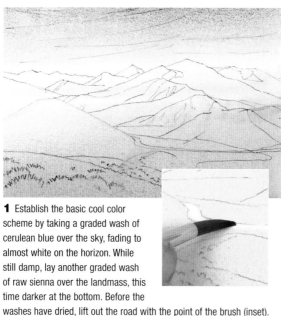

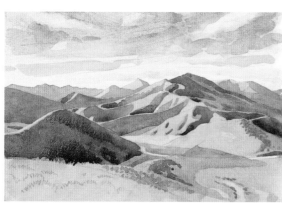

1 Establish the basic cool color scheme by taking a graded wash of cerulean blue over the sky, fading to almost white on the horizon. While still damp, lay another graded wash of raw sienna over the landmass, this time darker at the bottom. Before the washes have dried, lift out the road with the point of the brush (inset).

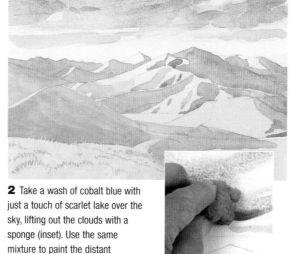

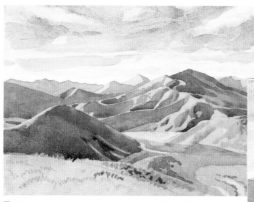

2 Take a wash of cobalt blue with just a touch of scarlet lake over the sky, lifting out the clouds with a sponge (inset). Use the same mixture to paint the distant mountains and all the shadows, including some lightly suggested shadows under clouds.

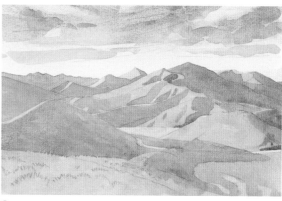

3 When the previous colors have dried, take a wash of raw sienna and aureolin yellow over the middle and near the hills and the foreground, lifting out the pale curve in the immediate foreground. This small, nonspecific shape plays an important part in leading the eye into the picture and echoing the curve of the road.

6 To complete the painting, add a little more detail to the foreground, suggesting the recession in the clumps of grass with raw sienna touched with scarlet lake, but don't overdo it—the mountains are the focal point.

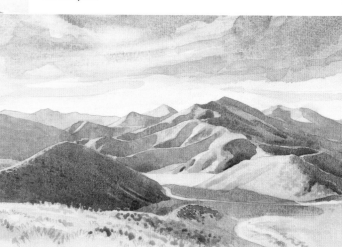

4 Darken the right-hand sides of the hills with the same mixture used in Step 2, increasing the proportion of scarlet lake for the nearest hill so that it comes forward in space.

5 Use raw sienna to model the curves of the hill slopes, and lift out some folds on the right side of the nearest hill. Dot in some touches of red in the foreground with the point of the brush and a mix of scarlet lake and raw sienna.

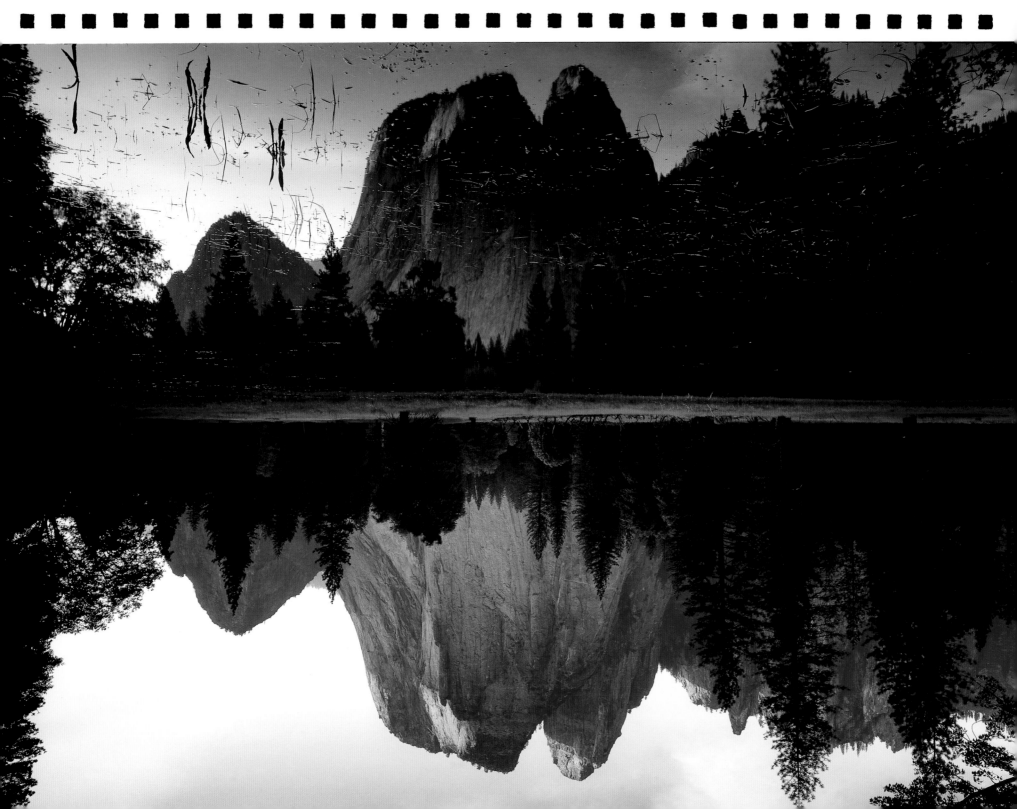

Peaks in Yosemite

The composition of this photograph worked well as a basis for a painting. The artist has introduced a lighter area of grass between the trees to help lead the eye into the picture, and has given additional atmosphere to the scene by exaggerating the misty effect at the bottom of the mountains and their reflections.

PAINTS
Winsor blue
Venetian red
Dioxazine violet
New gamboge
Permanent rose
Sap green

MATERIALS
Watercolor board
Round brushes, #10
 and #7
2-in. (5-cm) flat brush
Dip pen
HB and 2B pencils
Tissues

TECHNIQUES USED
Graded and
 variegated washes,
 page 16
Overlaid washes,
 page 16
Lifting out, page 22

1 Sketch in the scene with pencil, using heavier lines around the outlines of the trees so that they will show up after several washes.

2 Carefully working around the patches of light on the mountains and their reflections, lay an uneven, allover blue-violet wash of Venetian red and Winsor blue with a touch of dioxazine violet, grading to clear water to the right of the mountains. Roughly echo dark patches in the sky with patches of darkness in the water.

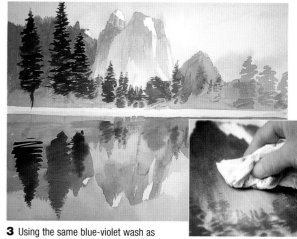

3 Using the same blue-violet wash as before, block in the mid-tones on the mountains and fill in the positions of the trees before the pencil lines are lost under washes. To give the suggestion of mist behind the trees, lift out some of the color with a tissue dampened with clean water (inset).

6 Again with the large flat brush, wash clear water over the right side and lay a darker wash of blue-violet over the rest of the painting, making it darker on the water. Mix sap green into the blue-violet and paint in the grass with the #10 round brush. Paint the trees and their reflections with a denser mix of the same colors and the #7 brush, then wash the brush and use the point to lift out some ripples from the water. Finally, lift out a little more mist from the cliff face.

4 Use the dip pen to draw in small cracks on the rock face. This gives a finer line than a brush and is easier to control.

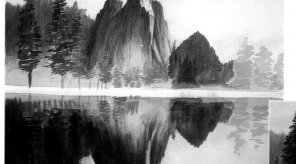

5 Build up the forms of the rock faces using darker mixes of the blue-violet wash, then lay in a warmer tone in the sky and reflections with a mixture of new gamboge and permanent rose, carrying this right across the mountains, including the light-struck areas. Reflections are always darker than the object reflected, so lay another wash of blue-violet over the water with the 2-in. (5-cm) flat brush.

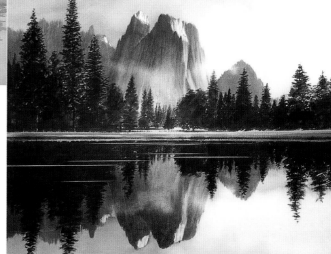

Sunlit Crags

The horizontal line of the river and strip of beach provides an anchor for the upward-thrusting near verticals of the rocky crags. The artist has simplified the foliage to focus attention on the rocks.

PAINTS

Cobalt blue
Rose madder
Madder brown
Phthalocyanine blue
Manganese violet
Pure yellow
Indian yellow
Chrome orange
Manganese blue
Ultramarine blue
White gouache

MATERIALS

Rough watercolor
 paper, 300 lbs
 (640 gsm)
Sable brushes, #12
 and #8
Rigger brush, #4

TECHNIQUES USED

Surface mixing,
 page 17
Wet-in-wet, page 18
Wet-on-dry, page 18
Directional
 brushstrokes,
 page 20

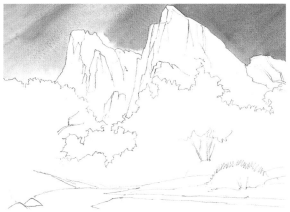

1 Draw the scene in pencil, then turn the board upside down, wet the paper in the sky area, and drop in ultramarine blue, cobalt blue, and rose madder, using diagonal brushstrokes to give a sense of movement.

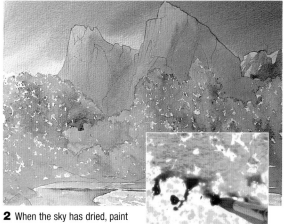

2 When the sky has dried, paint the rock face with pure yellow, dropping in Indian yellow, chrome orange, madder brown, and a little manganese violet, allowing the colors to merge wet-in-wet. With a loaded brush, flick first yellows and then blues with a touch of rose madder into the tree areas (inset).

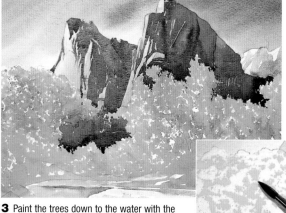

3 Paint the trees down to the water with the yellows and blues used previously, touching on the paint lightly with the tip of the brush (inset). Then paint the strip of water with the sky colors and flick some Indian yellow and rose madder over the foreground.

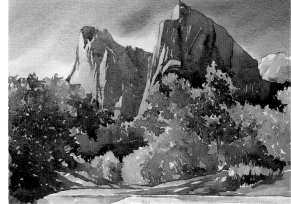

4 Paint in the shadows of the mountains with madder brown, cobalt blue, manganese violet, and manganese blue, applying each color directly and letting them mix on the paper rather than premixing. Keep the board tilted so the paint runs down the paper and mixes as it goes. Paint around the tree lines in a random manner, using the tip of the brush.

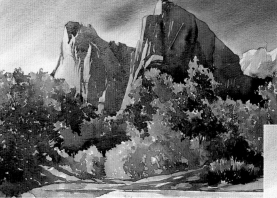

5 Add darks to the trees with the darker green mix of phthalocyanine blue, madder brown, and pure yellow, adding more madder brown, especially on the left, to echo the tones and colors of the mountains. Keep the painting loose, softening edges here and there, and leaving patches of the original light greens showing to portray a sense of light.

6 Lift out some paler reflections in the water and drag some white gouache across to give a sparkle. Work back into the mountains, punching in some strong darks of phthalocyanine blue, madder brown, and pure yellow with the rigger brush to describe the forms of the strata. Take care to vary the thickness and strength of these linear brush marks, and keep the sunlit sides free of shadow. Finally, add more darks to the foliage where needed, and paint the tree trunks on the right with a strong mix of cobalt blue and madder brown.

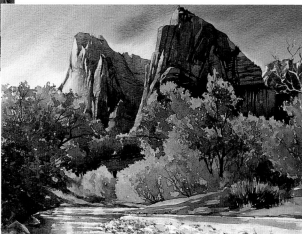

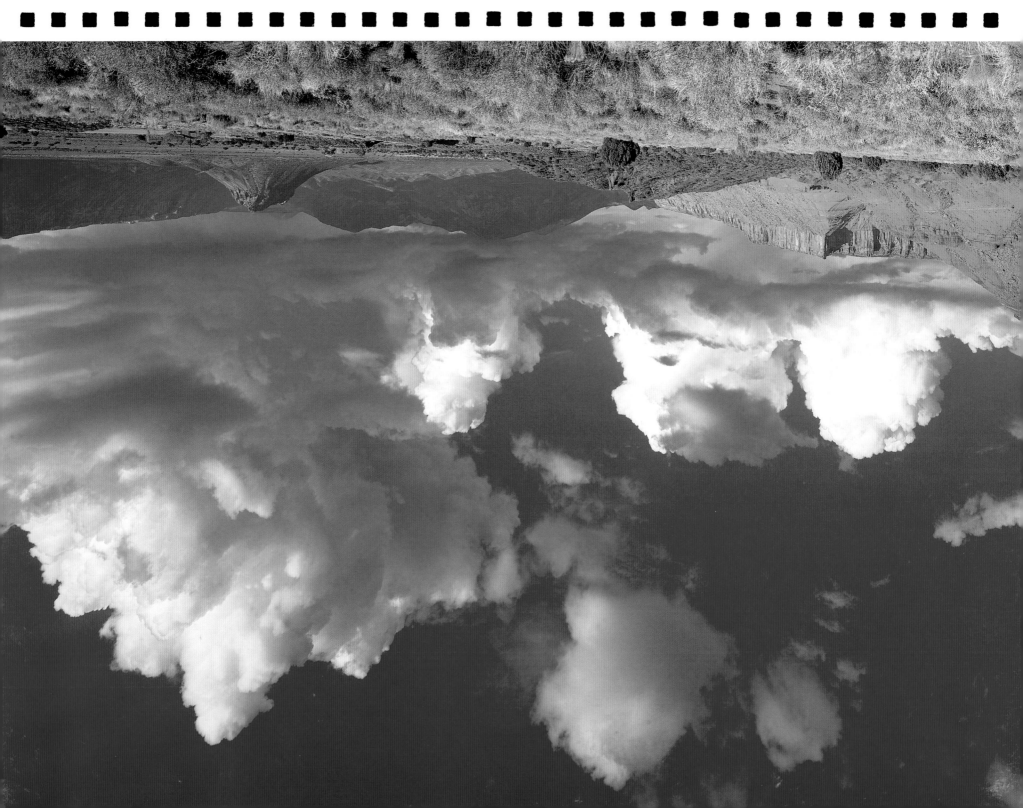

Cloudscape with Hills

The artist has softened the colors to produce an interpretation better suited to the watercolor medium, and more greens have been introduced into the foreground. In addition, much of the detail has been omitted.

PAINTS

Dioxazine purple
Payne's gray
Cobalt blue
Cerulean blue
Sap green
Yellow ochre
Raw umber
Brown madder
Naples yellow

MATERIALS

Cold-pressed paper,
 300 lbs (640 gsm)
Gum arabic
#7 round sable brush
1-in. (2.5-cm) flat
 brush
Rigger brush
Dip pen

TECHNIQUES USED

Overlaid washes,
 page 16
Backruns, page 17
Granulation, page 19
Descriptive
 brushwork, page 20

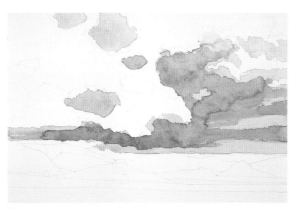

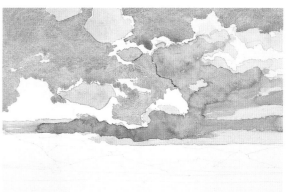

1 First paint in the clouds. Do this before adding in the sky. Mix dioxazine purple, Payne's gray, and cobalt blue to create a steely blue-gray for the shaded areas. Make sure the mixture is not too dark. Add gum arabic to the mix so that any hard edges can be softened later by adding water. Use a #7 brush, rolling it rather than making a clean stroke; this will produce broken edges (inset).

2 Let the wash dry, then intensify the color to introduce some darker clouds, rolling the brush as before and dropping in clean water to form backruns.

3 Once the clouds are dry, mix cobalt and cerulean blue and paint the sky. Use the same #7 brush and take care to apply around the edges of the clouds. Cerulean blue is one of the pigments that tends to granulate on application, adding additional interest.

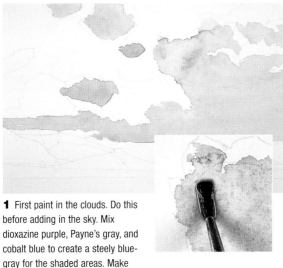

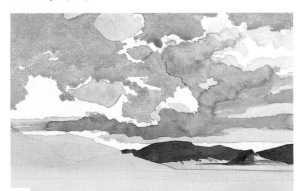

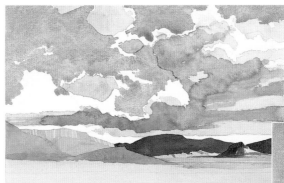

6 Mix a dull green using sap green and raw umber, then use a rigger brush to carefully paint in the band of green that runs across the middle distance. Use the same brush and a mix of raw umber, sap green, and yellow ochre to draw in the flowing lines of the grasses. Once dry, rework the grasses using a dip pen. The tufts of grass are important to add foreground interest. Use several separate layers of pen work, letting each dry before applying the next.

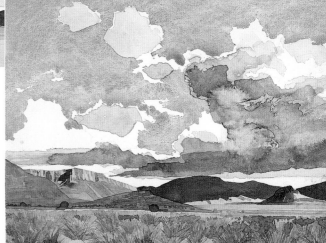

4 Mix a pale green wash of sap green, yellow ochre, and Payne's gray with plenty of water and apply to the distant hills. Once dry, overpaint with a darker gray made from Payne's gray and a little raw umber. Leave to dry before applying a light orange mix of brown madder, yellow ochre, and Naples yellow over the cliffs on the left and down to the foreground. To form the hill in the center, allow a mix of light and dark gray to run together (inset).

5 Intensify the color of the cliffs with a mix of brown madder, yellow ochre, and some raw umber. Paint in the linear shadows cast by the rocky crags, using the edge of a flat brush to create thin lines. Use the darker orange mix for the shallower fissures, and the green-gray mix used for the hills to achieve the main shadow.

Mountain Lake

What you leave out of a painting is as important as what you put in, and the artist here has produced a simple but strong composition by omitting much of the detail in the lake. She has also balanced the diagonals of the tree line with the horizontals of the sky and its reflections.

PAINTS
Winsor blue
Venetian red
Dioxazine violet
Cerulean blue
Rose madder
Winsor orange
Sap green

MATERIALS
Watercolor board
Pencil
Flat brushes,
 2 in. (5 cm) and
 3 in. (7.5 cm)
Round brushes,
 #7 and #3
Dip pen

TECHNIQUES USED
Overlaid washes,
 page 16
Descriptive
 brushwork, page 20
Lifting out, page 22

1 Draw the composition in pencil, using a heavier line for the trees so that they will continue to show after several washes.

2 Mix a gray-violet from Winsor blue, Venetian red, and dioxazine violet, and block in the mountains and their reflections with the #7 round brush. Use the same mix with the small round brush to add details, fissures, shadows, and texture (inset).

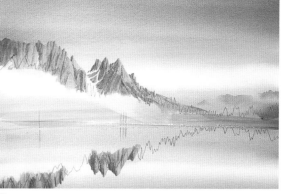

3 Add cerulean blue to the gray-violet mix, then use the 3-in. (7.5-cm) flat brush to paint this color over the whole picture. Lift out some of the color on the right-hand side of the sky and blend in a little rose madder. Do the same in the water to create the bands of color in reverse.

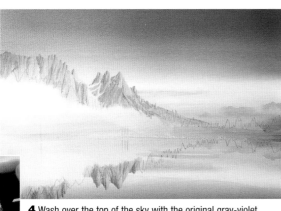

4 Wash over the top of the sky with the original gray-violet mix, blending into clear water toward the horizon, then repeat in the reflections. Add a flash of rose madder and Winsor orange in both the sky and the reflections using the 2-in. (5-cm) flat brush (inset).

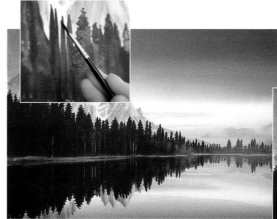

5 Make another strong mix of the gray-violet with the addition of sap green and use to paint the trees and their reflections. Use the #7 round brush to block in the basic shapes, lightening the color as it recedes into the distance, then add branches and details with the #3 brush (inset).

6 Use the same dark green mix to paint in the reeds in the foreground, making short strokes using the #3 round brush. Finally, work a few lines over the top with the pen dipped into the watercolor.

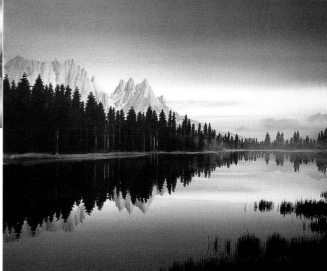

Olive Grove in Spain

The main change made to this composition was simplifying the background hills to avoid competition with the olive trees. The colors and tones have been considerably altered, however, with the near-white highlights on the trees creating an airy, sunlit effect.

PAINTS

Raw sienna
Cobalt blue
Raw umber
Aureolin
Burnt sienna
Alizarin crimson
Ultramarine
Light red

MATERIALS

Cold-pressed paper,
 140 lbs (300 gsm)
#8 squirrel mop
 brush
4B pencil

TECHNIQUES USED

Graded and
 variegated washes,
 page 20
Wet-on-dry, page 22
Descriptive
 brushwork, page 24

1 Draw the composition in pencil, concentrating on the shapes made by the lines of trees and their proportions in relation to the small trees at the back. Apply a slightly variegated wash to the sky, using a mix of raw sienna, cobalt blue, and raw umber. Paint the fields with aureolin and raw umber, working around the trees (inset).

2 Paint the darker fields with a mix of burnt sienna and raw umber; then mix aureolin, raw umber, and burnt sienna and wash over the areas of sunlit soil. Use various mixes of aureolin and cobalt blue for the trees and green fields in the distance. Wash over the olive trees with pale mixes of raw sienna and cobalt blue, and aureolin and cobalt blue.

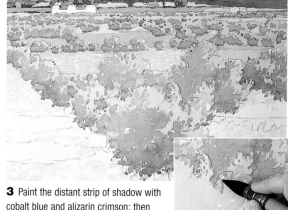

3 Paint the distant strip of shadow with cobalt blue and alizarin crimson; then begin to build up the forms of the trees using mixes of raw sienna and cobalt blue, and aureolin and cobalt blue. Work with the tip of the brush, using small, dabbing motions (inset). When the trees are complete, dot pale flecks of raw sienna onto the soil areas to create texture.

6 To complete the painting, dot pale flecks of burnt sienna onto the soil areas for extra texture and add a few more shadows to the foliage of the olive trees using a mix of ultramarine and light red.

4 Paint the roofs of the buildings with raw sienna and alizarin crimson. Add the shadows of the live trees using a strong mix of ultramarine and light red. This produces a muted purplish hue that provides complementary contrast to the yellow of the soil.

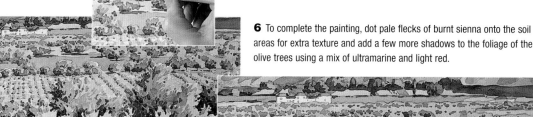

5 Paint the lines of crops in the middle field with a mix of aureolin and cobalt blue. Use a mix of ultramarine and light red for the flecks of shadow on the leaves, and dot the same color onto parts of the ground (inset). Remember to make the brush marks smaller toward the distance to create perspective. Paint in the doors and windows on the buildings, using light brushstrokes.

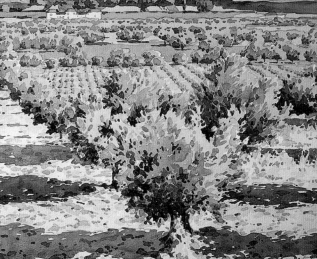

Gorse in Flower

The artist has interpreted the foreground gorse bushes in an interesting and personal way. She has concentrated on their overall shape, omitting much of the detail, so that there is a gentler transition from foreground to middle ground.

PAINTS

Cadmium yellow
Cobalt blue
Permanent rose
Ultramarine violet
Bright green
Chrome oxide green
Indian red
Ultramarine blue
Sap green
Yellow ochre

MATERIALS

Cold-pressed
　watercolor paper,
　300 lbs (640 gsm)
Pencil
Masking fluid
Brushes, #9, #5,
　and #2
Rigger brush
Tissues

TECHNIQUES USED

Graded and
　variegated washes,
　page 16
Wet-in-wet, page 18
Masking fluid,
　page 21
Lifting out, page 22

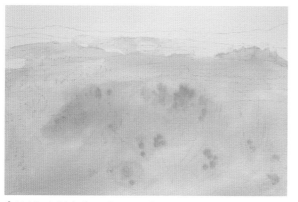

1 Lightly sketch in the main points of the landscape. Wet the foreground hills with clean water, then drop in a wet wash of cadmium yellow, using the #9 brush. Wait until the wash is almost dry before adding more color to the bright flower spikes in the foreground.

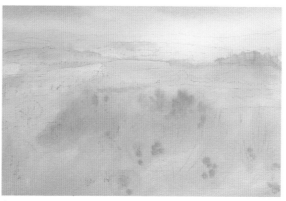

2 Once dry, wet the sky area and the distant hills, then apply a variegated wash of cobalt blue at the top, blending to permanent rose at the lower edge. Apply masking fluid to some areas of the now dry yellow flower spikes.

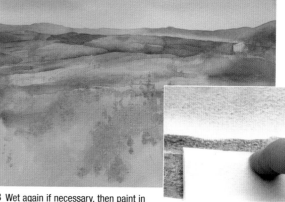

3 Wet again if necessary, then paint in the distant hills with ultramarine violet.
Add bright green to the nearer hills and touches of chrome oxide green and Indian red to both areas. Paint the villa with a pale wash of Indian red. Add a more intense mix of cadmium yellow to the foreground, allow to dry, then mask out more flowers. Using mixes of cobalt blue, ultramarine blue, and ultramarine violet, paint shadows on the rolling hills and, when almost dry, lift out the color at the bottom edge to suggest mist (inset). Paint a mid-green mix behind the flower spikes.

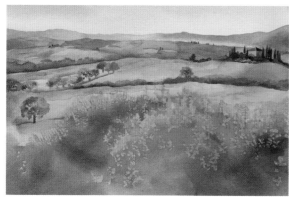

4 Now start on the detail. Using the blues and greens from the palette, paint all the trees and bushes with the smaller brushes, working some small areas wet-in-wet and others wet-on-dry, to achieve a mix of hard and soft edges. Still using the blues and greens, add the trees and shadow work to the villa. Wet the shadow areas in the foreground and drop in sap green and Indian red. Let the colors bleed randomly, then use a rigger brush to paint the flower spikes by pulling up the dark, still-wet mix from the shadow areas.

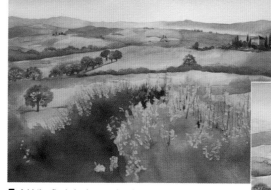

5 Add the final shadow work using the same mixes as in Step 4 with touches of ultramarine violet, and paint in the window details on the villa. Apply more dramatic washes of Indian red and violet to the foreground bushes and create more spikes with the rigger.

6 Remove the masking from the yellow flowers and add darker mixes of cadmium yellow and ochre to give form to the flowers. Add cobalt blue to the shadows in the trees to make them glow.

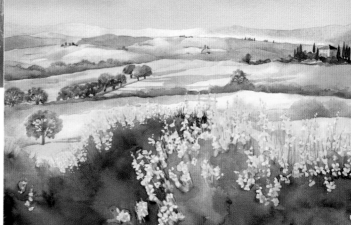

Late Summer Hayfields

The main departure from the photograph has been to omit the blue sky altogether, making the dark hills and foreground areas into a frame for the sunlit fields and fence. The omission of the blue has also allowed the artist to achieve a more consistently warm color scheme.

PAINTS

Indian yellow
Quinacridone gold
Quinacridone sienna
Permanent rose
Brilliant red violet
Manganese blue
Winsor violet
Alizarin crimson
Cobalt blue
Ultramarine
Scarlet lake
Juane brilliant

MATERIALS

Cold-pressed paper,
 140 lbs (300 gsm),
 pre-stretched
Masking fluid
Fine-point applicator
 such as a dip pen
2-in. (5-cm) or 1½-in.
 (4-cm) wash brush
Flat brushes, ¼ in.
 (6 mm) and 1 in.
 (2.5 cm)
Squirrel-quill brushes,
 #8, #6, #4, #2, and
 #00
Palette knife
Small, flat synthetic
 brush

TECHNIQUES USED

Wet-in-wet, page 18
Descriptive brushwork,
 page 20
Masking fluid,
 page 21
Lifting out, page 22

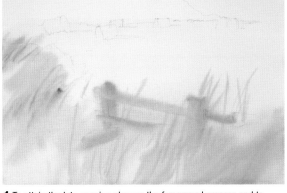

1 To attain the late-evening glow on the foreground grasses and to achieve a soft effect, moisten the area, then apply a light wash of Indian yellow. Wait until the paper has dried a little—it needs to be damp rather than wet—then build up the foreground by brushing in quinacridone gold and quinacridone sienna.

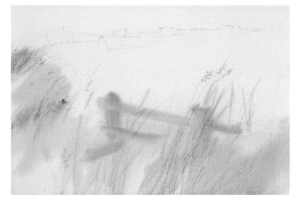

2 Apply masking fluid to protect the foreground grasses (marked here in blue). Additional masking fluid will be applied later over darker washes to create variety in the color and tone of the foreground grasses. This will help to retain their brilliant afternoon glow when the dark pigment of the middle ground and foreground is applied. Use a fine-point applicator such as a dip pen or, as here, masking fluid that has the applicator already attached.

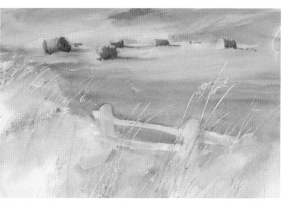

3 Paint a light wash of quinacridone sienna and permanent rose over the background hills, onto the middle-ground field, and around the fence post and foreground grasses. While still damp, stroke on a light wash of quinacridone sienna and brilliant red violet, using a brush movement that simulates the roll of the hills. Use the same mix to form the shaded sides of the haystacks, their shadows, and the flatter ground of the field. Mix quinacridone sienna with manganese blue and brush over the shadowed part of the field and around the fence and foreground grasses.

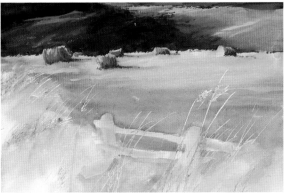

4 Paint in the dark hills with a strong mix of quinacridone sienna and brilliant red violet, taking the color around the haystacks and along the edge of the field. Where the shaded hill intersects with the sunlit one, use the dark pigment to add further definition to the sunny areas. Brush quinacridone sienna mixed with Winsor violet into the wet pigment to create variations in color and tone, then brush this mix onto the far hill to define the top of the sun-struck middle hill. Shape the haystacks by dropping in a mix of quinacridone sienna and permanent rose, followed by a mix of quinacridone sienna and alizarin crimson.

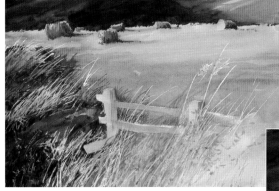

5 Apply more masking fluid over the warmer and darker washes in the foreground, this will save grasses of a different color and value, creating more visual entertainment in this area. Then brush in the quinacridone sienna and alizarin crimson mixture on the left side of the foreground. While still damp, drop in quinacridone sienna and brilliant red violet, then add mid-green mixtures of Indian yellow and cobalt blue to the immediate foreground. Strengthen the shaded part of the field, before removing the masking fluid.

6 Add detail to the tallest grass heads with a light mixture of Indian yellow, then stroke the same color over the blades of light grass to build up the sunlit feel. Make a mix of scarlet lake and Indian yellow and use to glaze over some of the grass and to build up more detail on the fence post. With a ¼-in. (6-mm) flat, damp synthetic brush, lift out small highlights on the field and in a few places on the middle hill. Use the same brush to soften some of the edges of the foreground grasses.

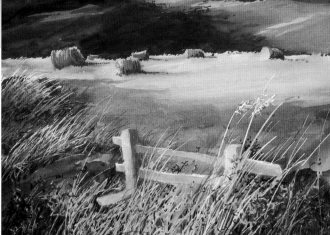

Evening Sunlight

This photograph contains a lot of detail and vivid color in the middle-ground fields, which the artist has suppressed to create a greater sense of space and recession. The foreground bushes added by the artist play an important role in balancing the dark tones of the mountain and the bushes that separate the foreground and the middle ground.

PAINTS

Cadmium yellow
Titanium white
 (acrylic)
Yellow ochre
Cadmium orange
Mars black (acrylic)
Cerulean blue
Quinacridone violet
Ultramarine
Cadmium yellow
Cadmium red

MATERIALS

Cold-pressed
 watercolor paper,
 140 lbs (300 gsm),
 pre-stretched
Pencil
3-in. (7.5-cm) flat
 squirrel-hair brush
Wood scraper (chisel-
 edged wood tool
 with sharpened
 points on both
 ends) or similar
 pointed implement
1-in. (2.5-cm) flat
 natural-hair brush
#6 bamboo round
 brush

TECHNIQUES USED

Graded and
 variegated washes,
 page 16
Wet-in-wet, page 18
Wet-on-dry, page 18
Scratching off,
 page 23

1 Begin with a fairly detailed pencil drawing. This will help to achieve the sense of perspective that is so strong in this image. Proportion the sizes of the clumps of trees and hills in the distance in relation to the background sea. Lightly sketch in the main cloud shapes.

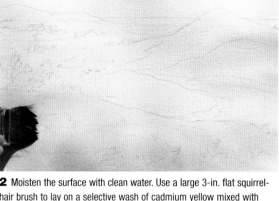

2 Moisten the surface with clean water. Use a large 3-in. flat squirrel-hair brush to lay on a selective wash of cadmium yellow mixed with titanium white acrylic, lightly touching in the sky area, background, middle ground, and foreground. While still wet, add a deeper tone of yellow ochre and cadmium orange at the base of the hill on the right and in the foreground area.

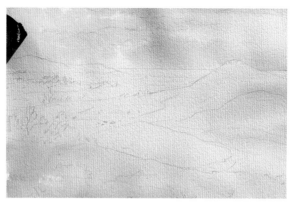

3 Once dry, rewet the sky area and float in the purple-gray background clouds using a mix of titanium white, Mars black, cerulean blue, and quinacridone violet.

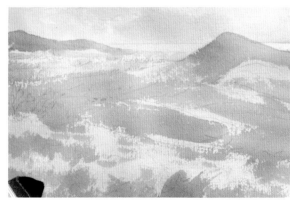

4 The background mountain, contoured green valley, hills, and foreground are worked wet-on-dry. Lay in the shapes using bold, quick strokes, focusing on generalized patterns. Allow parts of the original yellow to show through. Use a mix of ultramarine and titanium white with a touch of Mars black for the mountains. Create the green tones from a mix of yellow ochre, ultramarine blue, and Mars black.

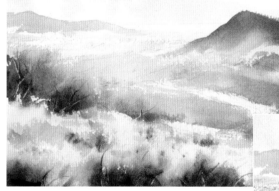

5 Rewet the darker shadow areas of the background, the large mountain to the right, the contoured areas beneath it, and the foreground trees and bushes. Paint on a mixture of ultramarine, cadmium yellow, and Mars black to produce a deeper tone that adds depth and contrast. While still moist, add more Mars black to the mix and stroke the darker color into the deeper shadow areas of the mountain, the lower parts of the foreground trees, and the bushes behind. Use a pointed scraper to indicate the tree trunks and branches and some detail in the foreground. Use a mix of dilute cadmium red touched into the foreground areas with a large brush to add a complementary contrast to the greens.

6 Darken the middle ground to separate it from the distant fields. Touch in the small trees and clumps with the point of a small round brush. Use the same method to suggest a road leading from the foreground to the middle ground. Add a touch of light cadmium red to the roofs of the background farms. To add texture, use the 3-in. (7.5-cm) brush to scumble some areas of the foreground with mid-toned greens mixed from cadmium yellow and ultramarine.

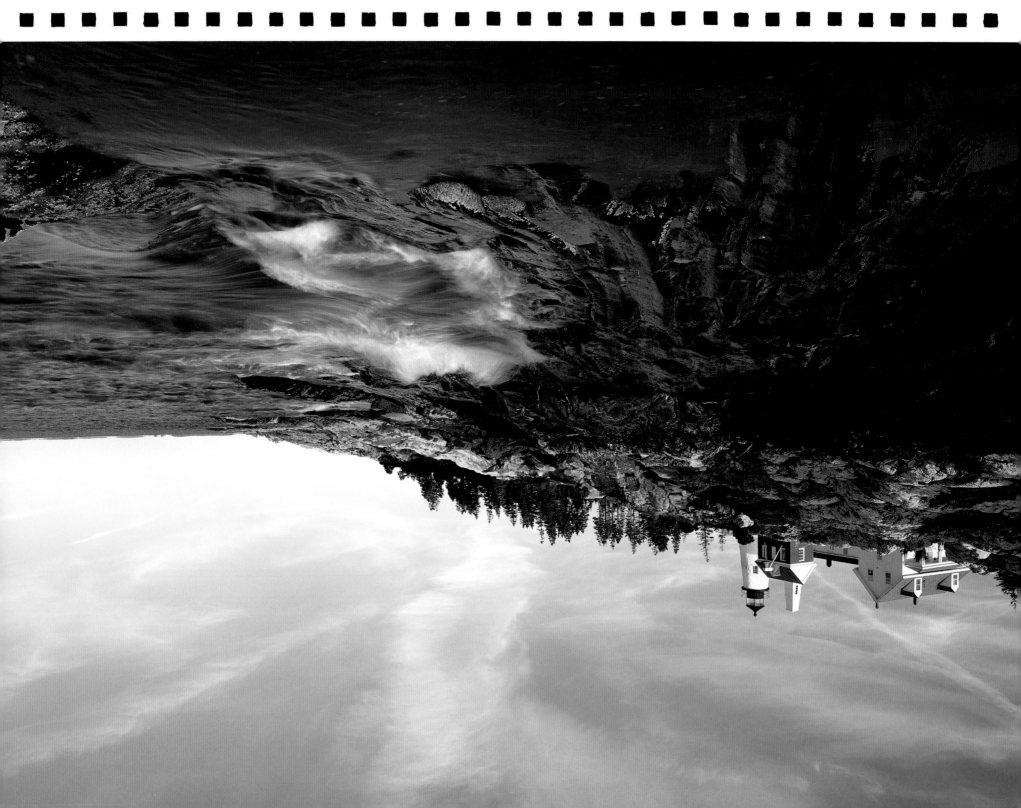

Winter Lighthouse

Although the composition is little changed from that of the photograph, the artist has given a bleak and wintry atmosphere to the scene not only by bringing in patches of snow on the rocks, but also by using a color scheme based on deep blue mixes.

PAINTS

Permanent rose
Cobalt blue
Ultramarine
Raw sienna
Burnt sienna
Cadmium yellow deep
Light red

MATERIALS

Rough watercolor
 paper, 140 lbs
 (300 gsm)
Round sable and
 rigger brushes,
 #12, #8, and #3
Scalpel or craft knife
2B pencil

TECHNIQUES USED

Flat washes, page 16
Graded and
 variegated washes,
 page 16
Wet-in-wet, page 18
Wet-on-dry, page 18
Lifting out, page 22
Scratching off,
 page 23

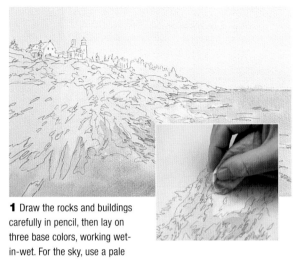

1 Draw the rocks and buildings carefully in pencil, then lay on three base colors, working wet-in-wet. For the sky, use a pale mix of ultramarine and permanent rose, grading to raw sienna near the horizon. For the rocks, use a light wash of raw sienna. When dry, paint a relatively flat wash of pale ultramarine over the sea. While still damp, lift out the white areas of the breaking waves with a tissue (inset).

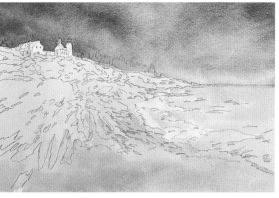

2 Dampen the whole sky area with clean water, and while damp but not too wet, apply mixes of ultramarine, cobalt blue, and permanent rose, leaving light areas for the clouds, and following the formations as closely as possible.

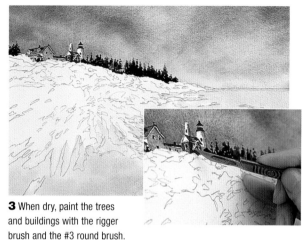

3 When dry, paint the trees and buildings with the rigger brush and the #3 round brush.
Use various mixes of light red, ultramarine, and burnt sienna for the buildings, and mixes of ultramarine, cadmium yellow deep, and light red for the dark pine trees, keeping the style fairly loose. When dry, scratch out white highlights with a sharp blade (inset).

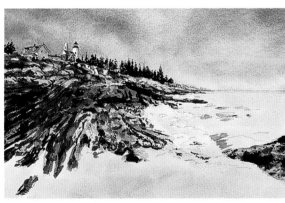

4 Now build up the rocks and lichen, using various combinations of ultramarine, light red, cadmium yellow deep, and burnt sienna. Paint in the darker tones first, laying lighter washes over the top. Allow some of the colors to blend wet-in-wet, but take care to leave crisp-edged areas of the first pale wash showing for the patches of snow.

5 Wet the whole of the sea area with clean water, and apply a strong mix of light red, ultramarine, and cobalt blue, making the color stronger in the foreground to create depth. Use a slightly damp small brush to soften the edges of the breaking waves.

6 Finally, adjust tone and colors where necessary, taking care not to overwork the painting, and use the blade again to scratch out small spots of floating foam in the foreground and a few linear highlights at the top of the right-hand rock.

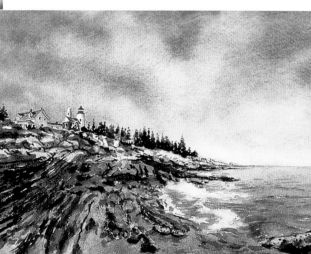

Chapel with Cypress Trees

In this painting, the clouds have been made into a more dominant feature, with their strong shapes serving as a balance to those of the trees.

PAINTS

Cerulean blue
Cobalt blue
Yellow ochre light
Cadmium red
Naples yellow
Dioxazine purple
Yellow ochre
Brown madder
Payne's gray
Sap green
Raw umber
Cadmium orange

MATERIALS

Cold-pressed paper,
 140 lbs (300 gsm)
Round sable brushes,
 #10 and #7
Small natural sponge
1-in. (2.5-cm) flat
 brush
Rigger brush
Gum arabic
Dip pen
HB pencil

TECHNIQUES USED

Graded washes,
 page 16
Dropping in colors,
 page 17
Descriptive
 brushwork, page 20
Sponge painting,
 page 24

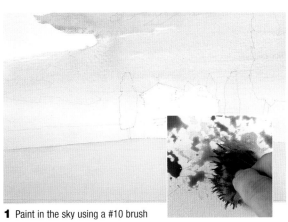

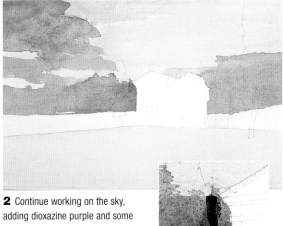

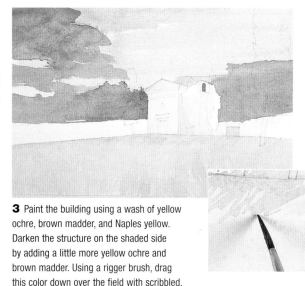

1 Paint in the sky using a #10 brush and a mix of cerulean and cobalt blue mixed with plenty of water. Apply this as a graded wash, becoming lighter toward the horizon, and work the colors carefully around the building. Form the clouds by dabbing on the same mix with a sponge to create the dark and light areas (inset). When dry, lay a wash over the fields, using yellow ochre light mixed with a little cadmium red and Naples yellow.

2 Continue working on the sky, adding dioxazine purple and some cobalt blue to the original wash. Paint the long, sweeping clouds using the #7 sable brush, dragging the paint across the paper to create a broken edge. While still wet, drop in more color to intensify the hue (inset).

3 Paint the building using a wash of yellow ochre, brown madder, and Naples yellow. Darken the structure on the shaded side by adding a little more yellow ochre and brown madder. Using a rigger brush, drag this color down over the field with scribbled, open brushstrokes (inset).

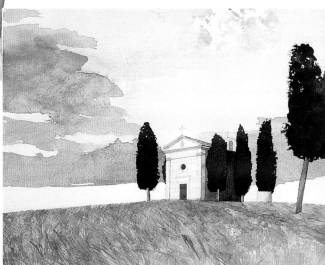

6 Add a little gum arabic to this field-color mix, so that, when dry, it can be manipulated by adding water. Make diagonal strokes following different directions to produce a sense of movement in the field. Spatter water and soften the original brushstrokes, then rework the stubble by applying paint with both a rigger brush and a fine dip pen. Finally, add in the cross on the chapel and brickwork detail using an HB pencil.

4 Add dioxazine purple and a little Payne's gray to the previous mix and paint in the detail on the building, the shadow area, and the doors and round window aperture. When dry, make a dark green mix of sap green, Payne's gray, and a little raw umber to paint the trees. Use a rigger brush for the smallest ones, but use the sponge for the larger trees to create a broken edge that describes the foliage (inset). More paint can be dropped in with a #7 sable brush.

5 Paint the tree trunks with a light brown made from raw umber and yellow ochre. When dry, darken the shadow on the building with a mix of dioxazine purple and cadmium orange. Puddle the dark paint carefully around the trees using the rigger brush. When the previous washes are dry, work on the field, using directional strokes and light orange mixtures made from yellow ochre light and orange, and yellow ochre with cadmium orange and raw umber.

Light on the Water

To simplify the composition, both the small boat and the tree on the left have been omitted, and the pine tree has been cropped at the top. The artist has given a lovely feeling of looking toward the sun through the contrast of delicate, pale colors in the sky and background and strong contrasts in the foreground.

PAINTS
Raw sienna
Cobalt blue
Permanent rose
Aureolin yellow
Burnt sienna

MATERIALS
Cold-pressed
 watercolor paper,
 140 lbs (300 gsm),
 pre-stretched
Pencil
Sponge
Round sable brushes,
 #20, #14, and #6

TECHNIQUES USED
Overlaid washes,
 page 16
Wet-in-wet, page 18
Descriptive brushwork,
 page 20
Lifting out, page 22

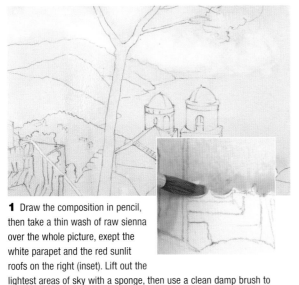

1 Draw the composition in pencil, then take a thin wash of raw sienna over the whole picture, exept the white parapet and the red sunlit roofs on the right (inset). Lift out the lightest areas of sky with a sponge, then use a clean damp brush to lift out the color at the top of the railings.

2 Make a wash of cobalt blue with a touch of permanent rose, and paint wet-in-wet over the sea and sky areas. Leave the original yellow wash showing in the center of the sky and the left-hand area of the sea. Allow to dry slightly, then paint the same mixture over the land and buildings. Drop in darker color on the headland, reserving the roofs and parapet as before.

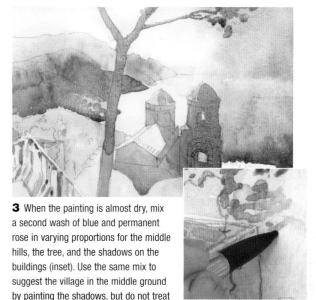

3 When the painting is almost dry, mix a second wash of blue and permanent rose in varying proportions for the middle hills, the tree, and the shadows on the buildings (inset). Use the same mix to suggest the village in the middle ground by painting the shadows, but do not treat this area in detail.

6 Finally, darken the detail on the buildings and railings with a mixture of burnt sienna and cobalt blue. Building up the picture in layers, from cool washes through to warmer ones in the foreground, will give a sense of distance.

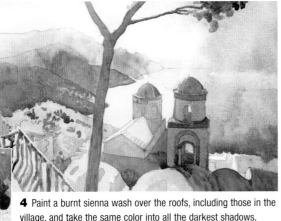

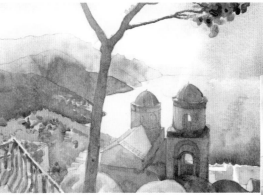

4 Paint a burnt sienna wash over the roofs, including those in the village, and take the same color into all the darkest shadows, including the tree. Use strong color inside the tower to make the light through the window shine outward. For the tree, use curving brush marks and small dots and dabs to suggest foliage (inset).

5 Mix a little aureolin yellow into raw sienna and paint over the hill that surrounds the village. Take the same mixture over all the foliage, the church roof, and the terrace area inside the railings.

Hillside Church

This composition is based closely on the photograph, although the artist has brought in some small trees on the left to lead the eye in toward the church. In addition, the dark foreground has been replaced with "stripes" of sunlit grass.

PAINTS

Winsor blue
Cerulean blue
Venetian red
Naples yellow
Sap green
Burnt umber

MATERIALS

Watercolor board
Pencil
Masking fluid
Dip pen
Ruler
Tissue
Salt
2-in. (5-cm) flat brush
Round brushes, #10
 and #3

TECHNIQUES USED

Wet-on-dry, page 18
Masking fluid,
 page 21
Lifting out, page 22
Salt spatter, page 25

1 Draw the composition in pencil and mask out the sunlit walls of the church. Use a pen and ruler for the straight edges of the buildings. Also, mask out the sunlit areas of the trees and grasses.

2 Paint in successive layers for the hills, using the large flat brush and a thin wash of Winsor blue and cerulean blue with a touch of Venetian red. Allow each layer to dry before applying the next. Lift color from the valley using a tissue.

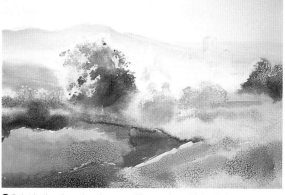

3 Paint in the sky using the same blue wash and bring it down over the hills. Blend in with clear water, then use the large flat brush to cover the land area with Naples yellow. Allow to dry and then cover the area once more with a mix of yellow, sap green, and some of the blue wash. Use the large round brush for the trees, dropping in darker greens made from sap green and the blue wash. Sprinkle on some salt to add texture, and let dry.

6 To finish the grasses, wipe off surplus paint with a damp tissue, leaving an "echo" of what was there. It will now look drier and dustier. Spatter some Naples yellow onto the shadow areas for flowers, then soften the shadows on the buildings with a damp tissue. Draw in some grasses using the pen dipped in Naples yellow.

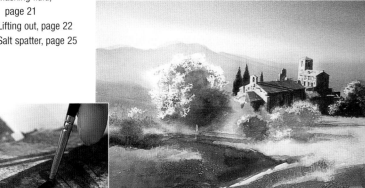

4 Paint in the cypresses behind the church with a dark mix of sap green and the blue wash, then work on the buildings. Paint in the shadows on the church with a mix of burnt umber and the blue wash, stippling and dabbing with the small round brush to give texture (inset). Next, use the large flat brush to add another blue wash to the sky, mountains, and church.

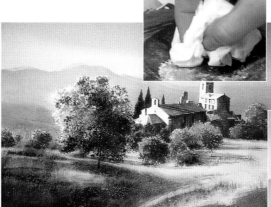

5 Remove the masking fluid and lay a thin wash of Naples yellow with a touch of burnt umber on the sunlit areas of the church. Build up the foreground shadows and trees, using the green mixed for the cypress trees for the darker areas, and the blue wash alone for the shadows on the yellow grass. While still wet, lift off some of the paint with a damp tissue (inset).

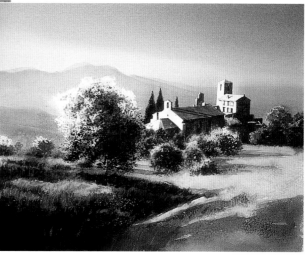

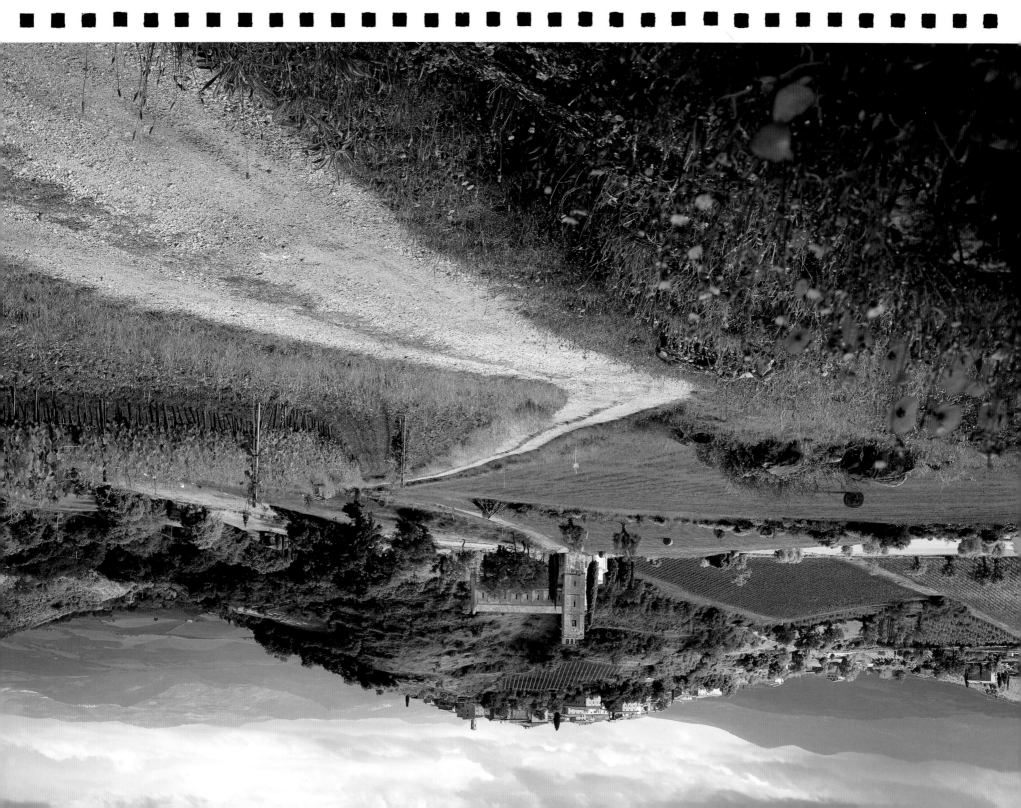

Road Through Vineyards

The building has been moved to the right, and the area of pale field on the left has been increased to balance the road. The colors have been heightened by bringing in more reds and red-browns, and the angle of the plowed field with vines has been changed to form diagonals that lead into the building.

PAINTS

Cobalt blue
Perinone orange
Cobalt violet
Manganese blue
Scarlet lake
Indian yellow
Quinacridone sienna
Cobalt violet
Quinacridone gold
Aureolin
New gamboge
Ultramarine
Brilliant red violet

MATERIALS

Cold-pressed paper,
 140 lbs (300 gsm),
 pre-stretched
Tracing paper
Soft pencil
Toothbrush
2-in. (5-cm) or 1½-in.
 (4-cm) wash brush
Flat brushes, ¼ in.
 (6 mm) and 1 in.
 (2.5 cm)
Squirrel-quill brushes
 #8, #6, #4, #2, #1,
 and #00

TECHNIQUES USED

Wet-in-wet, page 18
Spattering, page 23

1 The road is a very important compositional device; it connects all the elements and leads in toward the monastery, which forms the focal point of the picture. Here the artist has made two preliminary studies: a linear plan to position the parts of the painting in the best way (inset); and a tonal drawing to plan the placing of the light and dark tones. To make the tonal drawing, place tracing paper over the line drawing and use a soft pencil to "color in" the light, middle, and dark tones. Leave white paper for the lightest tone.

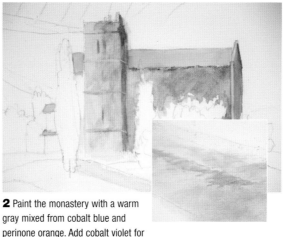

2 Paint the monastery with a warm gray mixed from cobalt blue and perinone orange. Add cobalt violet for the warmer areas, and manganese blue for darker, cooler ones. For the roof, mix scarlet lake with Indian yellow. Leave the front of the building white for now. Wash quinacridone sienna and cobalt violet over the road, and use a toothbrush to spatter quinacridone sienna, cobalt violet, and quinacridone gold to suggest texture (inset). While still damp, paint the grassy middle of the road with a mix of cobalt blue and Indian yellow.

3 Paint the sky with a deep-toned mix of cobalt blue and perinone orange. Paint around the houses on top of the hill to reserve their whites. Next, paint the bright green fields (the sunny areas) with washes of manganese blue and aureolin. While still damp, add shading by dropping in mixtures of cobalt blue and new gamboge. Once the sky is dry, paint in the trees on top of the hill with a deep-toned mixture of ultramarine and Indian yellow. The combination of underlay and the blue-orange mix will make the trees darker and cover the sky, giving an impression of distance.

6 Complete the greens of the fields and foliage, using the same mixes, but making the colors stronger in the foreground. Paint the rocks in the middle ground with the red-brown used for the plowed field, creating a visual movement across the painting. Paint the poppies with scarlet lake and new gamboge, then work the grasses around them; applying color in short diagonal strokes, working from light to dark. When dry, use a damp ¼-in. (6-mm) flat brush to lift out a few linear highlights.

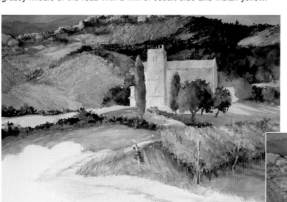

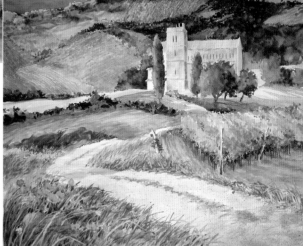

4 For the hills, wash over the sunny areas with mixes of manganese blue and aureolin, then shade with washes of cobalt blue and new gamboge. To define the fields, hills, and foliage, mix darker greens using cobalt blue with Indian yellow, and ultramarine with Indian yellow. Again, paint around the tiny houses. Using the mid-green mix, paint in the cultivated fields in stippled rows. When dry, wash a rose-brown mix of quinacridone sienna and a small amount of cobalt blue over the cultivated fields. Use this same color for the white of the hill buildings.

5 Continue to build up the fields, using the greens mixed for the vineyard fields. Use a strong red-brown mixed from quinacridone sienna and cobalt violet for the soil around the plants, then dab in a mix of quinacridone sienna and brilliant red violet in rows corresponding to the lines of the vines. Vary the methods of application to give interest and texture. For the smoother areas, wet paint can be brushed on with long, flowing strokes. For the darker, bushier areas, scrub on less diluted pigment.

Lavender Fields

The artist has made a significant alteration in terms of emphasis by playing down the sunlit village by avoiding the strong contrasts of tone seen in the photograph.

PAINTS

Cerulean blue
Cobalt blue
Dioxazine purple
Payne's gray
Raw umber
Sap green
Yellow ochre
Brown madder
Cadmium orange
Ultramarine

MATERIALS

Cold-pressed paper,
 300 lbs (640 gsm)
Small natural sponge
#10 round sable
 brush
Rigger brush
Fan-shaped blending
 brush
Dip pen

TECHNIQUES USED

Overlaid washes,
 page 16
Reserving white
 paper, page 21
Sponge painting,
 page 24

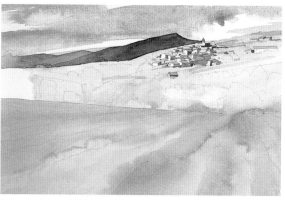

1 Using a small sponge and a #10 round brush, wet the areas where the clouds will appear. Use the same brush and a mix of cerulean and cobalt blue to paint the sky, letting the color flow into these wet areas (inset). Take the blue mix down over the distant hills. When dry, repaint them with the same mix plus some dioxazine purple and Payne's gray.

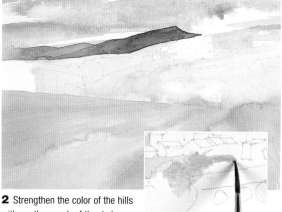

2 Strengthen the color of the hills with another wash of the dark blue, then make a watery mix of raw umber, sap green, and yellow ochre. Use this to paint in the hillside, working carefully around the buildings with a rigger brush (inset). Add some dioxazine purple to the green mix and paint in the foreground field.

3 Now paint the buildings, using a terra-cotta mix of brown madder, raw umber, and yellow ochre for the rooftops and a mix of dioxazine purple and cadmium orange with a little added ultramarine for the shadowed sides of the walls. Use the rigger brush to apply darker patches of color between the buildings.

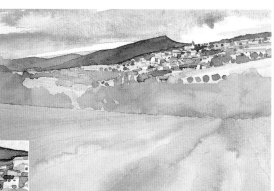

4 To create a range of greens for the landscape, use mixes of sap green, yellow ochre, raw umber, and dioxazine purple applied with the #10 brush. Use the rigger for detail (inset). Add blobs to represent individual trees or clumps. Bring the greens down to describe the tree line behind the lavender fields.

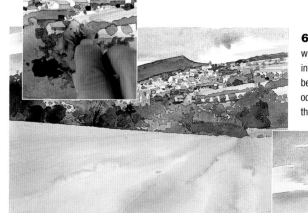

5 When the previous colors are dry, add additional trees and patches of foliage using a range of greens made from mixes of sap green, raw umber, Payne's gray, and yellow ochre. Work some of these intense greens around and in front of the buildings. Use the rigger to apply the paint in precise positions. Use a sponge dipped in paint to achieve the broken edge of foliage behind the field of lavender and the larger trees (inset). Wet the sponge first so that it holds more paint.

6 Using a fan-shaped blending brush, paint in the lavender bushes with a mixture of dioxazine purple and ultramarine. Let the color puddle in places so that it dries darker. When dry, paint the green areas between the rows of lavender using sap green mixed with a little yellow ochre, adding Payne's gray and dioxazine purple for the shadows along the edges of the bushes.

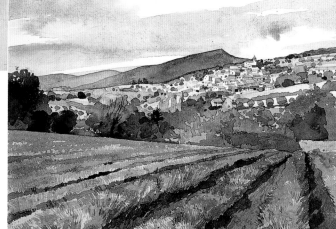

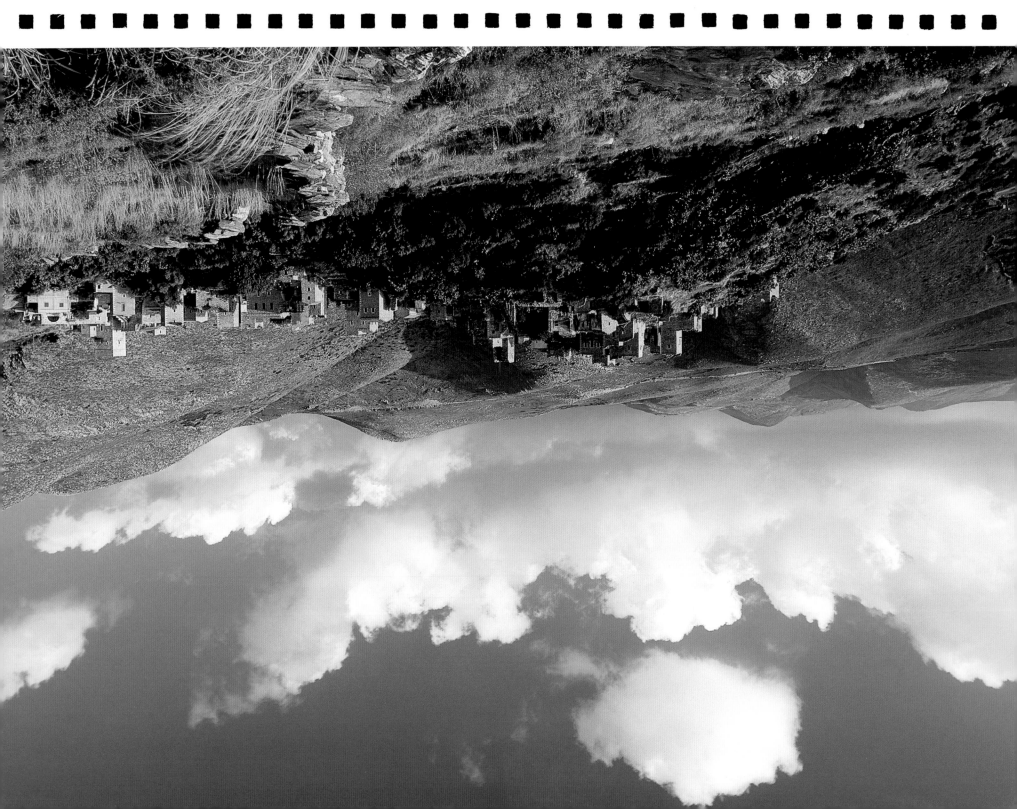

Hill Village in Greece

Apart from adapting the photograph to suit his own style, the major changes the artist has made are to insert a dark cloud at the top right to balance the cloud bank on the left and to generalize the foreground and lighten the tones overall.

PAINTS

Titanium white
 (acrylic)
Mars black (acrylic)
Ultramarine
Yellow ochre
Cadmium red
Cadmium orange

MATERIALS

Cold-pressed
 watercolor paper,
 140 lbs (300 gsm)
 pre-stretched
Pencil
Masking fluid
3-in. (7.5-cm) flat
 squirrel-hair brush
1-in. (2.5-cm) flat,
 natural-hair brush
#6 bamboo round
 brush
Eraser

TECHNIQUES USED

Wet-in-wet, page 18
Reserving white
 paper, page 21
Masking fluid,
 page 21
Scumbling, page 25

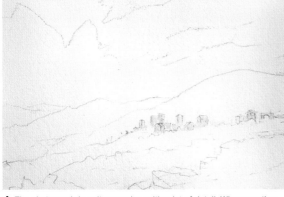

1 The photograph is quite complex, with a lot of detail. When creating your pencil drawing, try to simplify things. Concentrate on the general patterns and outlines. Once the drawing is complete, mask out the small buildings in the middle ground. Leave to dry.

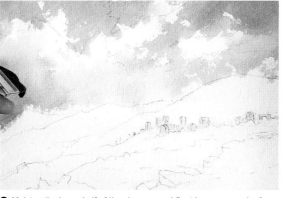

2 Moisten the lower half of the sky area and float in a gray wash of cloud bank using a mix of titanium white, Mars black, and ultramarine. Leave to dry before painting in the darker blue upper sky with strong ultramarine, taking the color carefully around the white clouds. The dark cloud at the top right should be painted in at the same time using the 3-in. (7.5-cm) brush.

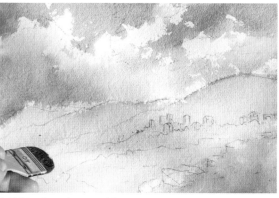

3 Moisten the entire area of the mountains and ground, then float in a wash of yellow ochre. While still moist, paint in a dilute mix of cadmium red in the left foreground and a dilute cadmium orange in the right foreground. This will add color variation and interest.

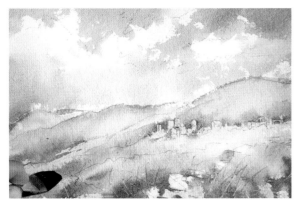

4 Rewet the land area with clean water and define the mountains and areas of the middle ground with a dilute mix of ultramarine, yellow ochre, titanium white, and Mars black. Float in some of this color behind the buildings to indicate foliage and provide contrast.

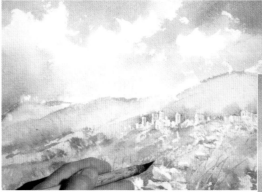

5 Remove the masking and paint in the small buildings, adding a touch of dilute cadmium red to the roofs. Work around the rocks using the same greenish tones as in Step 4 in order to give them definition.

6 Using the 3-in. (7.5-cm) flat brush, quickly scumble in a suggestion of green foliage in the foreground and under the buildings. Finally, use a #6 bamboo round brush to suggest grasses in the foreground before erasing the pencil lines.

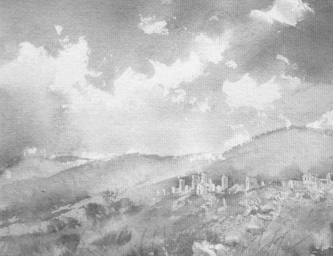

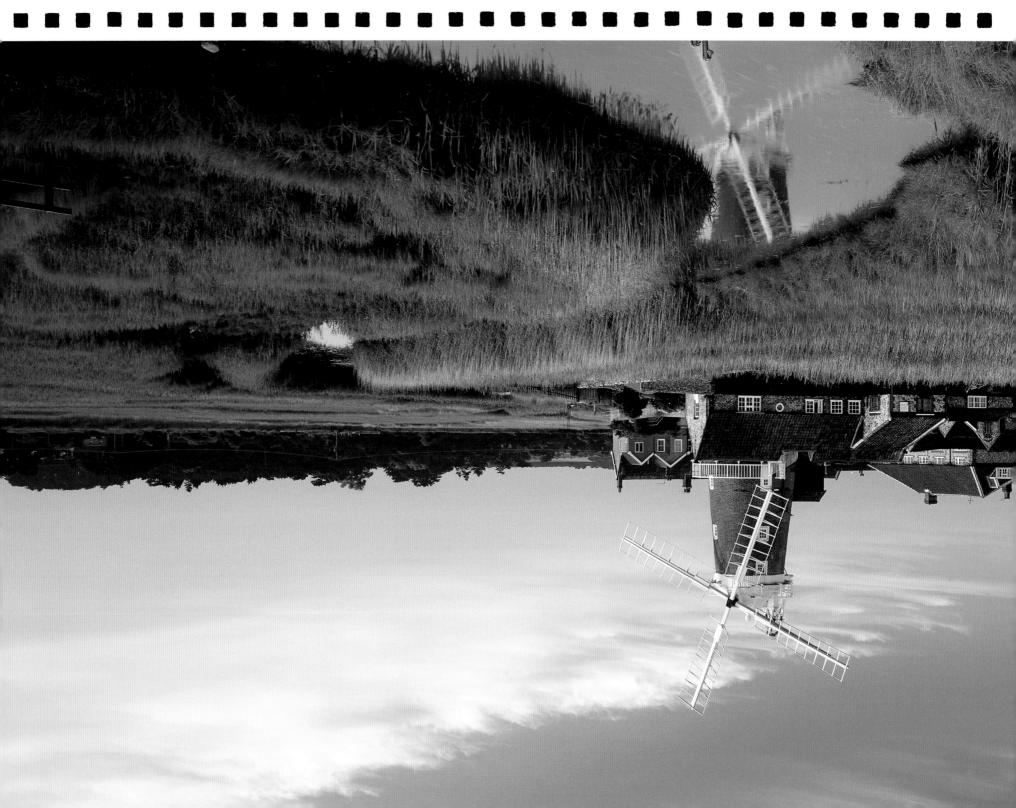

Windmill in East Anglia

The artist has made a stronger focal point of the windmill by emphasizing the horizontal lines of both the river and the field, leading the eye into and around the picture. In addition, he has simplified the reed beds in the foreground.

PAINTS
Cerulean blue
Dioxazine purple
Ultramarine
Yellow ochre
Cadmium red
Burnt sienna
Raw umber
Sap green
Payne's gray

MATERIALS
Cold-pressed paper,
　300 lbs (640 gsm)
2B pencil
Masking fluid
Rigger brushes, #2
　and #4
#10 round brush

TECHNIQUES USED
Overlaid washes,
　page 16
Masking fluid,
　page 21
Pencil and watercolor,
　page 27

1 Draw the composition in pencil, keeping the perspective in mind. Mask out the white areas on the windmill and buildings with masking fluid and the small rigger brush (inset). Rinse out the brush regularly to prevent the fluid from drying out and clogging the hairs. When dry, use the #10 round brush to wash over the sky with a very light mix of cerulean blue and dioxazine purple. Deepen the color by adding more pigment and block in the river. Allow the white paper to show through to create reflections.

2 Darken the sky mixture by adding more cerulean blue and a little ultramarine and block in the area on the left using the #10 brush. Make up a light mix of yellow ochre and cadmium red and paint in the brown patches of reed. Leave to dry.

3 Use mixes of burnt sienna, raw umber, and yellow ochre to lay the first tone on the buildings and the reflection of the windmill with the #4 rigger brush. When dry, use a dark green mix made from sap green, raw umber, and Payne's gray for the reflection of the reeds along the edges of the watercourse.

6 Redefine the shapes of the buildings and the wall in front using a mix of raw umber and dioxazine purple. Finally, use the #2 rigger to create a series of lines to represent the reed beds.

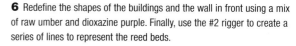

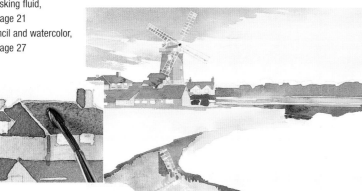

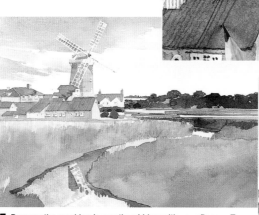

4 When dry, develop the buildings further by painting in the red-brown rooftops and the mid-tones. Use mixes of burnt sienna, raw umber, yellow ochre, and cadmium red (inset). Let the paint puddle slightly in places to provide extra interest. Paint the band of trees running across the center of the image with a mid-green made from sap green, yellow ochre, and raw umber.

5 Remove the masking by gently rubbing with your fingers. To give more precise lines, use a 2B pencil rather than a brush to draw in detail on the buildings (inset). Use a deep green mix of sap green, raw umber, and dioxazine purple to add more darks to the trees on the horizon. Apply a lighter green mix of sap green and yellow ochre to the foreground reeds. Use the #10 brush for this area initially, but pull out the color in places with the fine rigger.

Church in Tuscany

The artist has made a strong focal point of the building by leaving out much of the detail of the middle ground on the left and the hilltop village. He has also omitted some of the foreground conifers in order to give a more coherent pattern to this area, and has increased the tonal contrast to provide a sunny feel.

PAINTS

Cobalt blue
Burnt sienna
Alizarin crimson
Lemon yellow
Ultramarine
Raw sienna
Phthalocyanine blue

MATERIALS

Cold-pressed paper,
 140 lbs (300 gsm),
 pre-stretched
#8 squirrel mop
 brush
4B pencil

TECHNIQUES USED

Wet-in-wet, page 18
Descriptive
 brushwork, page 20
Reserving white
 paper, page 21

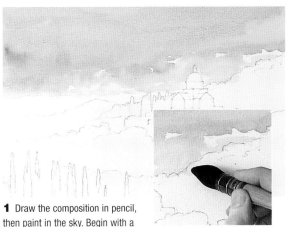

1 Draw the composition in pencil, then paint in the sky. Begin with a wash of cobalt blue, leaving small patches of white paper (inset). While still wet, drop in a little burnt sienna and alizarin crimson in various places. Let the colors bleed into one another.

2 Moisten the distant hill area and drop in a mix of cobalt blue and alizarin crimson, concentrating most of the color on the left side. When dry, apply a wash of lemon yellow mixed with a little cobalt blue over the middle ground and foreground. Bring the color carefully around the edges of the building (you could mask this if preferred).

3 Now begin to build up the foliage. Paint the trees behind the building using the point of the brush with mixes of ultramarine and lemon yellow. For the trees and bushes in the middle ground, use mixes of raw sienna and phthalocyanine blue, leaving patches of the yellow showing. Drop patches of burnt sienna onto parts of the foreground to create a dappled effect.

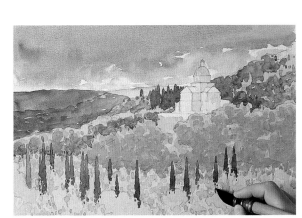

4 Apply a very dilute wash of alizarin crimson and cobalt blue to the roof and shadowed areas of the building. Darken the trees in the middle ground with a mix of raw sienna and phthalocyanine blue, then dab a weak mix of alizarin crimson and cobalt blue onto the foreground. Paint in the conifers with a strong mix of burnt sienna and phthalocyanine blue, making little dots at the bases where the foreground foliage overlaps.

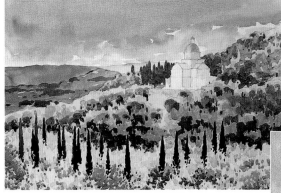

5 Using a mix of raw sienna and ultramarine, lay additional small washes on the trees behind the conifers, then paint in the dark shadows with a mix of ultramarine and alizarin crimson. Use the brush to make rounded blobs that describe the clumps of foliage. Introduce darker greens to the foreground, using mixes of burnt sienna and phthalocyanine blue for the conifers and raw sienna and phthalocyanine blue for the bushes.

6 To complete the painting, darken the foreground conifers with a second tone of burnt sienna and phthalocyanine blue. Next, dapple a darker mix of raw sienna onto the foreground bushes and add a second tone of raw sienna and ultramarine to the trees behind the building to create more contrast. Add detail to the stonework of the building using pale washes of ultramarine and alizarin crimson, with some burnt sienna in places. Finally, use the point of the brush to paint in the doors, windows, and other details.

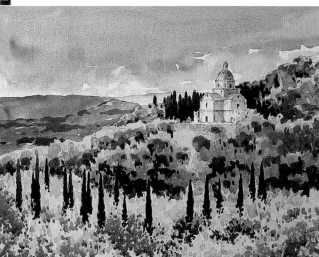

Mediterranean Village

This composition is nearly identical to the photograph, except that the artist has simplified the mass of buildings, treating some with more detail than others, so that the group makes a coherent shape in itself. He has lightened the main tone of the sea in order to add shadow details.

PAINTS

Cadmium red
Naples yellow
Payne's gray
Raw umber
Cobalt blue
Phthalocyanine blue
Cadmium lemon
Yellow ochre
Cadmium red
Sap green

MATERIALS

Cold-pressed
 watercolor paper,
 300 lbs (640 gsm)
Pencil
Round brushes, #10
 and #6
Small rigger brush
1-in. (2.5-cm) flat
 brush
2B graphite stick

TECHNIQUES USED

Wet-in-wet, page 18
Descriptive brushwork,
 page 20
Pencil and watercolor,
 page 27

1 Make a careful drawing, then mix pale washes of cadmium red, Naples yellow, Payne's gray, and raw umber. Use this to block in the buildings and cliffs, working wet-in-wet with the flat brush (inset). The brush is ideal for describing the geometric shapes. This wash will act as an underpainting and provide the base color for all subsequent work.

2 Once the first wash is dry, mix a mid-blue from cobalt blue with a little phthalocyanine blue added, and lay a graded wash. Use the #10 round brush and make the color lighter at the bottom over the sky. Let dry, then strengthen the wash by adding more phthalocyanine blue, Payne's gray, and cadmium lemon. Use to paint in the sea, letting the color puddle at the bottom of the picture. Let dry again.

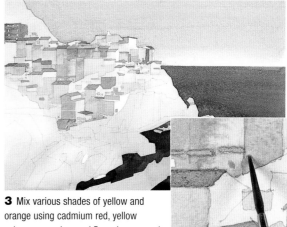

3 Mix various shades of yellow and orange using cadmium red, yellow ochre, raw umber, and Payne's gray, and begin to paint in the buildings. Start by suggesting the roofs, then the brightly painted walls of each building. Allow some of the colors to mix wet-in-wet. When the first washes are dry, paint individual buildings wet-on-dry with the small rigger brush, so that each has its own identity (inset).

4 Use the #6 round brush and pale mixes of sap green, yellow ochre, and Payne's gray to suggest the trees and shrubs growing on the cliffside. For the mid-tones on the cliffs and rocks, use a mix of raw umber, a little cadmium red, and Payne's gray, painting in the strata with the edge of the flat brush.

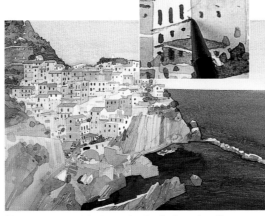

5 Now you can add the interesting details. To produce the small waves in the cove, work a mix of Payne's gray and phthalocyanine blue into the nearer sea area with the rigger brush. Use the rigger again to paint in the dark window apertures and colored shutters (inset). Draw in additional details and small shadows with the graphite stick, which gives precise marks that bring the image to life.

6 To complete the painting, add the dark shadows using a mix of Payne's gray, raw umber, and phthalocyanine blue. Use the rigger for detailed areas and the large flat brush for larger ones.

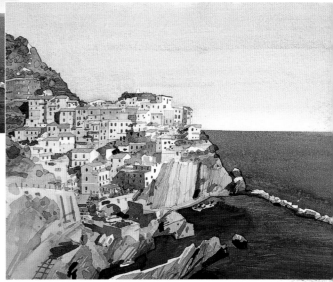

Bluebell Wood

In the photograph, the light on the tree is more prominent than the bluebells, which are close in tone to the grasses. By simplifying the tree and adding more bluebells in the distance, the artist has made a stronger feature of the grass and flowers.

PAINTS

Cerulean blue
Dioxazine violet
Raw sienna
Sap green
Winsor blue
Burnt umber
White gouache

MATERIALS

Watercolor board
Pencil
Masking fluid
Toothbrush
Tissue
Salt
2-in. (5-cm) flat brush
Round brushes, #10,
 #7, and #3
Dip pen

TECHNIQUES USED

Graded washes,
 page 16
Masking fluid,
 page 21
Scumbled masking,
 page 22
Spattering, page 23
Salt spatter, page 25
Opaque watercolor,
 page 26

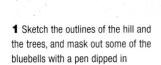

1 Sketch the outlines of the hill and the trees, and mask out some of the bluebells with a pen dipped in masking fluid. Take care not to overdo the masking. Use an old brush to spatter more masking fluid around the base of the tree trunks and in the shadows of the overhanging branches, then use a toothbrush, which gives a finer spatter, for the distant bluebells (inset). Use a torn tissue as a mask to give an irregular edge to the toothbrush spatter.

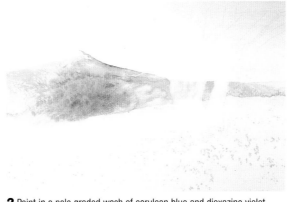

2 Paint in a pale graded wash of cerulean blue and dioxazine violet, darker at the bottom, over the foreground and sky areas and, when dry, paint the hills with mixes of raw sienna and sap green, dropping in darker color for the distant woods on the lower slopes. Spatter in some salt for texture and, when dry, paint shadows on the hill with the same blue/lilac wash as the sky.

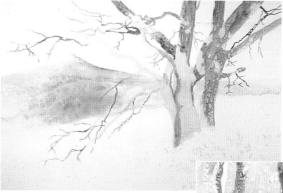

3 Block in the trunk and branches of the tree with raw sienna, and indicate the main shadow areas with burnt umber. When dry, paint on masking fluid, leave to dry, then drag your finger over it to make holes and streaks without removing it completely (inset).

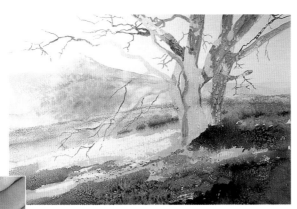

4 With mixes of raw sienna, sap green, and a darker version of the sky wash, very loosely splash and spatter color over the foreground area (inset), then sprinkle salt into the wet paint and allow to dry. Now go over the entire foreground area with a pen and masking fluid, drawing in leaves, grasses, and stalks (this can take a long time). Next, use a toothbrush to spatter a mix of cerulean blue and dioxazine violet over the distant bluebells. For the leaves, spatter dark green paint with a medium round brush.

5 Protect the distant bluebell area with tissues, and flick and spatter raw sienna and green for the trees. Using rough, irregular strokes, paint various mixes and shades of green all over the foreground, then spatter dark green to suggest leaves over the branches of the tree. Using a "colored black" made from a strong mix of sap green and Winsor blue, mark in the twigs and smaller branches silhouetted against the sky. Paint green and burnt umber over the holes made in the masking fluid on the trunk.

6 Once dry, remove all the masking fluid and work on the shadows of the trunk and branches with the previous dark mix plus burnt umber. Wash pure sap green over most of the foreground to soften and unify the leaves before painting in the bluebells. To do this, use a mix of cerulean blue and dioxazine violet with a touch of white gouache, painting those in the previously masked-out areas using the small round brush and flicking and spattering others with a larger brush. Add a little more white to the mix to paint in the bluebells in the lighter, sunlit areas.

Fall Tints

The composition has changed little from the photograph, although the artist's lively pointillist technique has made a stronger feature of the pattern of bracken in the foreground. The sky also has been subtly but significantly altered, so that the clouds and mist sweep downward to form a link with the mountains below and echo the vertical of the tall tree.

PAINTS
Cobalt blue
Burnt sienna
Alizarin crimson
Aureolin
Raw umber
Phthalocyanine blue
Ultramarine
Raw sienna

MATERIALS
Cold-pressed paper,
 140 lbs (300 gsm),
 pre-stretched
#8 squirrel mop
 brush
4B pencil

TECHNIQUES USED
Dropping in colors,
 page 17
Reserving white
 paper, page 21
Negative painting,
 page 23

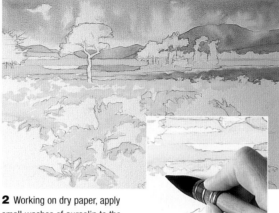

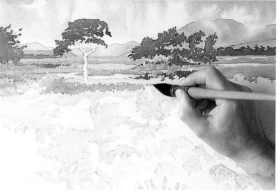

1 Draw the composition in pencil, then wet the sky area with clean water and wash on a mix of cobalt blue and burnt sienna. Leave some white paper to suggest clouds and mist. Once this is dry, wet the area of the mountains and paint them with the same color. While still wet, drop in touches of alizarin crimson on the right. Blot out a little color to suggest low clouds.

2 Working on dry paper, apply small washes of aureolin to the land areas in the middle ground and foreground. Leave gaps to paint in the patches of heather later. Use the point of the squirrel brush to define the individual shapes (inset), and make small dotted marks to suggest foliage, also in aureolin.

3 Warm up the yellow in the distance with a wash of raw sienna and then use a mix of raw sienna plus phthalocyanine blue for the green in the middle distance. Dot touches of dilute alizarin crimson onto the white patches reserved for the heather flowers in the foreground. Next, paint in the dark green trees with a mix of raw umber and phthalocyanine blue. Add a band of lighter green in front.

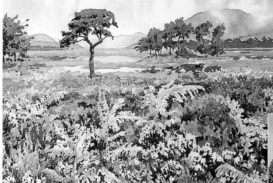

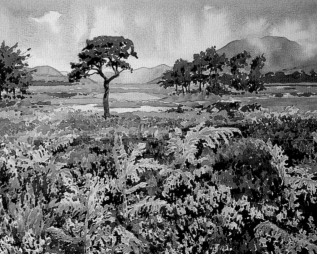

6 Use a mix of raw umber and phthalocyanine blue to add darker shadow to the foliage of the trees. Paint shadows on the trunks with a strong mix of raw umber and ultramarine, and paint the bracken with a light wash of burnt sienna, leaving small patches of the original yellow. To finish, dot a mix of alizarin crimson and raw sienna onto the heather flowers, add more dark greens to the foreground, and apply another wash of cobalt blue and alizarin crimson to the mountains.

4 Mix a bright green from aureolin and cobalt blue for the foreground, and paint the negative shapes surrounding the light bracken (inset). Build up the area gradually, first with a darker hue of aureolin and ultramarine, then with various mixtures of aureolin and cobalt blue, raw sienna and phthalocyanine blue, and aureolin with ultramarine.

5 Continue to build up the foreground in the same way, remembering always to use the point of the brush. Paint the tree trunks with a mix of raw umber and ultramarine. Add touches of raw sienna to the middle ground, then paint the shadow in the mid-foreground with a dark green mix of burnt sienna and phthalo blue.

Sunlight through Trees

The artist has made more of the path leading through to the distant view. The sun's position is effective in a photograph but would be too dazzling for a painting, so he has moved the position of the sun, placing it fully behind the tree, where it still casts shadows that radiate outward.

PAINTS
Aureolin yellow
Cobalt blue
Permanent rose
Ultramarine blue
Burnt sienna
Raw sienna
Viridian

MATERIALS
Cold-pressed paper,
 140 lbs (300 gsm),
 pre-stretched
Pencil
Sponge
Round sable brush,
 #16
Synthetic brush, #10

TECHNIQUES USED
Dropping in colors,
 page 17
Wet-in-wet, page 18
Wet-on-dry, page 18
Lifting out, page 22

1 Draw the composition in pencil, taking note of the negative shapes of sky between the trees and branches. Set the scene of bright sunshine glowing through the leaves by laying a wash of aureolin yellow over the whole picture, then quickly lift out the palest patches of sky with a tissue (inset).

2 Mix cobalt blue touched with permanent rose to give a pale violet and paint in the patches of sky, leaving the sunlit leaves yellow. Use the same mixture to plot in the distant horizon and all the main areas of shadow, including the tree trunks (inset). The blue-violet over the yellow produces a soft gray.

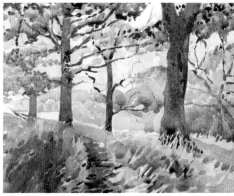

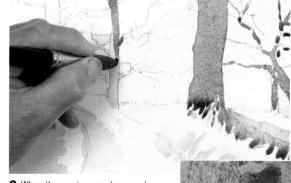

3 When the previous washes are dry, strengthen the tree trunks and branches with a mix of ultramarine and burnt sienna. Run the burnt sienna down into the foreground, adding a little permanent rose while the paint is still wet (inset).

6 To complete the painting, lift off patches of reflected light on the leaves within the path and adjust the tracery of the branches.

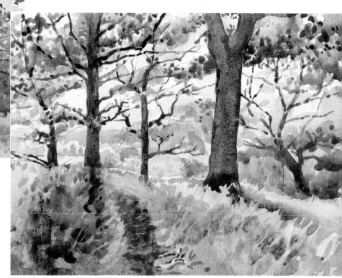

4 Leave to dry again, then add more aureolin yellow to the foliage. Drop in raw sienna here and in the foreground to enhance the sunlit effect.

5 Darken the areas beneath the leaves lit behind from the sun with a mix of viridian and permanent rose. Use the same mixture to add shadows to the tree trunks and other dark areas.

Countryside Shrine

The artist has reduced the tonal contrast and used subtler colors than those in the photograph. He has decided to lose much of the detail in the foreground, in order to lead the eye to the building.

PAINTS

Cobalt violet
Cobalt blue
Ultramarine
Permanent magenta
Raw sienna
Burnt sienna
Aureolin
Cerulean blue
Viridian

MATERIALS

Cold-pressed paper,
 140 lbs (300 gsm),
 pre-stretched
2B pencil
Masking fluid
Synthetic brush
Round sable brushes,
 #3, #5, and #8
Light-toned pastel
 pencils (optional)

TECHNIQUES USED

Wet-in-wet, page 18
Wet-on-dry, page 18
Watercolor and
 pastel, page 27

1 Draw the composition in pencil, then apply masking fluid to highlights and lighter areas of the painting using a synthetic brush (inset). Rinse out the brush regularly to prevent the fluid from drying out and clogging the hairs.

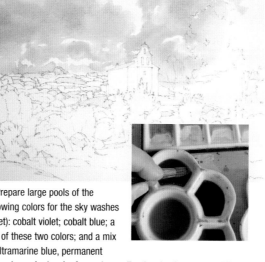

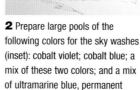

2 Prepare large pools of the following colors for the sky washes (inset): cobalt violet; cobalt blue; a mix of these two colors; and a mix of ultramarine blue, permanent magenta, and a touch of raw sienna. For the clouds, use two different mixes of cobalt blue and permanent magenta, plus a touch of raw sienna, one stronger than the other. Apply the colors, wet-in-wet on premoistened paper.

3 Mix up pools of color for the rest of the painting. For the ground and rocks, use raw sienna both on its own and mixed with cobalt violet, plus various mixes of burnt sienna, cobalt blue, and ultramarine blue. For the trees and grass, make mixtures of raw sienna, aureolin, cerulean blue, cobalt blue, and viridian. If the paper dries out too much, moisten again before laying on the colors.

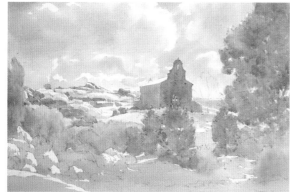

4 At this stage, you need sharper edges, especially for the building, so work on dry paper but let the colors blend wet-in-wet within each separate area. Use the same colors as in Step 3, but leave areas of the original washes showing through and avoid bringing in too many dark tones. Remove the masking and soften any unrealistically hard edges using a damp brush.

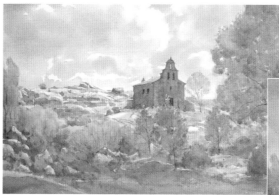

5 Next, build up the foreground and gradually adjust the balance of tones. For the foreground, make two more mixtures—one of raw sienna and permanent magenta, and another of cobalt blue and permanent magenta. Rewet the paper and leave until just damp, then apply the colors over the immediate foreground. Take some of the color up into the bottoms of the trees because this will help to avoid hard edges.

6 Add a little definition to the trees and darken the foreground slightly using the previous mixes. If you feel the highlights need more emphasis, draw them in with a pale yellow pastel pencil. An alternative method is to use gouache (opaque watercolor).

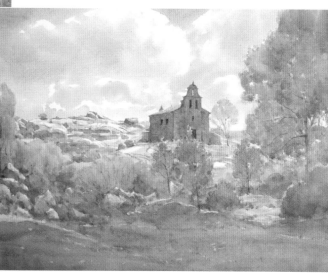

About the Photographs

by Joe Cornish

The raw material of photography is light, but this is also its heart and soul. In the first instance, the photographer must get the exposure right, a straightforward enough prospect. Yet making that distinct fragment of time and light into something more than just a visual record is much harder. Those who take up landscape photography as an easier alternative to painting may find themselves thinking they were better off with a brush!

Qualities of composition such as space, line, pattern, proportion, tension, flow, energy, geometry, shape, and texture are as vital in photography as they are in painting. But the painter will never be hindered by excessive contrast, or unsightly features of the landscape that don't work in a composition. The photographer is limited by the facts of light.

Timing is critical in photography; it is not simply a question of exposing masses of photographs in the hope that one is good enough, as some nonphotographers imagine. Good judgments, decisions, and a little luck are all required to produce a great photograph, for once the moment has passed, it has passed. But if photography wasn't so infernally difficult, it wouldn't be nearly such good fun!

Page 30, Uig Sands, Isle of Lewis, Scotland. Low tide, sunset.

Page 32, Pink granite coast, Le Gouffre, Brittany, France. Summer sunset.

Page 34, Ayton Banks, North Yorkshire, England. Fresh snow, winter sunset.

Page 36, Belvedere, Val d'Orcia, Tuscany, Italy. Valley mist just before sunrise.

Page 38, Upper Lake, Killarney, County Kerry, Ireland. Still twilight.

Page 40, Bull Head Beach, Glacier Island, Prince William Sound, Alaska, USA. Summer twilight.

Page 42, Gondola, Burano, Venice lagoon, Veneto, Italy. Evening twilight.

Page 44, Bamburgh beach and castle, Northumberland, England. Sunrise.

Page 46, Bedruthan Steps, Cornwall, England. Early summer afternoon.

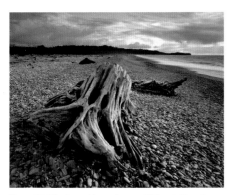

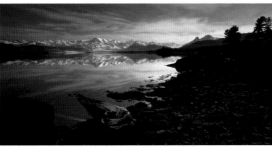

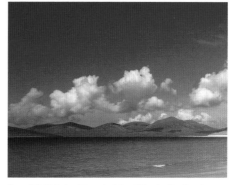

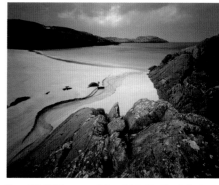

Page 48, Weathered tree stumps, Gillespie Beach, South Island, New Zealand. Late afternoon.

Page 54, Jade Island, Columbia Glacier and Chugach Mountains, Prince William Sound, Alaska, USA. Summer morning.

Page 56, Seilebost beach, Isle of Harris, Scotland. Midday.

Page 58, Hidden cove, Achmelvich, Scotland. Early morning light.

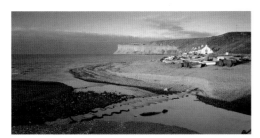

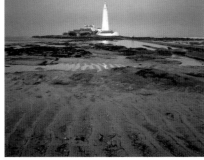

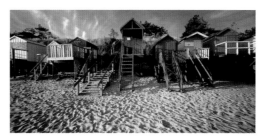

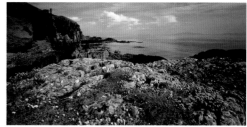

Page 60, Smuggler's village, Saltburn, Cleveland, England. Summer afternoon sunlight.

Page 62, Lighthouse, St Mary's island, Tyne and Wear, England. Twilight.

Page 64, Beach huts, Wells-next-the-sea, Norfolk, England. Early morning.

Page 66, Carsaig Arches, Isle of Mull, Scotland. Midday, spring.

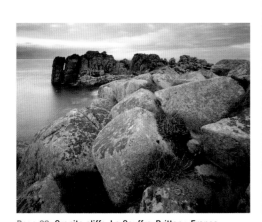

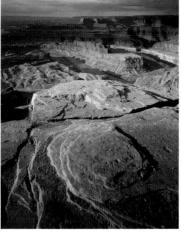

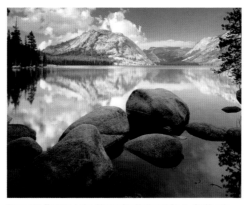

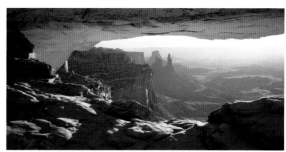

Page 68, Granite cliffs, Le Gouffre, Brittany, France. Summer evening.

Page 70, Colorado river, Dead Horse Point State Park, Utah, USA. Unsettled weather.

Page 72, Tenaya Lake, Yosemite National Park, California, USA. Summer afternoon.

Page 74, Mesa Arch, Canyonlands National Park, Utah, USA. Sunrise.

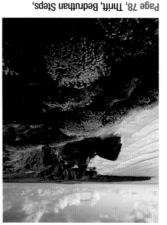
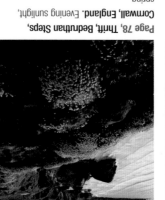

Page 76, Rumps Point, Cornwall, England. Afternoon sunlight, summer.

Page 78, Thrift, Bedruthan Steps, Cornwall, England. Evening sunlight, spring.

Page 80, Hawthorn tree on limestone pavement, Southerscales, Ingleborough, Yorkshire Dales National Park, England. Fall afternoon, late sunlight.

Page 82, Temperate rain forest, Routeburn Track, South Island, New Zealand. Overcast and drizzle.

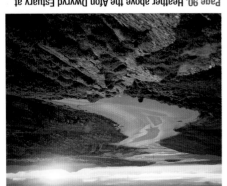

Page 84, Lockkeeper's house, River Wey navigation, Surrey, England. Winter dawn.

Page 86, Sligachan River and Cuillin Hills, Skye, Scotland. Summer afternoon.

Page 88, Swans on Loughrigg Tarn, Cumbria. Fall morning.

Page 90, Heather above the Afon Dwyryd Estuary at Penrhyndeudraeth, North Wales. Sunset.

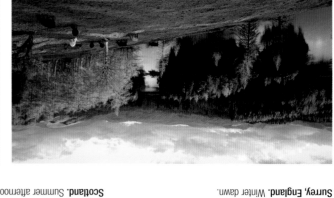

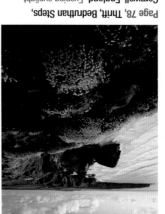

Page 92, Cattle grazing at Tarn Hows, Coniston, Cumbria. Fall afternoon.

Page 94, Marshes of Le Grand Brière, Brittany, France. Late winter sunlight.

Page 96, Lake Tekapo, Southern Alps, South Island, New Zealand. Fall afternoon.

Page 98, Poppies in barley, Sant'Antimo, Montalcino, Tuscany, Italy. Summer.

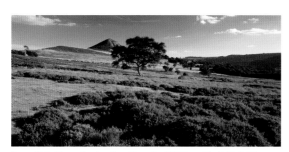

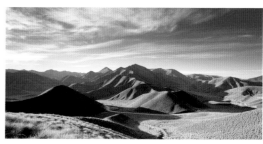

Page 100, Flowering heather, Hawnby Hill Crag, North York Moors, England. Late summer.

Page 102, Mountains of the moon, Urbino, Marche, Italy. Summer sunset.

Page 104, Cleveland Hills from Scarth Wood Moor, North Yorkshire, England. Early summer.

Page 106, Lindis Pass, South Island, New Zealand. Fall.

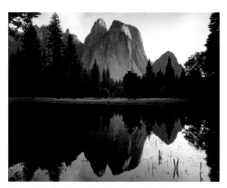

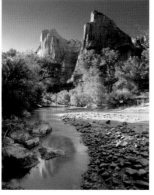

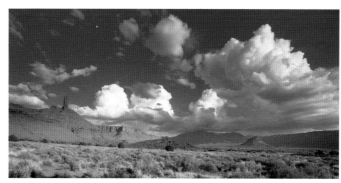

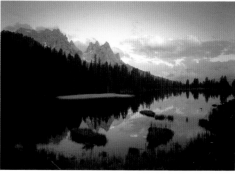

Page 108, Cathedral Peaks, Yosemite National Park, California, USA. First light.

Page 110, Virgin River and Court of the Patriarchs, Zion Canyon National Park, Utah, USA.

Page 112, Castle Valley, Moab, Utah, USA. Fall afternoon.

Page 114, Gruppo di Cadin, Lago Antorno, Dolomiti, Veneto, Italy. Evening twilight.

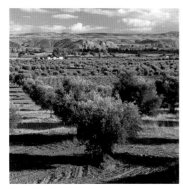

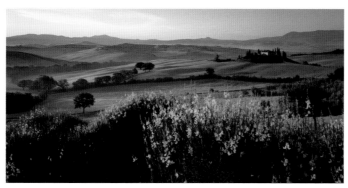

Page 116, Olive grove and hills north of Chinchon, Castile, Spain.

Page 118, Flowering broom, Belevedere, Val d'Orcia, Tuscany, Italy. Spring dawn.

Page 120, Stile, Sutton Bank, North York Moors, England. Late summer evening.

Page 122, Cleveland Hills and Roseberry Topping, North Yorkshire, England. Summer evening.

Page 126, Vitaleta chapel, Val d'Orcia, Tuscany, Italy. Late sunlight.

Page 130, Courbons, Provence, France. Summer morning.

Page 132, The road to Sant'Antimo, Castelnuovo Dell'Abate behind, Tuscany, Italy. Changeable weather.

Page 134, Lavender fields, Aurel, Provence, France. Summer afternoon.

Page 136, Vathia, Inner Mani, Pelopponese, Greece. Fall afternoon.

Page 138, Windmill, Cley-next-the-Sea, Norfolk, England. Evening sunlight.

Page 140, San Biagio, Montepulciano, Tuscany, England. Showery weather.

Page 144, Bluebells and oak tree, Roseberry Topping, North Yorkshire, England. Late afternoon, spring.

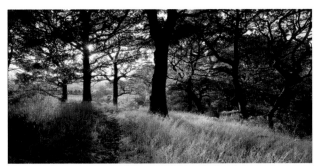

Page 146, Bracken, heather, Scots pines, Loch Tulla, Highland, Scotland. Fall dawn.

Page 148, Cliff Ridge Wood, Great Ayton, North Yorkshire, England.

Page 150, Chatmartin, Avila, Castile, Spain. Early fall.

Other photographers' work

Page 50 Beach on a Maldives Island. Late summer, evening. Danielle Gali.

Page 52 Palawan Island, Philippines. Spring morning. Peter Adams.

Page 124, Pemaquid Lighthouse, Maine, USA. Winter. James Randklev.

Page 128 Villa Rufolo, Ravello, Amalfi Coast, Italy. Early Afternoon. Demetrio Carrasco.

Page 142 Manarola, Riviera di Levante, Liguria, Italy. Spring evening. Walter Bibikow.

About the Artists

Robert Brindley

www.robertbrindley.com

Winter Sunset **35**
Tranquil Waters **39**
Gondola at Rest **43**
Fishing Village **61**
Sunshine and Frost **85**
Fall Reflections **95**
Countryside Shrine **151**

Working in watercolor, oils, and pastels, Robert Brindley's main inspiration is the challenge of capturing light and atmosphere in a modern impressionistic style.

Moira Clinch

Enchanted Forest **83**
Quiet Reflections **97**
Gorse in Flower **119**

Moira Clinch trained at Central Saint Martins School of Art in London and has exhibited at the Royal Academy's Summer Exhibition in London. She is the author of the *Watercolor Artist's Pocket Palette*.

Barry Herniman

www.barryherniman.com

Swans on Lake **89**
Sunlit Crags **111**

Barry Herniman travels extensively running workshops and has exhibited in Ireland, England, Canada, and the USA. He has published videos and books about painting with watercolors. He won the Artist of the Year Award for the SAA in 2001.

Tom Love

www.artincanada.com/thomaslove

Driftwood and Pebbles **49**

Tom Love is a Western Canadian artist who has specialized in watercolor for over 20 years. His subject matter is varied, including the human figure, and is representational without being photographic.

Diane Maxey

www.dianemaxey.com

Poppy Fields **99**
Late Summer Hayfields **121**
Road Through Vineyards **133**

Diane Maxey teaches her innovative watercolor techniques in classes and workshops across the US, and has taken workshop groups to Spain, Italy, Greece, and France. She also exhibits regularly in galleries across Arizona.

Jill Mumford

www.jillmumford.co.uk

Tropical Beach **53**

Jill Mumford is motivated by color, atmosphere, and light. Her landscapes and flower paintings are done in watercolor, oil paint, and aquatint etching. She travels extensively to find colorful locations to paint, and has exhibited her work in Paris, London, and Maui.

Jane Leycester Paige

www.oldbrewerystudios.co.uk

The Lake District **93**
Folded Mountains **107**
Light on the Water **129**
Sunlight Through Trees **149**

Jane is an artist with much experience in watercolor. She is a keen traveler and combines her love of painting and nature in her sketchbooks.

Robert Sheffield

www.robertsheffield.co.uk

Rock Stacks **41**
Palm Tree Beach **51**
Beach Huts **65**
Brittany Coast **69**
Winter Lighthouse **124**

Robert Sheffield's watercolors are painted in a loose, impressionistic style. Landscapes, waterscapes, and old buildings are his favored subjects. The countryside and rivers in his Hertfordshire home provide plenty of inspiration.

Ian Sidaway

Glacial Lake **55**
Utah Landscape **71**
Summer on the Moors **105**
Cloudscape with Hills **113**
Chapel with Cypress Trees **127**
Lavender Fields **135**
Windmill in East Anglia **139**
Mediterranean Village **143**

Ian Sidaway is a professional artist who works across a wide range of media. He is the author of over 20 practical art books and holds annual watercolor and drawing workshops in Italy.

James Harvey Taylor

www.jamesharveytaylor.com

Cornish Beach **47**
Rocky Shore **57**
Lighthouse at Low Tide **63**
Boulders in Lake **73**
Skye River **87**
Heather-clad Moors **101**
Evening Sunlight **123**
Hill Village in Greece **137**

James has painted impressionistic watercolor landscape scenes for over two decades as a full-time professional artist. His original works are in hundreds of private and corporate collections and his work has been featured in many art books and publications. In addition to painting for fine art galleries, James also runs watercolor workshops.

Robert Tilling

www.thisisjersey.com/art/roberttilling

Sunset over Sand **31**
Castle at Dawn **45**

Robert Tilling has held over 35 solo exhibitions and has exhibited regularly at the Royal West of England Academy, Bristol, and the Royal Academy, London. His work has been widely published, and he has illustrated work for, among others, Charles Causley and Spike Milligan.

Naomi Tydeman

Sunburst **33**
Tuscan Mist **37**
Flower-strewn Rocks **67**
Mesa Arch at Sunrise **75**
Celtic Seascape **79**
Estuary at Sunset **91**
Sunset Over Mountains **103**
Peaks in Yosemite **109**
Mountain Lake **115**
Hillside Church **130**
Bluebell Wood **145**

Naomi Tydeman runs her own successful gallery and artist's studio in Tenby, Wales, where she produces delicate and realistic watercolor paintings. Self-taught, she is a member of the Royal Institute of Painters in Watercolour and the Welsh Watercolour Society.

David Webb

www.atwebb.fsnet.co.uk

Early Morning Calm **59**
Rocky Headland **77**
Sun-kissed Hills **81**
Olive Grove in Spain **117**
Church in Tuscany **141**
Fall Tints **147**

David Webb is a popular artist and tutor, specializing in watercolor. He is a regular contributor to artist magazines and runs his own classes and workshops.

Index

Credits

Page 50 Beach on a Maldives Island
D. Gali/jonarnoldimages.com

Page 52 Palawan Island, Philippines
P. Adams/jonarnoldimages.com

Page 116 Pemaquid Lighthouse, Maine
J. Randklev/CORBIS

Page 128 Villa Rufolo, Ravello, Amalfi Coast, Italy
D. Carrasco/jonarnoldimages.com

Page 142 Manarola, Riviera di Levante, Liguria, Italy
W. Bibikow/jonarnoldimages.com